The
Natural Way
to Draw

Kimon Nicolaides

The
Natural Way
to Draw

A Working Plan for Art Study

by Kimon Nicolaïdes

Houghton Mifflin Company Boston

ISBN 0-395-08048-7
ISBN 0-395-20548-4 (pbk.)

Printed in the United States of America

A 45 44 43 42 41 40 39 38 37

'The supreme misfortune is when

theory outstrips performance.'

Leonardo da Vinci

Publisher's Note

WHEN Kimon Nicolaïdes died in the summer of 1938, the first draft of this book had been complete for two years. It could, perhaps, never have been published other than posthumously, for the author was reluctant to put into final form his constantly developing methods of art teaching.

After the author's death, the manuscript was prepared for publication under the auspices of the G.R.D. Studio, an enterprise for the development of young American artists in which he had been associated with Mrs. Philip J. Roosevelt. The editorial work was undertaken by Mamie Harmon, who had studied with Nicolaïdes for a number of years and who had collaborated with him in the writing.

The preparation of the text involved mainly arrangement of the material in accordance with the author's plan, and the incorporation of his other writings or authentic student notes to remedy a few omissions. Most of the illustrations, on the other hand, had to be selected without his advice, although every effort was made to adhere to his known preferences. Even that was not always possible in view of the difficulty of obtaining material from abroad.

Nicolaïdes had planned to draw especially for the book certain sketches and diagrams that would explain the directions for the exercises. Since that was not done, there were substituted sketches made by him in his classes for individual students. These sketches are naturally rough and informal, but they should serve the purpose and will perhaps add somewhat to the personal tone of instruction which he wished to maintain. The student drawings used are likewise examples of work done in actual classes — by students at approximately the same stage in the plan of study as those who are using the book. The master drawings were selected primarily with the idea of showing how the artist sets to work.

It was only with the enthusiasm and co-operation of the former students of Nicolaïdes that the book was brought to the form in which it now appears.

Hundreds of Nicolaïdes items were sent to the G.R.D. Studio when it became known that a book was in preparation. Again and again these generous contributors indicated that they were not so much conferring a favor as paying a debt to a beloved instructor.

Acknowledgment is gratefully made in behalf of the editor to the collectors who have lent drawings for reproduction, to Stuart Eldredge, who has been willing to share the responsibility for the additions which have been made, and to a group of former students whose help and advice have been invaluable — namely, Lester B. Bridaham, Lesley Crawford, Daniel J. Kern, Lester Rondell, Willson Y. Stamper, and William L. Taylor.

Contents

Introduction

THE impulse to draw is as natural as the impulse to talk. As a rule, we learn to talk through a simple process of practice, making plenty of mistakes when we are two and three and four years old — but without this first effort at understanding and talking it would be foolish to attempt to study grammar or composition. It is this vital preparation, this first mouthing of the words which mean actual things, that parallels the effort a student should make during the first years of his art study.

There is only one right way to learn to draw and that is a perfectly natural way. It has nothing to do with artifice or technique. It has nothing to do with aesthetics or conception. It has only to do with the act of correct observation, and by that I mean a physical contact with all sorts of objects through all the senses. If a student misses this step and does not practice it for at least his first five years, he has wasted most of his time and must necessarily go back and begin all over again.

The job of the teacher, as I see it, is to teach students, not how to draw, but how to learn to draw. They must acquire some real method of finding out facts for themselves lest they be limited for the rest of their lives to facts the instructor relates. They must discover something of the true nature of artistic creation — of the hidden processes by which inspiration works.

The knowledge — what is to be known about art — is common property. It is in many books. What the teacher can do is to point out the road that leads to accomplishment and try to persuade his students to take that road. This cannot be a matter of mere formula.

My whole method consists of enabling students to have an experience. I try to plan for them things to do, things to think about, contacts to make. When they have had that experience well and deeply, it is possible to point out what it is and why it has brought these results.

The real laws of art, the basic laws, are few. These basic laws are the

laws of nature. They existed even before the first drawing was made.

Through constant effort, patient groping, bit by bit, certain rules have been established relating to the technique of picture making. These rules are the result of man's ability to relate the laws of balance, which he has found in nature, to the business of making a picture. But in the beginning it is not necessary to worry about them. In the beginning these rules and their application will remain a mystery no matter what one does about it.

Man can make only the rules. He cannot make the laws, which are the laws of nature. It is an understanding of these laws that enables a student to draw. His difficulty will never be a lack of ability to draw, but lack of understanding.

Art should be concerned more with life than with art. When we use numbers we are using symbols, and it is only when we transfer them to life that they become actualities. The same is true with rules of drawing and painting. They are to be learned, not as rules, but as actualities. Then the rules become appropriate.

To understand theories is not enough. Much practice is necessary, and the exercises in this book have been designed to give that practice.

KIMON NICOLAÏDES

The
Natural Way
to Draw

How to Use This Book

THIS book was written to be used. It is not meant simply to be read any more than you would sit down to read through an arithmetic book without any attempt to work out the problems it describes.

I assume that you are about to embark on a year of art study, and I plan to teach you as nearly as possible just what you would have learned if you had spent a year in one of my classes at the Art Students' League. I do not care who you are, what you can do, or where you have studied if you have studied at all. I am concerned only with showing you some things which I believe will help you to draw. My interest in this subject is a practical one, for my efforts consist in trying to develop artists.

The students who have come to my actual classes have been people of vastly differing experience, taste, background, and accomplishments. Some had studied a great deal, some not at all. Many were teachers themselves. I always ask them, as I am going to ask you, to approach these exercises from the beginning, exactly as if you were a beginner, whatever your preparation may have been. I believe that the reason for this will become apparent as you work. Each exercise develops from preceding ones, and it is conceivable that if you opened this book anywhere other than at the beginning you would be misdirected rather than helped.

The arrangement of the text has been determined, not by subject matter, but by schedules for work, because the work is the important thing. Each section of reading matter is accompanied by a schedule representing fifteen hours of actual drawing. Begin your first day's work by reading the first section until you come to the direction that you are to draw for three hours according to Schedule 1A. THEN STOP AND DRAW.

I ask that you follow the schedules explicitly because each one has been planned with care and for a definite purpose. You should not even read the succeeding paragraphs until you have spent the time drawing as directed. And that is true of the entire book, for the basic idea of its instruction is to have you arrive at the necessary relationship between thought and action. Each exercise has its place and carries a certain momentum. If you fail to do it at the time and for as long a time as you are instructed to, you disrupt that momentum. If you feel that you fail with some exercise, that you do not understand it at all, simply practice it as best you can for the required

time and then try the next. There are other exercises that will take up the slack provided the effort has been made.

In most courses of study of any sort the general idea prevails that it is to your credit to get through the work quickly. That is definitely not true in this study. If you are particularly apt, your advantage will lie, not in how much sooner you can 'get the idea' and 'finish,' but in how much more you will be able to do at the end of a year's work than someone less gifted. What you are trying to learn is not the *exercise* — that should be easy, for I have tried to make each one as simple as possible. You are trying to learn *to draw*. The exercise is merely a constructive way for you to look at people and objects so that you may acquire the most knowledge from your efforts.

As you begin, try to develop the capacity of thinking of only one thing at one time. In these exercises I have attempted to isolate one by one what I consider the essential phases of, or the essential acts in, learning to draw. I turn the spotlight first on one, then another, so that by concentrating on a single idea you may be able most thoroughly to master it. The exercises eventually become welded and the habits thus formed will contribute to every drawing you make.

Don't worry if for the first three months your studies do not look like anything else called a drawing that you have ever seen. You should not care what your work looks like as long as you spend your time trying. The effort you make is not for one particular drawing, but for the experience you are having — and that will be true even when you are eighty years old.

I believe that entirely too much emphasis is placed upon the paintings and drawings that are made in art schools. If you go to a singing teacher, he will first give you breathing exercises, not a song. No one will expect you to sing those exercises before an audience. Neither should you be expected to show off pictures as a result of your first exercises in drawing.

There is a vast difference between drawing and making drawings. The things you will do — over and over again — are but practice. They should represent to you only the result of an effort to study, the by-product of your mental and physical activity. Your progress is charted, not on paper, but in the increased knowledge with which you look at life around you.

Unfortunately most students, whether through their own fault or the fault of their instructors, seem to be dreadfully afraid of making technical mistakes. You should understand that these mistakes are unavoidable.

THE SOONER YOU MAKE YOUR FIRST FIVE THOUSAND MISTAKES, THE SOONER YOU WILL BE ABLE TO CORRECT THEM.

To keep the exercises clear, the book is written as if you were an enrolled student in an art school. However, I realize that there are many talented people who are not in a position to go to a school and yet who deserve some opportunity of guidance because of their ability and desire. In the hope that this book can serve as a teacher for such people, I have included the simplest and most practical details of instruction. Where no class is available, I suggest that you try to organize a small group to share the expense of a model. In such a group one student should be elected monitor so that there will not be any confusion.

As the exercises are described, it is assumed that a nude model is available. However, all the exercises may be done from the costumed model instead, except those in anatomy for which you can use casts. If you cannot afford or secure a model, call on your friends or family to pose for you whenever you can and work from landscapes and objects the rest of the time. You will find that, with a few exceptions, the exercises apply just as much to things as to people. I have made some suggestions as to the most suitable subjects from time to time, and you are expected to supplement your work by drawing such subjects, even if you work regularly from the model.

The model should be placed in the center of the room so that all the students can sit very close and can look at the pose from all angles. Sit in a straight chair and rest your drawing against the back of another chair in front of you. (For these exercises, this relaxed and familiar position is more suitable than sitting or standing at an easel.) If you work at night, use concealed lighting or overhead lights from more than one source, and if you work by day, do not allow sunlight to fall directly on the figure. Avoid anything that has the effect of a spotlight on the model.

At the beginning of each exercise you will find a list of whatever *new* materials you will need. Most of these materials are readily procurable anywhere. However, they may be ordered from the Art Students' League of New York, 215 West 57th Street, New York City. All the materials suggested are cheap, and they are more suitable for these exercises than expensive ones, even if you can afford them.

You can make several studies from any pose by looking at the model from different positions. Use this method of adapting the pose to your

needs if you work in some class where the schedule of this book is not being followed. When a pose is going on which does not fit your exercise, you can stop drawing the model and draw objects or the room or your classmates.

Whatever the circumstances in which you work — whether in a class or alone, with a model or without — your ultimate success depends on only one element, and that is yourself. It is a fallacy to suppose that you can get the greatest results with a minimum of effort. There is no such thing as getting more than you put into anything. You expect a man who is guiding you through the mountains to save your energy and tell you the best way, but you can't get any farther in that mountain than you can and will walk. My one idea is to direct you to make the right sort of effort, for if you do you are bound to win out.

If you have ever tried it, you will realize how difficult it is to speak clearly and concisely of art. One is always very close to contradictions. However, you will not simply read the things I have to say. You will act upon them, work at them, and therefore I believe that each of you will arrive at a proper index of these ideas through a natural and individual application of them. Each of you, in a way peculiar to yourself, will add something to them. The book has been planned to that end.

Section 1

Contour and Gesture

CORRECT OBSERVATION. The first function of an art student is to observe, to study nature. The artist's job in the beginning is not unlike the job of a writer. He must first reach out for raw material. He must spend much time making contact with actual objects.

Learning to draw is really a matter of learning to see — to see correctly — and that means a good deal more than merely looking with the eye. The sort of 'seeing' I mean is an observation that utilizes as many of the five senses as can reach through the eye at one time. Although you use your eyes, you do not close up the other senses — rather, the reverse, because all the senses have a part in the sort of observation you are to make. For example, you know sandpaper by the way it feels when you touch it. You know a skunk more by odor than by appearance, an orange by the way it tastes. You recognize the difference between a piano and a violin when you hear them over the radio without seeing them at all.

SCHEDULE 1

	A	B	C	D	E
Half Hour	Ex. 1: Contour (one drawing)	Ex. 2: Gesture (25 drawings)	Ex. 2: Gesture (25 drawings)	Ex. 2: Gesture (25 drawings)	Ex. 2: Gesture (25 drawings)
Half Hour	Ex. 1: Contour (one drawing)	Ex. 1: Contour (one drawing)	Ex. 1: Contour (one drawing)	Ex. 1: Contour (one drawing)	Ex. 3: Cross Contours (one sheet of drawings)
Quarter Hour	Ex. 1: Contour (one drawing)	Ex. 2: Gesture (15 drawings)	Ex. 2: Gesture (15 drawings)	Ex. 2: Gesture (15 drawings)	Ex. 2: Gesture (15 drawings)
Quarter Hour	Rest	Rest	Rest	Rest	Rest
Half Hour	Ex. 1: Contour (one drawing)	Ex. 2: Gesture (25 drawings)	Ex. 2: Gesture (25 drawings)	Ex. 2: Gesture (25 drawings)	Ex. 2: Gesture (25 drawings)
One Hour	Ex. 1: Contour (one or two drawings)	Ex. 1: Contour (one or two drawings)	Ex. 1: Contour (one or two drawings)	Ex. 1: Contour (one or two drawings)	Ex. 1: Contour (one or two drawings)

This schedule represents fifteen hours of actual drawing, which I have divided for convenience into five three-hour lessons — A, B, C, D, and E. You may, of course, divide the work into seven two-hour lessons or fourteen one-hour lessons, omitting the rest period if you shorten the time. The model is usually allowed to rest during five minutes of each half hour, so the half-hour pose is actually only twenty-five minutes. The longer poses should be fairly simple at first and should show various views of the figure — back and side as well as front.

Because pictures are made to be seen, too much emphasis (and too much dependence) is apt to be placed upon seeing. Actually, we see *through* the eyes rather than with them. It is necessary to test everything you see with what you can discover through the other senses — hearing, taste, smell, and touch — and their accumulated experience. If you attempt to rely on the eyes alone, they can sometimes actually mislead you.

I think you will realize that this is true if you imagine that a man from Mars or some planet totally different from ours is looking for the first time at a landscape on the earth. He *sees* what you see, but he does not *know* what you know. Where he sees only a square white spot in the distance, you recognize a house having four walls within which are rooms and people. A cock's crow informs you that there is a barnyard behind the house. Your mouth puckers at the sight of a green persimmon which may look to him like luscious fruit or a stone.

If you and the man from Mars sit down side by side to draw, the results will be vastly different. He will try to draw the strange things he sees, as far as he can, in terms of the things his senses have known during his life on Mars. You, whether consciously or not, will draw what you see in the light of your experience with those and similar things on earth. The results will be intelligible, the one to the other, only where the experiences happen to have been similar. But if you both start out and explore that landscape on foot, touching every object, inhaling every odor, both will approach closer to what it is.

A man can usually draw the thing he knows best whether he is an artist or not. A golfer can draw a golf club, a yachtsman can make an intelligible drawing of a sail. This is a thing with which he has had real experience, a thing he has touched and used. Many other things which he has seen as often, but not used, he would not even attempt to draw.

THE SENSE OF TOUCH. Merely to see, therefore, is not enough. It is necessary to have a fresh, vivid, physical contact with the object you draw through as many of the senses as possible — and especially through the sense of touch.

Our understanding of what we see is based to a large extent on touch. Advertising experts realize this and place sample objects in stores where people can touch them. If you close your eyes and someone puts into your hand an object that you haven't seen, you can doubtless tell what that object is without opening your eyes. You can probably draw it from the experi-

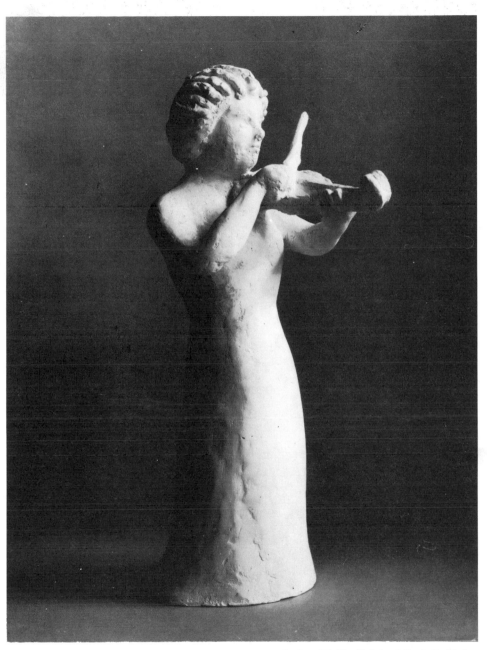

VIOLIN PLAYER BY CLARA CRAMPTON
(The artist has been blind since birth.)
You need not rely on the eyes alone.

DRAWING BY MATISSE

ence of touch without ever having seen it. If you go into a dark room to get a book, you will not bring back a vase by mistake even though the two are side by side.

I read recently of a girl whose sight was suddenly gained after a lifetime of blindness. As long as she was blind, she was able to move about the house with ease. When she began to see, she could not walk across the room without stumbling over furniture. Her difficulty lay in the fact that she could not yet coordinate her new sense of sight with what she had previously learned through the sense of touch.

The first exercise, which you are about to attempt, is planned consciously to bring into play your sense of touch and to coordinate it with your sense of sight for the purpose of drawing.

Look at the edge of your chair. Then rub your finger against it many times, sometimes slowly and sometimes quickly. Compare the idea of the edge which the touch of your finger gives with the idea you had from merely looking at it. In this exercise you will try to combine both those experiences — that of touching with that of simply looking.

EXERCISE 1: CONTOUR DRAWING

Materials: Use a 3B (medium soft) drawing pencil with a very fine point (sharpened on sandpaper) and a piece of cream-colored manila wrapping paper about fifteen by twenty inches in size. Manila paper usually comes in large sheets which may be cut into four pieces of that size. You may use, also, the kind sold as 'shelf paper' provided it is not glazed. Fasten the paper with large paper clips to a piece of prestwood or a stiff piece of cardboard. Wear an eyeshade. Do not use an eraser until you come to Exercise 28.

Sit close to the model or object which you intend to draw and lean forward in your chair. Focus your eyes on some point — any point will do — along the contour of the model. (The contour approximates what is usually spoken of as the outline or edge.) Place the point of your pencil on the paper. Imagine that your pencil point is touching the model instead of the paper. Without taking your eyes off the model, *wait* until you are *convinced* that the pencil is touching that point on the model upon which your eyes are fastened.

Then move your eye *slowly* along the contour of the model and move the pencil *slowly* along the paper. As you do this, keep the conviction that the pencil point is actually touching the contour. Be guided more by the sense of touch than by sight. THIS MEANS THAT YOU MUST DRAW WITHOUT LOOKING AT THE PAPER, continuously looking at the model.

Exactly coordinate the pencil with the eye. Your eye may be tempted at first to move faster than your pencil, but do not let it get ahead. Consider only the point that you are working on at the moment with no regard for any other part of the figure.

Often you will find that the contour you are drawing will leave the edge of the figure and turn inside, coming eventually to an apparent end. When this happens, glance down at the paper in order to locate a new starting point. This new starting point should pick up at that point on the edge where the contour turned inward. Thus, you will glance down at the paper several times during the course of one study, but do not draw while you are looking at the paper. As in the beginning, place the pencil point on the paper, fix your eyes on the model, and wait until you are convinced that the pencil is touching the model before you draw.

Not all of the contours lie along the outer edge of the figure. For example, if you have a front view of the face, you will see definite contours along the nose and the mouth which have no apparent connection with the contours at the edge. As far as the time for your study permits, draw these 'inside

STUDENT CONTOUR DRAWING
Let the lines sprawl all over the paper.

contours' exactly as you draw the outside ones. Draw anything that your pencil can rest on and be guided along. DEVELOP THE ABSOLUTE CONVICTION THAT YOU ARE TOUCHING THE MODEL.

This exercise should be done slowly, searchingly, sensitively. Take your time. Do not be too impatient or too quick. There is no point in finishing any one contour study. In fact, a contour study is not a thing that can be 'finished.' It is having a particular type of experience, which can continue as long as you have the patience to look. If in the time allowed you get only halfway around the figure, it doesn't matter. So much the better! But if you finish long before the time is up, the chances are that you are not approaching the study in the right way. A contour drawing is like climbing a mountain as contrasted with flying over it in an airplane. It is not a quick glance at the mountain from far away, but a slow, painstaking climb over it, step by step.

Do not worry about the 'proportions' of the figure. That problem will take care of itself in time. And do not be misled by shadows. When you touch the figure, it will feel the same to your hand whether the part you touch happens at the moment to be light or in shadow. Your pencil moves, not on the edge of a shadow, but on the edge of the actual form.

At first, no matter how hard you try, you may find it difficult to break the habit of looking at the paper while you draw. You may even look down without knowing it. Ask a friend to check up on you for a few minutes by calling out to you every time you look

STUDENT CONTOUR DRAWING
Draw without looking at the paper, continuously looking at the model.

at the paper. Then you will find out whether you looked too often and whether you made the mistake of drawing while you were looking.

This exercise should be used in drawing subjects of all sorts. At first, choose the contours of the landscape which seem most tangible, as the curve of a hill or the edge of a tree-trunk. Any objects may be used, although those which have been formed by nature or affected by long use will offer the greatest amount of variation, as a flower, a stone, a piece of fruit, or an old shoe. Draw yourself by looking

Draw anything.

in the mirror, your own hand or foot, a piece of material. It is the experience, not the subject, that is important.

CONTOUR VERSUS OUTLINE. 'Contour' is commonly defined as 'the outline of a figure or body,' but for the purposes of this study we are making a definite, if perhaps arbitrary, distinction between 'contour' and 'outline.'

We think of an outline as a diagram or silhouette, flat and two-dimensional. It is the sort of thing you make when you place your hand flat on a piece of paper and trace around the fingers with a pencil — you cannot even tell from the drawing whether the palm or the back of the hand faced downward. Contour has a three-dimensional quality; that is, it indicates the thickness as well as the length and width of the form it surrounds.

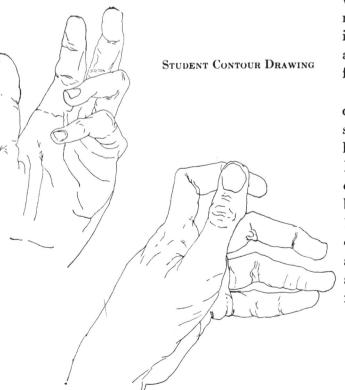

STUDENT CONTOUR DRAWING

We do not think of a line as a contour unless it follows the sense of touch, whereas an outline may follow the eye alone. Place two apples on a table, one slightly in front of the other but not touching it, as in Figure 1. Figure 2 shows the visual outline of both apples. Figure 3 shows the visual outline of the second apple. Neither Figure 2 nor Figure 3 could possibly be a

contour drawing because, in both, the line follows the eye and not the sense of touch. If you feel that you are touching the edge, you will not jump from the edge of the first apple to the edge of the second without lifting your pencil, as in Figure 2, just as you cannot actually touch the second apple with your finger at that place until you have lifted your finger from the first apple. As an outline, Figure 3 shows what you *see* of the second apple only, but if you think in terms of contour or touch, part of that line belongs to the first apple and not to the second. The outlines in both Figure 2 and Figure 3 are visual illusions. A contour can never be an illusion because it touches the actual thing.

Draw for three hours as directed in Schedule 1 A.
If you have not read the section on How to Use This Book, read it now.

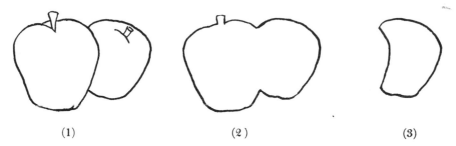

(1) (2) (3)

TWO TYPES OF STUDY. The way to learn to draw is by drawing. People who make art must not merely know about it. For an artist, the important thing is not how much he knows, but how much he can do. A scientist may know all about aeronautics without being able to handle an airplane. It is only by flying that he can develop the senses for flying. If I were asked what one thing more than any other would teach a student how to draw, I should answer, 'Drawing — incessantly, furiously, painstakingly drawing.'

Probably you realize already that contour drawing is of the type which is to be done 'painstakingly.' On the other hand, gesture drawing, which you will begin today, is to be done 'furiously.' In order to concentrate, one can act furiously over a short space of time or one can work with calm determination, quietly, over a long extended period. In learning to draw, both kinds of effort are necessary and the one makes a precise balance for the other. In long studies you will develop an understanding of the structure of the model, how it is made — by which I mean something more fundamental than anatomy alone. In quick studies you will consider the function of action, life, or expression — I call it *gesture.*

The quick sketches made by most students are exactly what they are called — quick sketches — which to my way of thinking is very bad practice. In fact, anything that is sketchy is bad practice. The word 'sketch' suggests something that is not completed. Quick studies, on the contrary, should indicate that there has been real study and a completion of the thing studied, representing a certain kind of concentration even though the study is quick. The way to concentrate in a short space of time is to concentrate on only one phase of the model. Naturally, I try to select an important phase and I have chosen the gesture.

Quick sketches are often used simply to 'loosen up' the student and not as a means of penetrating study. Often students do them well and are quite surprised at the results, which are far beyond any knowledge they have. The reason is that by working quickly they accidentally find the gesture. The gesture is a feeler which reaches out and guides them to knowledge.

Exercise 2: Gesture Drawing

Materials: Use a 3B or 4B pencil (keeping the point blunt and thick) and sheets of cream manila paper about ten by fifteen inches in size. (This is half the size used for contour drawing.) Use both sides of the paper, but put only one drawing on each side. Since you will make a great many gesture drawings, you may substitute for manila an even cheaper paper known as newsprint. Keep an ample supply of paper on hand.

The model is asked to take a very active pose for a minute or less and to change without pause from one pose to the next. If you have no model — or, frequently, even if you do — you should go to some place where you are likely to see people actively moving about. A playground, a football game, a bargain basement, a busy street, a lumber mill, a swimming hole, a building under construction, will give you excellent opportunities to study gesture.

As the model takes the pose, or as the people you watch move, you are to draw, letting your pencil swing around the paper almost at will, being impelled by the sense of the action you feel. Draw rapidly and continuously in a ceaseless line, from top to bottom, around and around, *without taking your pencil off the paper*. Let the pencil roam, reporting the gesture.

YOU SHOULD DRAW, NOT WHAT THE THING LOOKS LIKE, NOT EVEN WHAT IT IS, BUT WHAT IT IS *DOING*. Feel how the figure lifts or droops — pushes forward here — pulls back there — pushes out here — drops down easily there. Suppose that the model takes the pose of a fighter with fists clenched and jaw thrust forward angrily. Try to draw the actual *thrust* of the jaw, the *clenching* of the hand. A drawing of prize fighters should show the *push*, from foot to fist, behind their blows that makes them hurt.

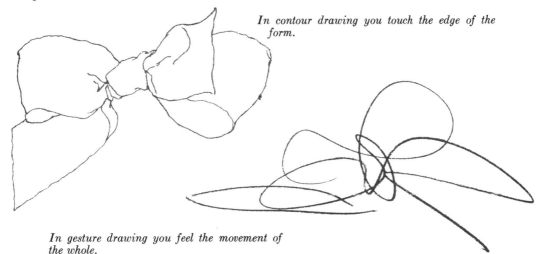

In contour drawing you touch the edge of the form.

In gesture drawing you feel the movement of the whole.

If the model leans over to pick up an object, you will draw the actual bend and twist of the torso, the reaching downward of the arm, the grasping of the hand. The drawing may be meaningless to a person who looks at it, or to you yourself after you have forgotten the pose. There may be nothing in it to suggest the shape of the figure, or the figure may be somewhat apparent. That does not matter.

As the pencil roams, it will sometimes strike the edge of the form, but more often it will travel through the center of forms and often it will run outside of the figure, even out of the paper altogether. Do not hinder it. Let it move at will. Above all, do not *try* to follow edges.

It is only the action, the gesture, that you are trying to respond to here, not the details of the structure. You must discover — and feel — that the gesture is dynamic, moving, not static. Gesture has no precise edges, no exact shape, no jelled form. The forms are in the act of changing. Gesture is movement in space.

To be able to see the gesture, you must be able to feel it in your own body,

You should feel that you are doing whatever the model is doing. If the model stoops or reaches, pushes or relaxes, you should feel that your own muscles likewise stoop or reach, push or relax. IF YOU DO NOT RESPOND IN LIKE MANNER TO WHAT THE MODEL IS DOING, YOU CANNOT UNDERSTAND WHAT YOU SEE. If you do not feel as the model feels, your drawing is only a map or a plan.

Like contour, gesture is closely related to the tactile experience. In contour drawing you feel that you are touching the edge of the form with your finger (or pencil). In gesture drawing you feel the movement of the whole form in your whole body.

The focus should be on the entire figure and you should *keep the whole thing going at once.* Try to feel the entire thing as a unit — a unit of energy, a unit of movement. Sometimes I let new students begin to draw on a five-minute pose and then, after one minute, ask the model to step down from the stand. The students stop drawing with surprise. I tell them to go ahead and draw, that they had started to draw and must have had something in

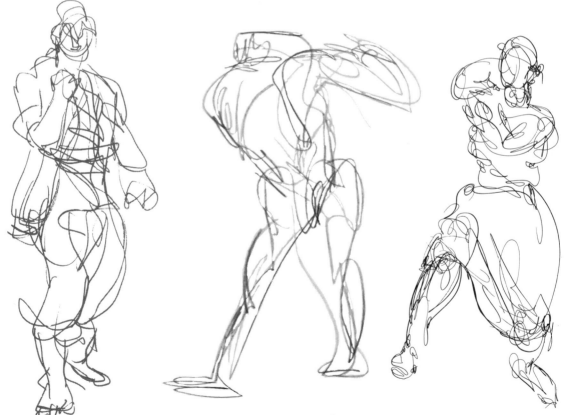

STUDENT GESTURE DRAWINGS
Draw not what the thing looks like, not even what it is, but WHAT IT IS DOING.

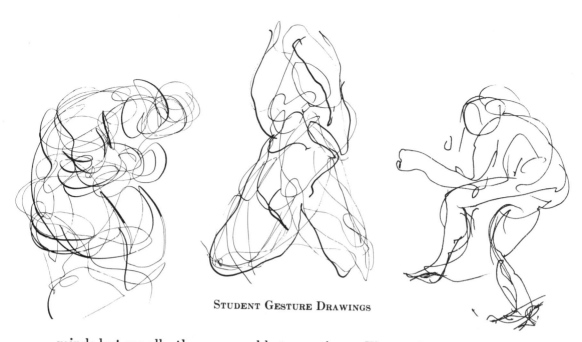

STUDENT GESTURE DRAWINGS

mind; but usually they are unable to continue. The truth is that they had started with some little thing, such as the hair, and had not even looked at the pose as a whole. In the first five seconds you should put something down that indicates every part of the body in the pose. Remind yourself of this once in a while by limiting a group of gesture studies to five or ten seconds each.

It doesn't matter where you begin to draw, with what part of the figure, because immediately you are drawing the whole thing, and during the minute that you draw you will be constantly passing from one end of the body to the other and from one part to another. In general, do not start with the head. Offhand, the only times I can think of when the head would be the natural starting place for an action would be when a man is standing on his head or hanging on the gallows.

Sometimes students ask whether they should think of gesture in this or that or the other way. My answer to that is that you should rely on sensation rather than thought. Simply respond with your muscles to what the model is doing as you watch, and let your pencil record that response automatically, without deliberation. Loosen up. Relax. Most of the time your instinct will guide you, sometimes guide you the better, if you can learn to let it act swiftly and directly without questioning it. Let yourself learn to reason with the pencil, with the impulses that are set up between you and the model. In short, listen to yourself think; do not always insist on forcing yourself to think. There are many things in life that you cannot get by a brutal approach. You must invite them.

If your model complains that he or she 'can't think of any more

In the first five sec-onds put something down that indicates every part of the body in the pose.

poses,' suggest the following: typical poses from all sports such as boxing, tennis, fencing; positions used in dancing; ordinary daily acts such as putting on one's clothes; typical movements in various kinds of work such as those of a farmer, a mechanic, a builder, a ditchdigger; poses expressive of different emotions such as fear, joy, weariness. The model should use all sorts of positions — standing, sitting, stooping, kneeling, lying down, leaning on something — and you should draw all sorts of views, front, back, and side. The poses should be natural and vigorous rather than artificial. Some of them should be quite twisted up and contorted.

SCRIBBLING. My students eventually began to call these studies 'scribble drawings.' They are like scribbling rather than like printing or writing carefully, as if one were trying to write very fast and were thinking more of the meaning than of the way the thing looks, paying no attention to penmanship or spelling, punctuation or grammar.

One student said of his first gesture drawings that they looked like 'nothing but a tangle of fishing line.' The drawing may look meaningless, but the benefits that you have at the moment of reacting to the gesture will pay large dividends eventually. Before your studies from this book are over, you will have made hundreds of these scribble drawings. You will never exhibit one of them — they are considered purely as an exercise — yet they will give you an understanding and power which will eventually find its way into all your work. No matter what path you pursue, you keep going back to gesture.

Feel free to use a great deal of paper and do not ever worry about 'spoiling' it — that is one of our reasons for using cheap paper. I notice that students working at their best, thinking only of the gesture and not of making pictures, often throw their drawings into the trash-can without even looking at them. A few should be kept and dated as a record of your progress, but the rest may be tossed aside as carelessly as yesterday's newspaper. Results are best when they come from the right kind of un-self-conscious effort.

MORE ABOUT CONTOUR. Like many other students, you may have trouble drawing slowly enough in the contour exercise. Try making your next contour study with the left hand instead of the right (or the reverse if you are naturally left-handed). This should have the effect of slowing you up and, since your left hand is less trained, you will find it less easy to relapse into some way of drawing which you had already mastered.

This is a suggestion which may be applied to other exercises that we shall take up. Each exercise is meant to constitute in some way a new experience even if you have been drawing for twenty years. The use of your untrained hand may give you something of the advantage that a beginner always has — the advantage of a fresh approach.

When you looked at your first completed contour drawing, you probably laughed. No doubt the lines sprawled all over the paper, the ends did not meet in places, and one leg or arm may have been much bigger than the other. That should not worry you at all. In fact, you will really have cause for worry only if your drawing looks too 'correct,' for that will probably mean either that you have looked at the paper too often or have tried too hard to keep the proportions in your mind.

The time you spend counts only if you are having the correct experience, and in this exercise that experience is a physical one through the sense of touch. After you have drawn the contour of the model's arm, pass your fingers slowly along the contour of your own arm. If the sensation of touch is just as strong in the first act as in the second, you have made a good start regardless of what the drawing looks like.

Contour drawing allows for concentrated effort in looking at the model rather than the usual divided effort of looking alternately at paper and model, which exercises mainly the muscles of the neck. In other words, the act of putting marks on the paper does not interrupt the experience of looking at the model. For that reason, you are able most effectively to follow forms to their logical conclusion, to learn where and how they relate to other forms. The parts of the figure are fairly simple in themselves — an arm, a finger, or a foot. But the way they fit together, the arm into the shoulder, the foot into the leg, is very difficult. They

A gesture drawing is like scribbling rather than like printing carefully — think more of the meaning than of the way the thing looks.

fit, not in a static way, but always in motion. Most students never settle down and follow out a form with all its nuances of movement, all the delicate transitions from one part to another. This exercise enables you to perceive those transitions because you follow closely the living form without taking your eyes off it.

Because the experience of looking at the model is not interrupted by looking at the paper, the drawing becomes a more truthful record of that one experience. If you made one leg longer than the other, it is probably because you spent more time looking at it. You may have done that simply because you had more patience than when you were drawing the other leg. Or you may have done it because the leg was closer to you, because more weight was on it, or because the position or turn of the leg attracted your interest. If you are drawing a model with very long arms, you may make the arms even longer than they are because your attention is attracted to their unusual length and you keep looking at them.

You need not think of these things. They happen subconsciously or, perhaps, accidentally. But, whether you know it or not, you are developing a sense of proportion, which may be a very different thing from a knowledge of proportion but is equally important — for the creative artist, more important.

Draw for three hours as directed in Schedule 1 C.

THE CONTOUR IN SPACE. The contour of any form in nature is never on one plane, but, as you follow it, is constantly turning in space. Assume that the model's arm hangs straight down at his side and that you are drawing the outer contour downward from the shoulder to the wrist. You will find, if you really are looking closely at the contour, that neither your eye nor the pencil can move straight down. Because the arm goes around as well as down, the contour seems sometimes to turn back away from you and then forward again toward you. Thus you will feel that you are sometimes drawing back into the paper and sometimes forward, as well as downward.

Draw for three hours as directed in Schedule 1 D.

EXERCISE 3: CROSS CONTOURS

This exercise calls for the same materials as the previous contour study, which it supplements. Like many of the exercises in this book, it grew out

(1)

(2)

of the effort to explain a particular point to a particular student. One night in my class I found a student who did not understand contour drawing, but was making outlines. In the attempt (a successful one) to show him what a contour really is, I explained that if he fixed his eye on the outside contour and moved straight across the body from one side to the other, he would be following a contour even though it was not at the edge of the figure. The value of this as an exercise then occurred to me.

Fix your eyes on a point on any one of the outside contours of the model, pencil on paper, as you did in the first exercise. Move both pencil and eyes across the figure at approximately a right angle to the contour you were touching when you started. For example, if your pencil was touching a point at the waist on a front view of the figure, you would not move it either up along the ribs or down along the thigh as previously, but straight across the abdomen. There is no visible line to guide you, but actually there is a contour from any point to any other point on the form.

If the position of the body changes, one of these cross contours, as we call them, may become an outside contour. For example, a line straight across the shoulders on the back of an erect figure may become the top contour if the figure bends over.

The line of a cross contour follows around the shape of the figure somewhat as a barrel hoop follows the rounded shape of a barrel. It dips down into the hollows and rises up over the muscles much as a piece of adhesive tape would if placed along the line you expect to draw. A contour on a leg, for example (Figure 1), can never be thought of as a line on a flat thing (Figure 2), because the leg is not flat.

Cross contours are different from the inside contours you have already drawn, such as that around the nose. An inside contour is at the edge of a clearly defined form even though that form does not happen to be at the edge of the whole figure. A cross contour may begin or end at any point on the body which your pencil happens to touch. It would be possible to make

a cross contour simply by placing two dots at random on the figure and drawing between them a line which follows the shape of the form.

As a rule, draw horizontal contours — that is, those at a right angle to the outside edge. Sometimes, however, it is helpful to follow a vertical contour such as one from the collar bone down the chest, the ribs, the pelvic region, and the front of the leg. These contours may be drawn haphazardly on the paper — one across the forehead followed by another across the chest. They need not be connected or in place, and to an uninitiated observer they will be entirely meaningless.

The study of cross contours should continue what contour drawing has already begun — to help you make a real and seemingly physical contact with the model through the sense of touch.

Draw for three hours as directed in Schedule 1 E.
It is important that you should not read on until you have finished Schedule 1.

Section 2

The Comprehension of Gesture

THE IMPULSE OF THE GESTURE. The study of gesture is not simply a matter of looking at the movement that the model makes. You must also seek to understand the impulse that exists inside the model and causes the pose which you see. The drawing starts with the impulse, not the position. The thing that makes you draw is the thing that makes the model take the position.

To make clear what I mean, I will describe a model posing. He is standing with his right foot on the ground, his left foot resting on the seat of a chair directly in front of him. He is bent at the waist so that his left elbow rests on his left knee. His chin is cupped in the palm of his left hand. His right hand is on his waist.

You now have a picture of this man's action, but it is entirely a mechanical picture. Although I have described him at some length, I have not given you the primary impulse. I have not supplied you with the material for the very first feeling you should have had, which was also the first feeling the

SCHEDULE 2

	A	B	C	D	E
Half Hour	Ex. 2: Gesture (25 drawings)	Ex. 2: Gesture (25 drawings)	Ex. 2: Gesture (25 drawings)	Ex. 2: Gesture (25 drawings)	Ex. 2: Gesture * (25 drawings)
Half Hour	Ex. 3: Cross Contours (one sheet of drawings)	Ex. 3: Cross Contours (one sheet of drawings)	Ex. 3: Cross Contours (one sheet of drawings)	Ex. 3: Cross Contours (one sheet of drawings)	Ex. 3: Cross Contours (one sheet of drawings)
Quarter Hour	Ex. 4: Potential Gesture (15 drawings)	Ex. 2: Gesture (15 drawings)	Ex. 5: Flash Pose (15 or more drawings)	Ex. 2: Gesture (15 drawings)	Ex. 2: Gesture (15 drawings)
Quarter Hour	Rest	Rest	Rest	Rest	Rest
Half Hour	Ex. 2: Gesture (25 drawings)	Ex. 2: Gesture (25 drawings)	Ex. 2: Gesture (25 drawings)	Ex. 2: Gesture (25 drawings)	Ex. 2: Gesture (25 drawings)
One Hour	Ex. 1: Contour (one drawing)	Ex. 1: Contour (one drawing)	Ex. 1: Contour (one drawing)	Ex. 1: Contour (one drawing)	Ex. 1: Contour (one drawing)

Alternate male and female models by schedules if you can. * Draw from objects.

model himself had. That feeling, the first impulse, was whether he stands quietly or alertly, tense or in repose.

This is where I should have begun: A man stands tired, at rest. Then I might have described the various details as much as I chose. And it is in this manner that one should attempt to see and draw. The fact that the man was alert or tired is of more importance than the angle of his legs or arms or the position of his hands. In fact he stood so, or so, because he was tired or alert.

What the eye sees — that is, the various parts of the body in various actions and directions — is but the result of this inner impulse, and to understand one must use something more than the eyes. IT IS NECESSARY TO PARTICIPATE IN WHAT THE MODEL IS DOING, to identify yourself with it. Without a sympathetic emotional reaction in the artist there can be no real, no penetrating understanding.

If the pose springs naturally from life as you know it, or from a strong and sincere emotion, you may more easily seek for and find the impulse. Do not make the mistake of thinking of this impulse only in terms of clearly defined or commonly recognized emotions, such as weariness and fear; when you say you 'feel' a thing, it is not necessarily something you laugh or cry about. What we seek is not so much an intellectual as a *physical* response. The model may take a pose in which he reaches down to tie his shoe. His impulse is merely to tie his shoe, a simple and everyday wish, but that is the cause, the reason for, the action which you see. As you draw from hundreds of action poses, you will become aware of a wide range of impulses. Many of them could never be put into words, although you can respond to them in drawing.

The specific directions given in Exercise 2 for gesture drawing were planned to open up the way for that response. As you draw, your comprehension of gesture will grow and naturally your way of drawing will develop and change. This should be a natural and entirely unconscious development. In all these exercises, the 'rules' are temporary ones, to which you subject yourself in order to get back to the laws of nature.

EXERCISE 4: POTENTIAL GESTURE

This is an exercise I have occasionally made use of in trying to explain vhat I mean by the impulse of the gesture. The model takes one-minute

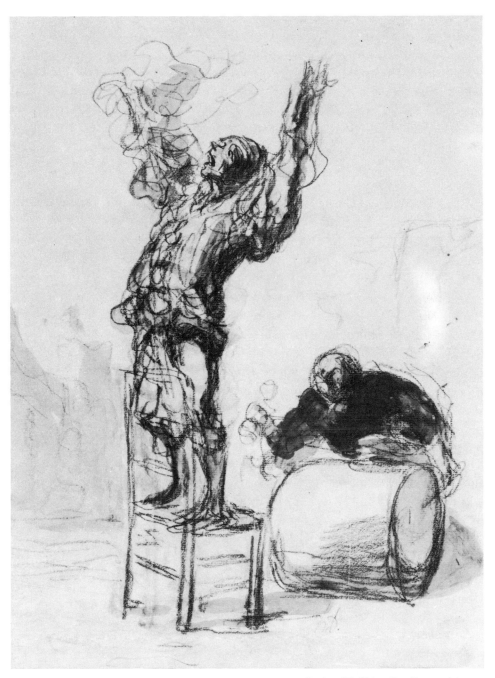

A CLOWN BY DAUMIER
Keep the whole thing going at once.

gesture poses as usual and you make scribbled drawings. Instead of drawing the pose you see, however, draw what you think the model may do next.

Of course, the pose you draw will seldom be the pose the model actually takes. But the effort to realize how the model could move from his present position — what it would be possible for him to do and what he might want to do — will help you to understand the forces at work behind the action you see.

Draw for three hours as directed in Schedule 2 A.

EXTRACTING THE GESTURE. Try for the present to think of the gesture as a thing in its own right, distinct from the form which your eye sees as it moves. You can become aware of a gesture without seeing it. If you hear someone clap his hands loudly, you can draw the gesture from the sound. You can draw something that you do yourself, because you feel the impulse even though you do not see the movement.

You can see the gesture of an object without seeing any of its details. Make a dot on a piece of paper and ask a companion to fix his eyes on it. Stand beside him and make a motion with your hand. He will be able to duplicate the motion, although he cannot tell whether the hand wore a ring or whether the fingers were long or short. Your signature is never the same twice, but it is always unmistakable because it has a characteristic gesture. When people use rows of large circles and pointed lines to practice penmanship, they are really 'extracting the gesture' because they have selected for practice the significant movements of the letters. One can sometimes read an illegible word by making the gesture of the handwriting, which will then suggest the letters to the mind.

This thing we call gesture is as separate from the substance through which it acts as the wind is from the trees that it bends. Do not study first the shape of an arm or even the direction of it. That will come in other exercises. Become aware of the gesture, which is a thing in itself without substance.

Gesture is intangible. It cannot be understood without feeling, and it need not be exactly the same thing for you as for someone else. To discover it there is required only practice and awareness on your part. You learn about it more from drawing than from anything I can say.

Draw for three hours as directed in Schedule 2 B.

DANCING FIGURES BY ROMNEY

STUDIES FOR ST. SEBASTIAN BY TINTORETTO
If you think of the whole figure, gesture becomes three-dimensional.

THE UNITY OF THE GESTURE. Try to grasp the unity which is inherent in any pose of the figure. Imagine that the model has jumped back and thrown her hands forward as if to protect herself from some strange animal. That particular thing which has made this pose a unit is the gesture caused by fear which takes place in every part of the figure. The gesture is the cement, the unifying element, that holds the various elements of the pose together.

By gesture we mean, not any one movement, but the completeness of the various movements of the whole figure. That is why in the beginning I told you to keep the whole thing going at once. The awareness of unity must be first and must be continuous.

The eye alone is not capable of seeing the whole gesture. It can only see parts at a time. That which puts these parts together in your consciousness is your appreciation of the impulse that created the gesture. If you make a conscious attempt merely to see the gesture, the impulse which caused it is lost to you. But if you use your whole consciousness to grasp the feeling — the impulse behind the immediate picture — you have a far better chance of seeing more truly the various parts. For the truth is that by themselves the parts have no significant identity. You should attempt to read first the meaning of the pose, and to do this properly you should constantly seek the impulse.

If you think of the whole figure, gesture becomes three-dimensional. It is not merely the direction of line but the essential action, the full form in space. Do not think too much of surfaces because the surface is only a part of the figure just as an arm is only a part and not the whole.

EXERCISE 5: THE FLASH POSE

Even in the short space of one minute, it is possible to see a great many things about a model and a pose. The flash pose is to be tried as an experiment in which you will be forced to see the whole pose as a unit because there is not time enough to see more.

The model does not stay on the model stand. He rushes to the stand, does one thing in a flash of a second, and then leaves the stand again as quickly as possible. His action should be a simple one such as putting his hand to his forehead or raising his arm. When you draw, you make a 'flash' scribbled drawing, recording only your basic reaction.

Draw for three hours as directed in Schedule 2 C.

GESTURE AND ACTION. By gesture we do not mean simply movement or motion or action. A thing does not have to be in motion to have gesture. You seek for it when the model is relaxed just as much as in a very active pose.

Gesture, as you will come to understand it, will apply to everything you draw. Even a pancake has gesture. There is gesture in the way in which a newspaper lies on the table or in the way a curtain hangs. Gesture describes

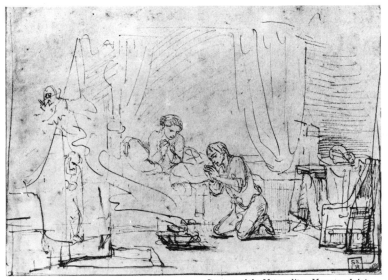

Courtesy of the Metropolitan Museum of Art
TOBIAS AND SARA BY REMBRANDT VAN RIJN
There is gesture even in the way a curtain hangs.

the compound of all forces acting in and against, and utilized by, the model. The term action is not sufficient.

We may think of gesture, rather, as the character of the action. Look at two vases — one tall and graceful, the other fat and squat. They are as different in character as two people might be. The similes in which our language is rich often aptly summarize the character of an action or a thing. We say that we felt 'as limp as a dishrag,' that he sat 'as stiff as a poker.' That quality which makes you compare the way the man sits to a poker may give you some clue to the gesture of both the pose and the object.

The key to the nature of a subject is its gesture. From it the other aspects of drawing proceed.

Draw for three hours as directed in Schedule 2 D.

GESTURE IN THINGS. Look at a lamp and think of what it is doing. It spreads out to hold a certain amount of kerosene. The glass chimney holds back the wind from the flame.

A chair invites you to sit in it. If it is a stiff straight chair it will hold you erect. If it is an ample easy-chair it will sink under you and make you relax. The man who made the chair was aware of the different needs of the people who would sit in it, and the chair reveals the mood or the character of the person who chooses it.

By using your feeling or imagination you can relate the gestures you see to those which are more universally understood. For example, the base of the lamp may have a sturdy, smug look which suggests to you a well-fed prosperous business man with a neat collar holding his head straight up. From an impression of that sort you get a very clear picture of the lamp so that when you see it again you instantly recognize it among twenty similar lamps not exactly from the same mold. Such observation is more instructive, as well as more interesting, than an observation of static lines and planes, and it results in a kind of knowledge that can be recalled ten years from now even though you have forgotten all about the act of observing.

Naturally, the impulse of the gesture in inanimate objects cannot be considered an emotional one, although we sometimes transfer our own emotions to things. This is common in literature and in the very phrases of our language, as when we name a certain kind of tree a 'weeping willow.' But to seek the actual impulse of the gesture in inanimate things we go back to natural causes. A plant grows upward toward the sun and the blossom begins to droop when it becomes too heavy for the stem. A bent tree-trunk may have been blown by storms, or blocked at some point in its growth, as by another tree. Water flows because it is liquid and the law of gravity urges it into a downhill path. Objects are made for a certain purpose and that purpose determines their shape and gesture. An auger is made to twist, a knife to cut, a ball to roll.

A tree does not grow from the top down but from the bottom up. Start then at the bottom, and in a loose, easy, tentative manner allow your pencil to move upward as you can feel that the tree moved up — upward and out along the branches. Let your pencil follow the sense of movement through to the leaves. Do they spread like bursts of flame from a skyrocket or do they fall down, dropping like water? As the tree reaches upward, it moves out from its core into a three-dimensional form.

The clouds in the sky are practically all movement. They reflect the movement of the wind. They may swell out at the top or be cut flat at the bottom. The grass has within it the movement of its own impulse to reach the sun and is pressed forward or downward by the passing wind. Stone walls can be seen as having been built by men, each stone lifted and fitted into place, where it now presses sideward and downward because of its weight. Roads move up over hills, down again into valleys, through forests. They were created by movement and exist for the purpose of movement.

Through your ability to grasp something of this, you will begin to understand other things like proportion and perspective, for the truth is that those things are caused by movement and are a part of it. It is far more important that your studies contain this comprehension of movement, of gesture, than that they contain any other single thing.

Draw for three hours as directed in Schedule 2 E.

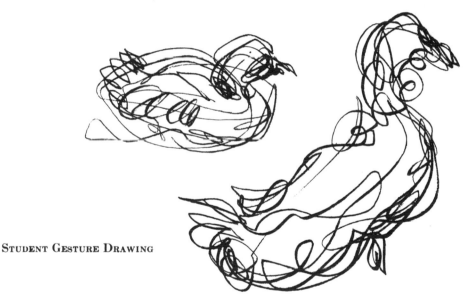

STUDENT GESTURE DRAWING

Section 3

Weight and the Modelled Drawing

FORM AND WEIGHT. With the word 'form' bandied back and forth as it is, one would believe that real progress is being made in the effort to understand the nature of form, to realize its significance. However, I have found that most students mistake a certain type of shallow, superficial surface modelling for form.

To me weight is the essence of form. And, since the life of a thing is its only real significance, I think of form as the *living* expression of weight.

To make clear what I mean by lack of form, I need only to remind you of the cast-iron clouds and balloon-like women that frequently appear in pictures. One feels that the solid-looking clouds should be settled firmly on the earth while the hollow, bulbous figures might well be floating in the air. What is lacking in the form is a comprehension of its weight.

You can grasp the essential weight of an object even before you become conscious of its form or shape. Suppose that you close your eyes and hold out your hand, keeping the palm flat. Someone places an object on your

SCHEDULE 3

	A	B	C	D	E
Half Hour	Ex. 2: Gesture (25 drawings)	Ex. 2: Gesture (25 drawings)	Ex. 2: Gesture (25 drawings)	Ex. 2: Gesture (25 drawings)	Ex. 2: Gesture (25 drawings)
Half Hour	Ex. 6: Weight (one drawing)	Ex. 6: Weight (one drawing)	Ex. 6: Weight (one drawing)	Ex. 7: Modelled Drawing (one drawing)	Ex. 7: Modelled Drawing (one drawing)
Quarter Hour	Ex. 2: Gesture (15 drawings)	Ex. 2: Gesture (15 drawings)	Ex. 2: Gesture (15 drawings)	Ex. 2: Gesture (15 drawings)	Ex. 2: Gesture (15 drawings)
Quarter Hour	Rest	Rest	Rest	Rest	Rest
Half Hour	Ex. 2: Gesture (25 drawings)	Ex. 2: Gesture (25 drawings)	Ex. 2: Gesture (25 drawings)	Ex. 2: Gesture (25 drawings)	Ex. 2: Gesture (25 drawings)
One Hour	Ex. 6: Weight (two drawings)	Ex. 6: Weight (two drawings)	Ex. 6: Weight (two drawings)	Ex. 7: Modelled Drawing (two drawings)	Ex. 7: Modelled Drawing (two drawings)

hand. Immediately you are aware of the weight of the object. If you close your hand around it, you can tell whether the object is round or square, smooth or rough, large or small. When you open your eyes and look at it, you recognize still other details such as its color. But the sensation of weight alone was first and not dependent on any of the succeeding sensations.

Form and weight are dependent upon all three dimensions — length, width, and thickness. A thing that has only length and width and no thickness (if there could be such a thing) can have no weight. We may think of form as the three-dimensional shape of weight.

WEIGHT AND ENERGY. In searching for a realization of weight it is not necessary to think in terms of ounces or pounds. You can feel it through your own sense of energy. Suppose you are trying to pick up some object from the ground. If it is a light object, little energy is required to lift it. If it is very heavy, a great deal of energy is required — you pull and tug at it. You can tell how heavy the thing is — comprehend its weight — by the amount of energy you expend in lifting it.

In fact, you can think of weight itself as having energy. The weight of a stone presses into the ground. As you attempt to lift the heavy object, its weight resists you. It is that understanding of its resistance to our energy that gives us a real awareness of weight.

EXERCISE 6: WEIGHT

Materials: Use a lithograph crayon (medium) broken in half and a large sheet of cream-colored manila wrapping paper (fifteen by twenty inches). If the edge of the crayon begins to stick, strike it sharply on a piece of paper several times or scrape it with a knife.

In this exercise you will attempt to comprehend the solidity of the model — its weight — the fact that it exists in space and moves in space in every direction. Just as in gesture drawing you concentrate on the one idea of gesture, here you are to concentrate on the one idea of weight. When you draw without a model, choose objects that are bulky and solid.

Work with the side and not the point of the lithograph crayon. Start in the middle of the figure and work out from the center to the outside contours. By the middle I mean actually the core, the imagined center, inside

the form. It is not the center between the two edges of the surface (Figure 1), nor is it the center of the half of the form which you can see (Figure 2). It is the center of the whole form, the surface of which can be seen only if you walk all the way around the model and back again.

You know, even if you don't see all of it at once, that the torso is shaped somewhat like a cylinder. Place your crayon along a line which you feel to be the center of that cylinder (Figure 3) and work outward until you come to the surface. Believe and feel that you are working backward and forward as well as up and down until you have actually filled up all the space between the center of the figure and all of its surfaces — back, front, and sides.

Grasp first the general position of the figure and feel its essential weight. Bulk up the thing as quickly and easily as possible. Then you may develop somewhat your feeling for the disposition of the various parts, showing, for example, that the lower leg goes back or the right arm comes forward. But think only of the weight of those parts. If the model stands with his weight on one leg, you should realize that that leg presses with greater weight against the floor than the other.

Perhaps the easiest way to describe this exercise is to say that you work, as nearly as possible, like a sculptor modelling in clay. Usually, the sculptor works around a piece of wire that corresponds somewhat to the center or core of the form. He takes up a casually shaped mass of clay and starts shaping it into the image of the model — a large hunk for the torso, smaller and longer hunks for the legs, until gradually he has filled with clay the space which the figure occupies.

Never think of yourself as drawing a line when doing this exercise. You scarcely think of yourself as drawing at all, but work as if building up the figure with a mass of clay. Leave the edges blurred and uncertain; because you are trying to get the sensation of weight, your attention should be fixed on the center, not on the edge. Your drawing will not show anything that looks like a

(1)

(2)

bulk

(3)

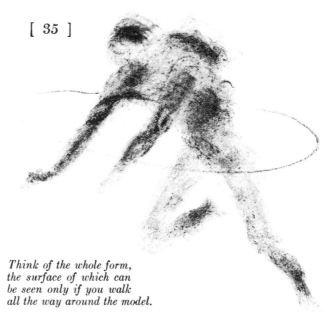

line. It should be a solid, dark mass.

There is no sense of light and shadow in this drawing because light and shadow lie only on the surface and you never draw the surface at all. If one part of your drawing looks darker than another, it will be the core. Keep going over the figure as long as the time allows. It doesn't matter how black the drawing becomes.

Think of the whole form, the surface of which can be seen only if you walk all the way around the model.

Do not try to work out in your mind any system for filling up the form. Work loosely, freely. Generally, a sort of rotating movement will best give the sensation of a constant and gradual reaching out from the center, the core, to the surfaces. Concentrate on the first big conception of the bulk. Respond with your own energy to the weight of the model.

Draw for three hours as directed in Schedule 3 A.

WEIGHT AND MASS. You may feel that the thing you are trying to respond to might be called 'mass' or 'volume' rather than 'weight.' It is true that you are learning to represent the mass or bulk of anything you draw, but it is necessary to think further than that. A paper cup and a silver cup may take up the same amount of space, but the one is a flimsy and unsubstantial thing while the other is strong and heavy. A glass test-tube and a piece of half-inch lead pipe, in spite of their similar size and shape, have an important difference in weight. Draw a feather pillow and an iron bar, or alternate studies of clouds and stones, thinking of their weight.

Draw for three hours as directed in Schedule 3 B.

THE CORE. The core is the motivation of the form. If you look at the stump of a tree, you can see how the tree grew, always outward from its core. With your crayon you reach inside the model and touch that core, letting the figure grow on paper as it grew in life.

Recently I watched a three-year-old child make a drawing of an apple. She carefully selected a red crayon from her box and made a dot on the paper. Then she drew with the crayon around and around the dot until a very solid, very red apple appeared. I have spent much time trying to explain how to do something that she did naturally.

The significance of the form is its relation to the core. Do not worry now about the shape. Let it be vague. Think of the form as a living substance, dependent on activity. Searching for the core is another way of searching for the living impulse. What we see, what we touch, is the shell. You can only sense the core.

Draw for three hours as directed in Schedule 3 C.

EXERCISE 7: THE MODELLED DRAWING

This exercise carries the preceding one a step further. Spend the first ten minutes making a weight drawing with lithograph crayon. Bulk up the form quickly and in exactly the same spirit as before, but don't let the drawing get too black in the beginning.

Then, still using your crayon on the side and not making any lines, go over all the vertical contours of the figure. This is an important change. In the first step you were working inside the figure, drawing from the center out and not drawing the surfaces. Now you are actually to touch the surfaces, to run your crayon over them from top to bottom or bottom to top. Since you are now drawing surfaces, you will naturally draw only those that you can see. Work loosely and freely with the same continuous movement that you used in the beginning.

Where the form goes back or in, you press back or in with your crayon. For example, as the form moves up over the chest and then back over the shoulder, your crayon moves lightly up over the chest and then presses heavily back over the shoulder. You are trying to believe that you are touching the model and all of its many contours. Naturally, you have to push farther to reach those that seem to go back.

Next you are to touch with your crayon all the horizontal contours of the figure. (You need not be too methodical about this — soon you will begin to touch the contours as you become aware of them whether they are vertical or horizontal.) You must not jump from one side of the figure to the

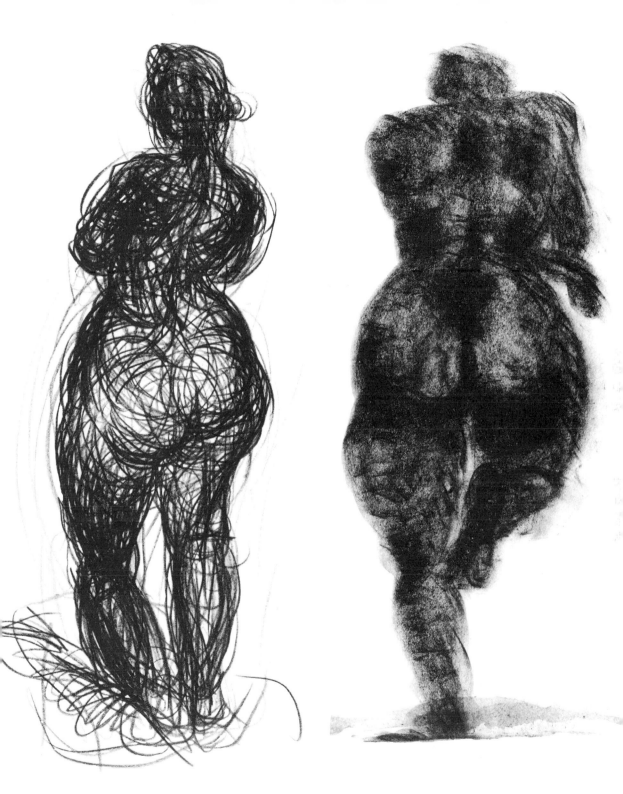

STUDENT MODELLED DRAWINGS
Bulk up the form as if you were modelling with clay.
(Different students may work in different ways and yet all be right.)

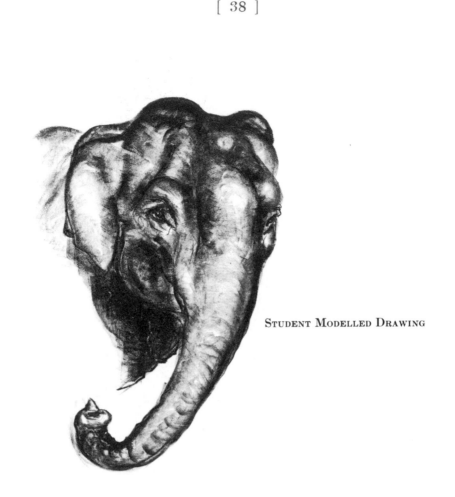

STUDENT MODELLED DRAWING

other merely shading the edges dark; you must move across exactly as if you were passing your hand over it.

I am sure you will see the kinship between this and the cross-contour exercise. You now use a flat crayon instead of a point and seek eventually to touch the whole figure instead of single lines, but the sense of touch is the basis of both exercises. Keep studying the model. Keep looking up there, constantly making a contact with the model as if through touch.

PRESS HARD WHERE THE FORM GOES BACK — PRESS MORE LIGHTLY WHERE IT COMES TOWARD YOU. When you press back, naturally the mark on the paper becomes darker. When you have finished, the darkest places on your drawing will be the parts of the figure that are farthest from you although they may not look dark on the model at all. The lightest places will be the

parts nearest to you. To illustrate this, I have chosen a simpler form than the human figure, a piece of wooden molding. Because it is simple, you can see more clearly that the crayon moved lightly up over the bulge and then pressed back heavily into the paper without strict regard for details. That is the principle by which the form is to be modelled, however simple or complicated it is.

Draw for three hours as directed in Schedule 3 D.

THE SENSATION OF MODELLING. Continue to work exactly as if you were a sculptor modelling with clay. You have taken your clay and distributed about the right amount of it to the various parts of the body. Now you begin to shape those parts by modelling with your fingers, pressing into the clay wherever there is a hollow in the form, pushing back wherever the form goes back. As you try to get into the smaller hollows of the form, as at the pit of the neck, you will use the point of your crayon just as a sculptor would use a smaller modelling tool. (In fact, you may come to use the point of the crayon altogether, if you like — the directions for these exercises are to be thought of only as a starting-point.) You can, bit by bit, develop a contact with every subtlety of the modelling if you attempt to feel it out with your sense of touch. Do not take anything for granted.

Draw for three hours as directed in Schedule 3 E.

Section 4

Memory Drawing and Other Quick Studies

SEEING THE WHOLE. With the exception of the contour study, there is no drawing that is not a memory drawing because, no matter how slight the interval is from the time you look at the model until you look at your drawing or painting, you are memorizing what you have just seen. Of course, in that kind of drawing in which the student looks back and forth from the model continuously, he is memorizing little bits at a time, hoping to be able, after he has assembled all the little bits, to put them together by some preconceived theory or plan or by some belated effort to see the model as a whole.

Actually, the best plan is to see the figure as a whole in the beginning and in the course of my teaching I have devised many exercises toward that end. The first and simplest of these, as I have already explained, is the quick gesture study. The second, memory drawing, is a variation of that exercise. Because you do not draw while the model is posing, you are less apt to look at specific details and you are able to fight with even greater concentration

SCHEDULE 4

	A	B	C	D	E
Half Hour	Ex. 2: Gesture (25 drawings)	Ex. 2: Gesture (25 drawings)	Ex. 2: Gesture (25 drawings)	Ex. 2: Gesture (25 drawings)	Ex. 2: Gesture (25 drawings)
Half Hour	Ex. 7: Modelled Drawing (one drawing)	Ex. 7: Modelled Drawing (one drawing)	Ex. 7: Modelled Drawing (one drawing)	Ex. 7: Modelled Drawing (one drawing)	Ex. 7: Modelled Drawing (one drawing)
Quarter Hour	Ex. 8: Memory (15 drawings *)	Ex. 8: Memory (15 drawings *)	Ex. 8: Memory (15 drawings *)	Ex. 8: Memory (15 drawings *)	Ex. 8: Memory (15 drawings *)
Quarter Hour	Rest	Rest	Rest	Rest	Rest
Half Hour	Ex. 2: Gesture (25 drawings)	Ex. 9: Moving Action (8 drawings)	Ex. 10: Descriptive Poses (10 drawings †)	Ex. 11: Reverse Poses (10 drawings †)	Ex. 12: Group Poses (12 drawings)
One Hour	Ex. 7: Modelled Drawing (one drawing)	Ex. 7: Modelled Drawing (one drawing)	Ex. 7: Modelled Drawing (one drawing)	Ex. 7: Modelled Drawing (one drawing)	Ex. 7: Modelled Drawing (one drawing)

* Five groups of three drawings each.
† Five drawings from imagination and five from the actual pose.

for a study of gesture, which is the thing that gives unity to the various parts.

Exercise 8: Memory Drawing

The model is asked to take three poses successively, holding each for about half a minute, and then to step down from the stand so that he cannot be seen. During the next minute, make gesture drawings (Exercise 2) of the three poses in any order that occurs to you. Even if the poses are not clear in your mind, put something down and keep drawing for a minute. After you have finished, the model does not repeat the poses but goes on to three new ones.

Make no attempt to draw while the model is posing. Sit with your arms folded and your pencil in your pocket so that you will not even 'draw' with a movement of your hand. You are not trying to remember merely the position of the model — just as, when you memorize a poem, you are not trying to remember the shape of the letters on the page. You should feel the whole movement with your whole body, not merely with your hand.

At first you may find yourself, like many other students, staring blankly at an equally blank paper. Draw something. Make some kind of lines whether you have any memory of the poses or not. Then try again. Soon you will find yourself remembering the gesture of at least one pose. A little later you will remember two and then three.

The poses need not be related, and it is not wise to enforce any system of memorizing them, because you will then be making the intellect reach out too far ahead of the very senses that this exercise is intended to train. You do not want an intellectual transposition of the gesture. Remember *with your own muscles* the movement.

As soon as you find that you can remember three poses fairly well, enlarge the group to four, and finally to as many as you can remember. Some of my classes have been able by the end of a year to enlarge the group of poses to ten. This may be impossible if you try to remember with your conscious mind, but it can be done if you are able to make use of a purely physical sensation. In this respect memory drawing is a little like the 'touch method' of writing on the typewriter; if you try consciously to think where the letters are you are likely to become confused, but if you rely on your sense of touch you can become very accurate.

STUDENT DRAWING OF MOVING ACTION
Keep your pencil moving as the model moves.

You can practice memory drawing from any group of quick poses. Simply watch as many of them as you think you can remember, then turn your back on the model and draw. Any of the subjects you use for gesture studies will serve equally well for memory studies — in fact, any subject will serve.

Draw for three hours as directed in Schedule 4 A.

EXERCISE 9: MOVING ACTION

The model is asked to take a moving pose. This needs an example: The model stands facing the class and turns, keeping his right leg in the same position but swinging his left leg around, twisting his torso and reaching with his left hand to the right; then he returns to the original position. He

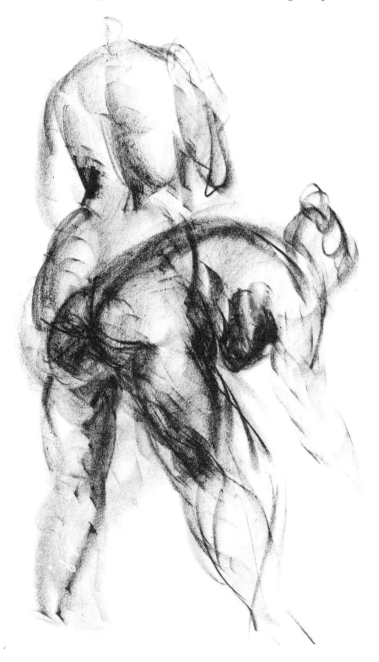

**STUDENT DRAWING COMBINING MOVING ACTION (EXERCISE 9)
WITH THE MODELLED DRAWING (EXERCISE 7)**

repeats this over and over again for three minutes, sometimes moving slowly, sometimes moving naturally.

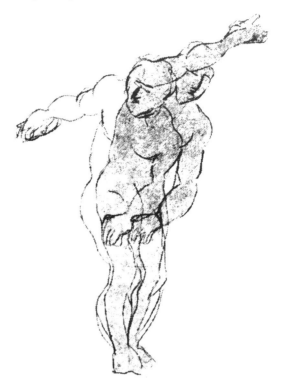

Starting with that part of the body which remains more or less stationary, make a gesture drawing of at least two poses, one at the beginning and another at the extreme of the action. In the pose described above, the right leg remained more or less stationary and the extreme of the pose occurred when the left hand was reaching to the right. These two drawings are made on the same paper and are superimposed, the part of the body

STUDENT DRAWING COMBINING
MOVING ACTION WITH CONTOUR

that was the same in both poses being drawn only once. Keep the pencil continually moving as the model moves. Later you may use the moving-action pose to make drawings that are more detailed, but for the present stick to the spirit and the style of a quick gesture study. Try to draw three positions whenever the pose permits.

To facilitate the model's work, suggest that he think of any natural action that allows some part of his body to remain in the same position. For example: (1) A man recognizes an acquaintance who has just passed him and half turns, waving his hand. (2) A man seated rises to reach for a pen he has dropped on the floor, keeping one hand on the back of his chair. Also practice this exercise from everyday life, drawing any action which you can see repeated — a boy pitching a baseball, a man chopping wood, a woman taking clothes from a basket and hanging them on a line.

Draw for three hours as directed in Schedule 4 B.

EXERCISE 10: DESCRIPTIVE POSES

Describe a pose which the model is to take. Then make a one-minute gesture study as well as you can from this verbal description, the model remaining in the meantime out of sight. After you have finished, ask the model to take the pose that has been described and make a two-minute gesture drawing of the actual pose on a fresh piece of paper. The whole process — the description and the two drawings — will take about five minutes.

The description of the pose may be given by each member of the class in turn (by either you or the model if you are working alone). The effort to describe the poses is good training in itself. It will naturally make you more observing and more conscious of what the human body can do, and you will begin to note the variety in the ordinary postures of people.

The descriptions should not be too elaborate or detailed. Describe the gesture in general terms, specifying only the direction in which the model is to face. You may say, for example, 'The model will be seated facing the class. He hears a door opened behind him and turns to see who it is.' The details of the pose are left to the model and it doesn't matter whether your idea of it coincides with his or not.

Draw for three hours as directed in Schedule 4 C.

EXERCISE 11: REVERSE POSES

During a three-minute pose make a gesture drawing of that pose as it would look in reverse. For example, if you see a side view of the model kneeling on his left knee, his right arm extended in front of him and his left arm back of him, draw as if he were facing in the opposite direction, kneeling on his right knee with his left arm forward and his right arm back. Whatever the pose, draw as if the model were facing the opposite way and were using the opposite limbs for the gesture. What you draw will resemble the reflection of the pose that would appear in a mirror held in front of your eyes. The model then takes this reverse pose and you draw it again on a fresh sheet of paper. Draw 'in reverse' a great variety of things, such as a piece of furniture, a house, a pitcher, an automobile.

Draw for three hours as directed in Schedule 4 D.

EXERCISE 12: GROUP POSES

Two or three members of the class, or two models, are asked to pose together for two minutes, using some natural gesture in which the figures are connected, such as the following: two people shaking hands; one person looking over the shoulder of another; a girl looking at another girl's necklace; a clerk fitting shoes or a hat; a doctor looking down a patient's throat; a boxing match; a barber at work. Subjects like these may be drawn also from everyday life.

The purpose of this exercise is to treat the two or three figures as a unit. Do not draw one figure and then the other, but FOLLOW THE GESTURE OF THE WHOLE, using the scribble technique.

Draw for three hours as directed in Schedule 4 E.

STUDENT POSES. After the class or group have worked together long enough to become acclimated to the serious purpose of their study, the students may sometimes take the poses for all these quick studies. This gives the students who are drawing a greater variety and it gives the student who is posing a better appreciation of the emotional impulse necessary to make the pose expressively natural.

When you are working alone try posing for yourself. Take a pose for a minute or two. Don't try to visualize it. Try to get the sense of the gesture, the essence of it. Think of it all as a unit, as you think of a spoken word as being a whole and not so many letters. Think how a certain part of the body pushes forward, how weight presses in a certain place. Then make a gesture drawing of your own pose.

STUDENT DRAWING OF A GROUP POSE
Treat the two figures as a unit.

Quick Studies from Memory. As soon as you are able to draw some-
what readily from memory, combine the principle of memory drawing with
the other quick studies I have described — moving action, descriptive,
reverse, and group poses. Watch without drawing while the model takes
the pose. Draw only after the model has left the stand.

STUDENT DRAWING OF A GROUP POSE
Follow the gesture of the whole.

Section 5

The Modelled Drawing in Ink—The Daily Composition

THE LIMITATIONS OF PRECONCEIVED IDEAS. In learning to draw, it is necessary to start back of the limitations that casual information sets upon you. Preconceived ideas about things with which you have no real experience have a tendency to defeat the acquiring of real knowledge.

One handicap that people have in looking at a painting is that they relate it, not to an actuality, but to other pictures of which they have accidental knowledge. Watch a child draw a house. He has in mind no picture that he has ever seen, no system for representing shingles or brick — unless he has been spoiled by the wrong kind of instruction. In his mind is an actual house, which he feels he is actually building as he draws. I watched one of my sons draw a dragon when he was about four years old. He contorted his own face and muscles as he drew and seemed actually to be afraid of the thing

SCHEDULE 5

	A	B	C	D	E
Half Hour	Ex. 2: Gesture (25 drawings)	Ex. 2: Gesture (25 drawings)	Ex. 2: Gesture (25 drawings)	Ex. 2: Gesture (25 drawings)	Ex. 2: Gesture (25 drawings)
Half Hour	Ex. 13: Modelled Drawing in Ink (one drawing)	Ex. 13: Modelled Drawing in Ink (one drawing)	Ex. 13: Modelled Drawing in Ink (one drawing)	Ex. 13: Modelled Drawing in Ink (one drawing)	Ex. 13: Modelled Drawing in Ink (one drawing)
Quarter Hour	Ex. 8: Memory (15 drawings)	Ex. 9: Moving Action (5 drawings)	Ex. 8: Memory (15 drawings)	Ex. 10: Descriptive Poses (6 drawings)	Ex. 8: Memory (15 drawings)
Quarter Hour	Rest	Rest	Rest	Rest	Rest
Half Hour	Ex. 2: Gesture (25 drawings)	Ex. 2: Gesture (25 drawings)	Ex. 2: Gesture (25 drawings)	Ex. 2: Gesture (25 drawings)	Ex. 2: Gesture (25 drawings)
One Hour	Ex. 13: Modelled Drawing in Ink (one or two drawings)	Ex. 13: Modelled Drawing in Ink (one or two drawings)	Ex. 13: Modelled Drawing in Ink (one or two drawings)	Ex. 13: Modelled Drawing in Ink (one or two drawings)	Ex. 13: Modelled Drawing in Ink (one or two drawings)

Beginning with Schedule 5 B, practice the Daily Composition (Ex. 14) EVERY DAY.

Start in the center of the form and work out toward all the surfaces.

STUDENT MODELLED DRAWINGS IN INK

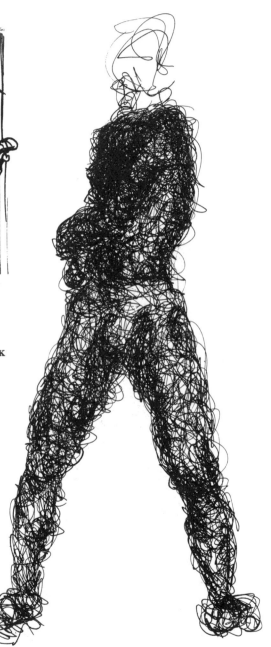

when he saw it on the paper. We think too often of the thing we draw in terms of the ways we have seen it drawn. Think of the figure, not as if painted by Titian or Renoir, but as actual flesh and bones.

If you make drawings of a knee until you are a hundred years old, your conception of it will still be far from what a knee actually is. Many painters learn to paint a knee in a certain way during their first year in art school and go on painting the same knee for the rest of their lives. Do not allow familiar labels to interfere with fresh impulses. Disregard ideas that are already formulated, or constantly test them by new fresh experiences. Realize the actual existence of an arm or a leg in space as contrasted with the idea of an arm or a leg.

The only way around the limits of our preconceived notions is the physical action of the five senses. You must get at a direct contact with the model.

There is much talk about 'beauty' and much talk about 'truth,' but all the student need concern himself with is reality — that natural reality which he recognizes in normal everyday life and which establishes itself in his mind through his senses. Do not miss the sort of thrust which says that this *is* sand, this is water, these are trees. Remember that trees could be cut up and made into some sort of lumber. Water is heavy and wet — it is not just so much color. Do not look at a woods interior as spots of green, but get into it and realize that there are trees in between other trees.

EXERCISE 13: THE MODELLED DRAWING IN INK

Materials: Use large sheets of cream manila paper (fifteen by twenty inches), black drawing ink, and an ordinary pen and penpoint. The point should be large and strong and blunt, preferably with a ball-shaped tip, so that it will move easily in any direction. Do not use a fountain pen.

This exercise is exactly like the modelled drawing in lithograph except that you have only the point of the pen with which to make contact instead of the broad surface of the crayon and consequently it becomes necessary to do a great deal of scratching around.

Start in the center of the form and make in the beginning the same sort of rotating movement that you made with the crayon, constantly filling in

the form and working out toward *all* the surfaces. Keep the pen moving over the paper in all directions without lifting it. Then, as with the lithograph crayon, make contact with the vertical and horizontal contours, pressing back where the form goes back and lightly where it is near you. Remember that there will be no outline because you do not think of edges.

Do not be timorous or hesitant. Press hard, even if the pen tears into the paper and makes huge blots. Work freely and vigorously. Do not hesitate to keep working over the forms until your drawing is completely black.

Draw for three hours as directed in Schedule 5 A.

Exercise 14: The Daily Composition

This is a memory drawing, to be done in scribbled gesture style, but instead of drawing a single figure or object you are to show the human being in relation to his environment.

Working in pencil, make a small drawing (about five by seven inches in size) of something you have seen during the past twenty-four hours. Put down as fast and easily as possible, and in any order, the various things you remember about a specific place and what was going on there. No more than fifteen minutes should be spent on one drawing. Make no corrections or alterations later, but go on to a new one the next day.

Do not feel that the compositions should be complicated or, because they indicate more complete pictures, that they ought to be story-telling in a dramatic sense. Do not try to make something difficult out of them. The following list will illustrate the simple type of subject matter desired: (1) A person getting into a street car or automobile. (2) A woman examining merchandise either in or on the outside of a store. (3) A man lighting a cigar or cigarette or pipe. (4) A shoe-black at work. (5) A man paying his check in a restaurant. (6) Children playing. (7) A woman in a beauty parlor. Any of the casual and usual activities around you will make suitable subjects.

If you find that you are frequently at a loss for something to draw, make in advance a week's schedule of the places you will use for the daily composition and go to the place when the day comes. For example: Monday, drugstore; Tuesday, restaurant; Wednesday, barber shop; Thursday, cigar store; Friday, lobby of a motion-picture theater; Saturday, elevator lobby of a

large building. Practice standing in the place and closing your eyes, trying to reconstruct the place in your mind. Observe the background and observe what a person could do in the place — where he could walk to, where he could sit down, where he might go upstairs, where he would pay if it is a store. As you come to blind spots, open your eyes and make further observation. This will teach you the things you need for drawing.

Remember that this is a gesture study and that you are, therefore, to seek for the movement of the whole. SEE THE WHOLE THING AS A UNIT. Just as, in the group poses, you drew the gesture of two or three figures together, not as separate units, here you draw the gesture of the figure or figures together with the place that surrounds them, thinking of the place, figures, and objects as one whole thing.

This exercise is to be considered as 'homework.' It is not included in the schedule proper because you are expected to practice it every day even though you may go to class only once or twice a week. Since you never use the model for it, you may conveniently practice it during any spare quarter of an hour in your day. However, if you have no other time, or if you have forgotten to do it, devote some time from your regular lesson to the daily composition. No other exercise in the book is more important than this one.

These compositions do not have to be right. They can be *all wrong*. THE IMPORTANT THING IS TO DO THEM — three hundred and sixty-five of them between today and this date next year. It will be helpful if you keep this up for a year, and it will be twice as helpful if you keep it up for two years. The really serious student will make a quick composition every day for the rest of his life despite everything else he has to do. Start with the scribbled gesture technique and go on from that to develop your own ways of working. The drawings on the following pages will show you some of the ways in which different artists have used the quick composition as a means of study.

Draw for twelve hours as directed in Schedule 5 B–E.

STUDY FOR GUERNICA BY PICASSO

HAMAN IMPLORES THE GRACE OF ESTHER BY REMBRANDT

IN THE MUSEUM BY TOULOUSE-LAUTREC

DON QUIXOTE BY DAUMIER

LAWYERS IN THE LOBBY BY FORAIN

RUGGIERO AND ANGELIKA BY VAN DYCK

OFFERING TO PAN BY MILLET

Louvre, Paris

CHRIST RISING FROM THE TOMB BY MICHELANGELO

THE STABBING BY GOYA

BATHERS UNDER A BRIDGE BY CEZANNE

MASSACRE OF THE INNOCENTS BY POUSSIN

LANDSCAPE BY GAINSBOROUGH

SKETCH BY AN EGYPTIAN ARTIST (18TH CENTURY B.C.)

Section 6

The Modelled Drawing in Water Color —
Right-Angle Study

VARIETY OF MEDIUM. Today you will begin the practice of the modelled drawing in a third medium — water color. Each medium that you use should enrich the others. Practice with pen and ink, for example, contributes something to the use of water color which practice with water color alone cannot give, making it fuller and more varied as a medium of expression. As far apart as etching and oil painting are, the one contributes to the other as in the work of Rembrandt.

This change of medium might be likened to a change of language. The experience of using two languages makes each more rich than it can possibly be by itself. And, more important, the attempt to convey a thought from one language to another makes possible a finer comprehension of the thought. We are all prone to accept our preconceptions instead of investi-

SCHEDULE 6

	A	B	C	D	E
Half Hour	Ex. 2: Gesture (25 drawings)	Ex. 2: Gesture (25 drawings)	Ex. 2: Gesture (25 drawings)	Ex. 2: Gesture (25 drawings)	Ex. 2: Gesture (25 drawings)
Half Hour	Ex. 15: Modelled Drawing in Water Color (one)	Ex. 15: Modelled Drawing in Water Color (one)	Ex. 16: Right-Angle Study (one drawing)	Ex. 16: Right-Angle Study (one drawing)	Ex. 16: Right-Angle Study (one drawing)
Quarter Hour	Ex. 8: Memory (15 drawings)	Ex. 11: Reverse Poses (6 drawings)	Ex. 8: Memory (15 drawings)	Ex. 12: Group Poses (7 drawings)	Ex. 8: Memory (15 drawings)
Quarter Hour	Rest	Rest	Rest	Rest	Rest
Half Hour	Ex. 2: Gesture (25 drawings)	Ex. 2: Gesture (25 drawings)	Ex. 2: Gesture (25 drawings)	Ex. 2: Gesture (25 drawings)	Ex. 2: Gesture (25 drawings)
One Hour	Ex 15: Modelled Drawing in Water Color (one)	Ex. 15: Modelled Drawing in Water Color (one)	Ex. 15: Modelled Drawing in Water Color (one)	Ex. 15: Modelled Drawing in Water Color (one)	Ex. 15: Modelled Drawing in Water Color (one)

Remember the Daily Composition (Ex. 14) EVERY DAY.

gating a thing fully and anew. Once we have had an experience, the repetition of the experience becomes muffled and not clear. We anticipate and in anticipating we lose the significance, the meaningful detail. The very difficulties of using a new medium, like the difficulties of using a new language, tend to bring you back to the meaning you desire to convey, because the medium can be used properly only in relation to your grasp of the meaning.

STUDENT MODELLED DRAWING IN WATER COLOR
In the first step build up the form quickly.

EXERCISE 15: THE MODELLED DRAWING IN WATER COLOR

Materials: Use large sheets of cream-colored manila paper (fifteen by twenty inches) and three tubes of cheap water color — yellow ochre, burnt sienna, and black. It is important that you should use tube colors and that you should use only the three colors named. Do not use water color paper, even if you can afford to; the tough manila paper is better for this exercise. You will need one sable water color brush, which should be quite large (size 9) and of the best quality you can afford. Use a cheap water color pan to mix the colors in, a glass of water, and several soft clean rags about six inches square.

This is essentially the same exercise as the modelled drawing in lithograph crayon, but, naturally, whether you press lightly or hard with a brush-load of color makes no difference in the lightness or darkness of the color that appears on the paper. Therefore, you will use the dark colors to give the sensation of pressing back that you have gotten previously by actually pressing with the crayon or pen.

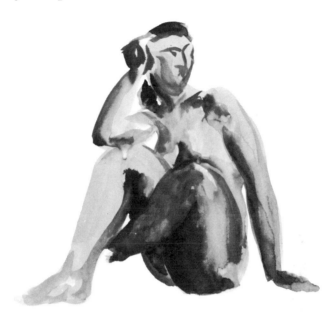

STUDENT MODELLED DRAWING IN WATER COLOR
Use the dark color to give the sensation of pressing back.

Use the lightest color (yellow ochre) for the first step, the building up of the form from the center to the outside surfaces. For the next step, touching the vertical and horizontal contours, mix burnt sienna and black until you get a sort of chocolate color, with which you model the forms before the yellow ochre is too dry. Keep the whole thing going at once and, as before, pay no attention to edges.

If a time comes when the paper is so wet that it refuses to take any more color without spreading it meaninglessly, start another study and keep the two going at once. Work on one while the other dries a little. Keep the brush fairly dry by wiping it with the rag before dipping it into the color. In the first stage, building up with yellow ochre, the brush will be wetter than

in the second stage. Keep the color full and thick. Fill the brush with it, using plenty of pigment. It should not be thin and watery.

THE USE OF WATER COLOR IN THIS EXERCISE HAS NOTHING TO DO WITH WATER-COLOR TECHNIQUE OR WITH 'COLOR.' It is simply an exercise in drawing for which we use a color roughly approximating that of flesh, instead of black. It will not approximate the color of many things you draw, but that does not matter. You should not think now of trying to reproduce any color that you may see. Work exactly as you did with the crayon and the pen, bringing the form forward when it is nearer you and pushing it back as it goes away from you. With the crayon you could push the surfaces back away from you by pressing harder. Here you must do it by letting the color get darker. That is the only difference.

Draw for six hours as directed in Schedule 6 A and 6 B.

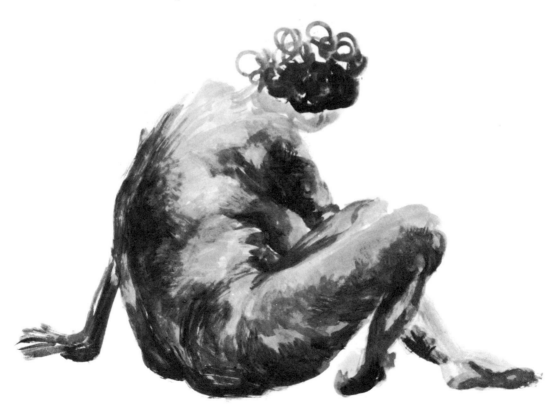

STUDENT MODELLED DRAWING IN WATER COLOR
Do not be afraid of overworking the drawing.

EXERCISE 16: RIGHT-ANGLE STUDY

Work from a half-hour pose, using pencil and a large sheet of paper. The following pose may be used the first time the exercise is attempted: The model sits erect on the left side of his chair directly facing you, the right knee straight forward with the right foot directly under it, the left foot pulled back with the toe placed on the floor directly under the left thigh, the right hand resting on the right knee and facing forward, the left hand at the waist.

During the first half of the pose, draw, not what you see, but what you think you would see if you were sitting at the left side of the model instead of in front of him. In the pose described above you see a front view, but you will draw from imagination a profile view. First attempt to visualize the relation of the feet to one another and to the chair, because the chair is responsible for the conditions in which the gesture took place. To your imagination it will appear that the model's right foot is to the left of the chair; that the left foot touches or is very near the back leg of the chair, that the left knee is not as far advanced as the right knee, that the left elbow directly faces you somewhat above the waist, and that the right elbow is bent.

The drawing is to be done as much as possible in the spirit of a gesture drawing. Naturally you will have to stop to think, to figure out where the various parts are in relation to each other, but think always of what they are doing.

Devote the remainder of the pose to a 'check-up' when you will actually go to the position from which you imagined the figure and note the difference between the actual pose and the drawing you made. The first thing to note is the unity of the gesture, as in any other kind of drawing. Do not correct your drawing or try to make a new one. Simply notice your mistakes.

Of course you will not always have a front view of the model for this exercise and if several people are working together they will all have different views. But the principle remains the same. We call this 'right-angle study' because if you drew a line from the place you are sitting to the model, and another line from the place you imagine you are sitting to the model, those two lines would be at right angles to each other. In the accompanying diagram the capital letters A, B, C, and D represent four students working from the same model. The first student is actually sitting at the place marked A. He

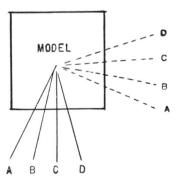

imagines that he is sitting at the place marked *a* and for the check-up he actually goes to the place marked *a*.

Do not limit yourself to the human figure. Look at a telephone, a lamp post, or a lawn mower and draw it as it would appear from a 'right-angle' view. This will force you to acquire a sound knowledge of the way the thing is constructed.

FUTURE RIGHT-ANGLE STUDY. For the present you are to consider none of the small details of the figure in this exercise but only the gesture. Later, you may devote an hour to each right-angle study, drawing lightly in the beginning so that an eraser may be used and then carrying it forward with all the skill of draughtsmanship you possess; but always begin with a gesture study. In the check-up for a one-hour study, make a second drawing. As you progress you can make use of the same kind of effort to go further in the way of detail. For example, having the front view of a knee, you can make a right-angle study of the side view, utilizing whatever knowledge of anatomy you possess at that stage.

Draw for three hours as directed in Schedule 6 C.

STRUCTURAL IMAGINATION. In right-angle drawing we are making use of something which I have called, for lack of a better name, 'structural imagination.' Some of my students have asked if this exercise is a matter of using the imagination. To answer that, it would be necessary to define imagination, which is far from our purpose. What we really do in this particular exercise is to attempt to assemble from a different visual point of view what is actually in front of us. It is an effort to construct in the mind by using the residue of knowledge from past experiences. The same principle is at work in the descriptive and reverse poses and in other exercises which are to come.

The great danger of drawing the thing which is in front of you is always that you may end by merely copying what the eye records. When you cannot copy by using the eyes, you must draw with your full intelligence in relation to the past experiences of your senses. The fact that there is an attempt on your part to visualize a pose through your experience and that you are then given the opportunity to see such a pose will promote keener observation. A real appetite is created for the study which follows when you look at the thing you have tried to visualize.

Draw for six hours as directed in Schedule 6 D and 6 E.

Section 7

Emphasis on Contour—The Head

DEVELOPING THE LONG STUDIES. You have been rushed through a number of exercises in what may seem a very short time. I realize that it has been impossible for you to go deeply enough into any one exercise, but it is necessary in the beginning to avoid the great danger of monotony. At this point we are going to take up in turn each of the four long exercises you have already begun, attempting to carry each one a step further along. In Schedule 7 we return to contour and you are asked once again to fix your mind on the basic idea of *touching* the edge of the form.

All of these exercises are aimed at the accomplishment of the same thing — keen observation and a full understanding of the motivation of movement and growth — and each exercise should make a real contribution to the others. When you attempted your first contour drawing, you started with a blank. Now you start with all the accumulated knowledge and

SCHEDULE 7

	A	B	C	D	E
Half Hour	Ex. 2: Gesture (25 drawings)	Ex. 2: Gesture (25 drawings)	Ex. 2: Gesture (25 drawings)	Ex. 2: Gesture (25 drawings)	Ex. 2: Gesture (25 drawings)
Half Hour	Ex. 3: Cross Contours (one sheet of drawings)	Ex. 18: Quick Contour (3 or 5 drawings)	Ex. 19: The Head (one drawing)	Ex. 21: Right-Angle Contours (one drawing)	Ex. 18: Quick Contour (3 or 5 drawings)
Quarter Hour	Ex. 8: Memory (15 drawings)	Ex. 9: Moving Action (5 drawings)	Ex. 20: Gesture of the Features (15 drawings)	Ex. 10: Descriptive Poses (6 drawings)	Ex. 8: Memory (15 drawings)
Quarter Hour	Rest	Rest	Rest	Rest	Rest
Half Hour	Ex. 2: Gesture (25 drawings)	Ex. 2: Gesture (25 drawings)	Ex. 2: Gesture (25 drawings)	Ex. 2: Gesture (25 drawings)	Ex. 2: Gesture (25 drawings)
One Hour	Ex. 17: Five-Hour Contour (one drawing)				
Remember the Daily Composition (Ex. 14) EVERY DAY.					

Henceforth, the same model should be kept throughout each schedule so that the long pose can be repeated.

ability which you have gained from weeks of hard work. Consequently, this will be a new experience.

Previously I have not asked you to devote more than an hour to one drawing, partly because I realized that your knowledge of the figure was limited and that you might not see enough to occupy you for a greater length of time. I remember vividly one of my first attempts at studying art. For several days the instructor did not visit the class. I drew the model as best I could, but after about an hour I couldn't think of anything else to do. Not wanting to lose any time, I started over and made a new study, but it showed little improvement because I knew no more than I did at first. When finally the instructor came and looked at my drawings, he made one comment, 'Why so many?' With that he went on to another student, leaving me as bewildered as I had been before. It was probably that experience which led me to adopt one of the principles on which all my teaching has been based — that the teacher should always recommend something positive for the student to do instead of telling him only what he has done wrong.

In the beginning you also probably felt after an hour that there was nothing more to draw. You may have felt that the contour from the knee to the ankle, for example, was a simple curve — that you might have made it with one stroke of the pencil instead of feeling your way slowly along it. I am sure you realize now that that curve is not so simple. You may even begin to sense the movement of the muscles and bones underneath the flesh. You will now be able to spend hours instead of minutes on a drawing before you have exhausted the sensation of touching the contours.

EXERCISE 17: THE FIVE-HOUR CONTOUR

Materials: You may use the same materials as in Exercise 1; or, if convenient, use a Wolfe Carbon pencil (2B or 3B) with a fine point, and a slightly larger piece of paper.

You are to make one five-hour contour drawing from the one-hour pose which is repeated throughout Schedule 7. As in Exercise 1, sit close to the model, do not look at your paper, and draw even more slowly and intently than before. If, after drawing the outside and inside contours, you find you still have time left, draw the important cross contours in their proper places on the figure.

In a way this drawing will be a test of how much you have learned. If you are able honestly to concentrate on one pose for five hours, it will mean that you have already gained a great deal of information about the figure. Every step in this book is founded on your willingness to *look* at the model.

As a substitute for the model, or as a helpful supplement to your class work, make a five-hour contour drawing of the interior of a room or a landscape. Draw all the details, but don't worry about whether their relative size or position is exactly correct. Feel as you draw that one thing is repellent to the senses while another is not — that a stone would cut and crush if it fell on your foot, that the sharp corner of a chair is not the sort of thing you would want to run into in the dark.

Read again the paragraphs about contour in Section 1. I ask you to do this, not because I think you have forgotten what you read or that you failed to read it carefully, but because it should mean something more now. Everything I say has meaning or truth only in relation to the act of drawing on your part. A thing said when you have completed five drawings means something else when you have completed fifty — and still something else when you have completed five hundred.

Draw for three hours as directed in Schedule 7 A.

EXERCISE 18: QUICK CONTOUR

This is a contour study to which you will devote only five or ten minutes. It is of necessity, due to the limited time, something that we would not have called contour study in the beginning, but when done correctly it has close kinship with the long contour.

In the long contour you move slowly, a particle of a second to a particle of a second, whereas with the quick contour your eye on the model moves quickly and your pencil on the paper moves quickly. However, you continue to have exactly the same consciousness that the pencil is actually touching the contours. The difference is like the difference in moving your hand quickly or slowly over a piece of wood. When you go quickly, the changes pile fast on one another and only the crescendos of movement will be felt. The contrasts are emphasized. The smooth,

STUDENT DRAWING: QUICK CONTOUR

uneventful forms take a second place and the more eventful or exciting forms become intensified.

Always draw the whole figure. In the beginning you may have some difficulty in getting exactly the right pace, but through practice you will learn the relationship of the time you have to the amount of study you have to accomplish.

Draw for three hours as directed in Schedule 7 B.

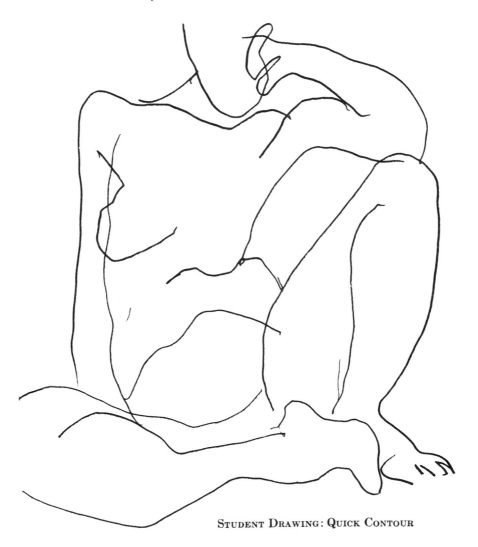

STUDENT DRAWING: QUICK CONTOUR

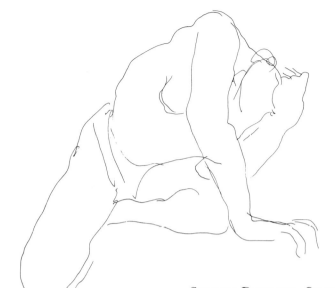

STUDENT DRAWINGS: QUICK CONTOUR

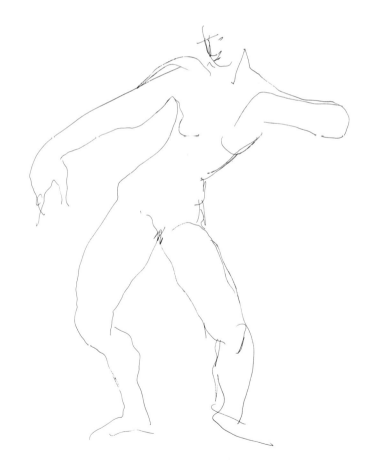

EXERCISE 19: THE HEAD

Because the head is one of the important parts of the body — the most important for the purpose of identification — devote one pose in each schedule to a separate study of the head, including enough of the neck and shoulders to support it. The drawing should be more than life size, filling a large piece of paper (fifteen by twenty). This exercise supplements the long study in each schedule. Work with the same materials and follow the same directions as in the long study, but use a different view of the head. In Schedule 7, for example, you will make a large contour drawing of the head.

Some students become self-conscious and confused as soon as they attempt to draw a face. Don't think of the head or the face as something different from any other part of the body. Draw it as you would draw a hand or an elbow or a knee.

Don't try to 'get a likeness' of your model. The tendency of the beginner is to separate likenesses from *drawing*. Draw strangers if you can because you care less what they look like. Do not draw members of your family — or at least do not show them your drawings — because their one reaction will be to look for the likeness. Keep it clearly in mind that YOU ARE NOT MAKING A PORTRAIT. You are making a study of a head.

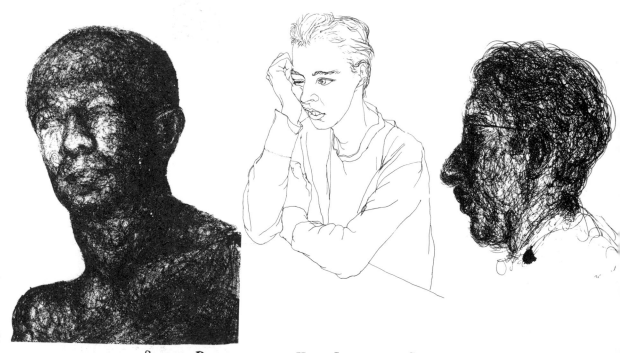

STUDENT DRAWINGS OF THE HEAD: LITHOGRAPH, CONTOUR, AND INK
Draw the head just as you would draw any other part of the body.

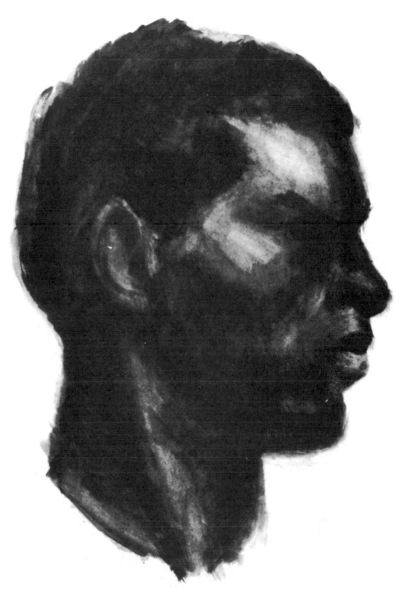

STUDENT DRAWING OF THE HEAD IN WATER COLOR

EXERCISE 20: THE GESTURE OF THE FEATURES

Each drawing of the head may be accompanied by a group of one-minute gesture studies, also of heads. This may be done most easily in places where you see many faces in rapid succession, as in a bus or a crowd. It may be done from the model during the usual one-minute poses if you use all views of the head or if you have a model who is clever enough to change his expression. The study of the gesture of the head — and by that I do not, of course, mean a movement of the head but its *character* — makes for the best appreciation of the shapes and proportions that you are trying to describe.

There is just as much gesture in the features and the sum-total of the features as there is in the body or any of its parts. You should not be concerned with the shape of the forehead, the eye, the nose, or the mouth, but become aware of it through the sense of movement. For example, one nose may seem to reach forward and turn and go back up under, whereas another may push back and suddenly bob up and stop short. But even that sort of description is inadequate. You are to think of the character of the gesture — that one nose is quick and another slow, one retiring, another quite positive and forward.

The hair grows and is arranged with a peculiar gesture. It may move back easily, quietly, or it may be stubborn and resist the effort of the comb and brush. It may grow straight or it may curve and twist and sometimes cascade. Even the eyes glow or droop or penetrate. The ear either tucks back quietly and unobtrusively or flares back aggressively. The chin may square off, move forward with force, or pull back timidly. The eyebrows may be knit together, drooped, or flaring. The principle of gesture applies also to the bone construction of the face, as in the reaching, inquisitive, cutting quality some faces have.

STUDENT DRAWING OF EXERCISE 20
*Become aware of the shape of the features
through the sense of movement.*

The words I have used to describe these faces are words suggesting movement. Notice how often writers use terms like those to bring home to the reader the actual look of the person they are attempting to describe. These pictures are more clear and immediate than when the head or any part of it is related to static things.

Draw for three hours as directed in Schedule 7 C.

EXERCISE 21: RIGHT-ANGLE CONTOURS

Begin this exercise by making a ten-minute right-angle drawing as described in Exercise 16. Then spend about five minutes drawing cross contours as you imagine they would appear from the right-angle position. In the check-up notice your errors, but do not try to correct them.

Draw for three hours as directed in Schedule 7 D.

CONTOUR AND LINE. We think of the contour as composed of the apparent lines around the structural forms of the body. Of course, there are no actual lines on the figure unless you take a piece of crayon and draw some on it. The edge of the figure, which you may heretofore have thought of as a line, is in reality simply the place where the figure ceases to exist. Whenever you think of lines and whenever you use them in drawing, you should realize that the figure is inside your lines and that actually there are no lines on the figure. LINES, IF YOU THINK OF THEM AT ALL, ARE CAUSED BY THE FIGURE. They are not separate from the figure but a part of it.

A contour drawing means to you now a drawing that is made without looking at the paper. Naturally, you are going to make much use of line in drawing and you will not always refuse to look at the paper while doing so. You don't have to go through the contour ex-

STUDENT DRAWING OF EXERCISE 20
(*A more advanced study making use of color.*)

ercise every time you draw a line, but in every line you draw there should be preserved the things you learned from it. One sees 'line drawings' everywhere. Many of them are outlines. Think of a line as a contour when it has the quality of contour — the sense of touch, the three-dimensional form, the conviction that the line is caused by the figure.

A line in drawing is not meant simply to record how long or how wide a thing is. If it were it might as well be drawn with a rule. The important thing is for the line to say as much as possible of all that you know about the thing.

Draw for three hours as directed in Schedule 7 E.

Frobenius Collection, Frankfurt-am-Main
Photograph by courtesy of the Museum of Modern Art

FACSIMILE OF A PREHISTORIC
ROCK ENGRAVING

ATHENIAN DRINKING CUP (CIRCA 480 B.C.) FOUND AT CORNETO

CHINESE PAINTING: KOREAN GENTLEMAN

THE DWARF OF MURAD II BY A PERSIAN ARTIST (16TH CENTURY)

BEATRICE APPEARING TO DANTE BY BOTTICELLI

PORTRAIT OF FRAU BURGERMEISTER DOROTHEA MEYER
BY HANS HOLBEIN, THE YOUNGER

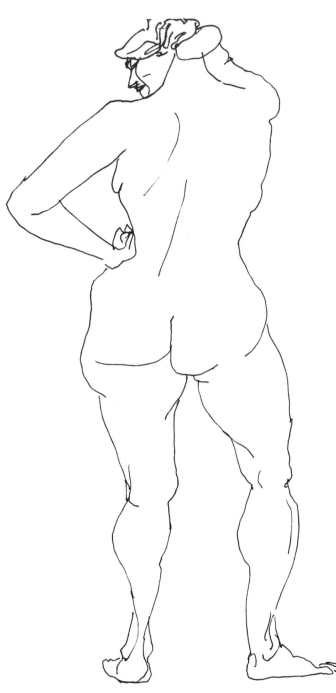

Courtesy of the Museum of Modern Art

STANDING NUDE BY GAUDIER-BRZESKA

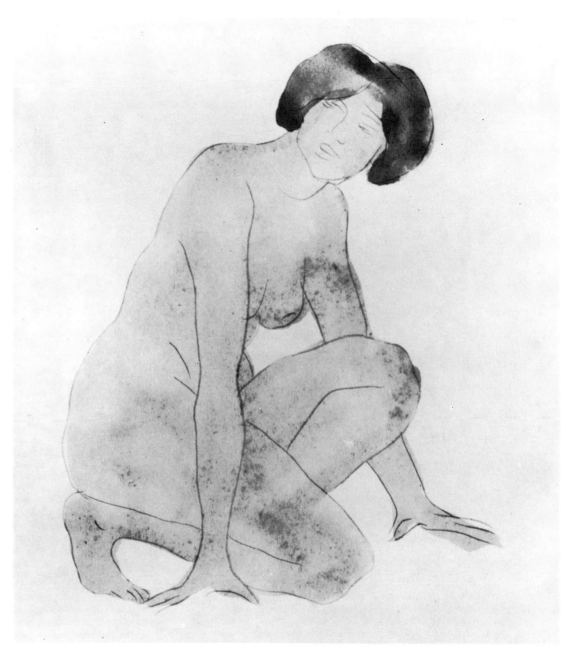

NUDE FIGURE KNEELING ON ONE KNEE BY RODIN

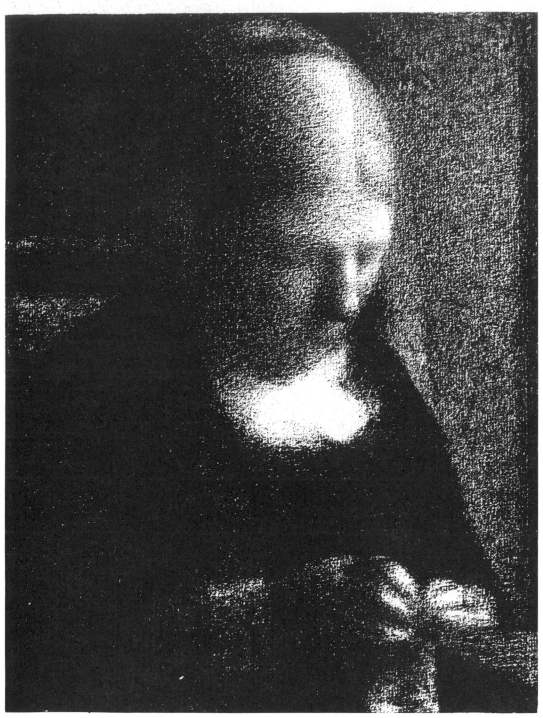

THE ARTIST'S MOTHER BY SEURAT
See first the large simple forms.

Section 8

Special Form Studies

DETAILS. When a boat comes out of the fog, you see first the large simple forms. As it comes closer, you see more. Each detail grows in place and with the same relationship to all the other details that it had at first. The details do not suddenly leap out at you but appear by gradual transition. Nothing is applied. Everything grows out of the thing itself. The thing grows and the details are the crescendo of the form. You put the cart before the horse if you put them first.

When you use a piece of soap molded into the shape of an animal, you see this process in reverse. The details gradually disappear, but the shape remains that of the animal.

As you proceed to more detailed studies, you have time to define clearly not only the larger forms but the smaller ones as well, such as the fingers,

SCHEDULE 8

	A	B	C	D	E
Half Hour	Ex. 2: Gesture (25 drawings)	Ex. 2: Gesture (25 drawings)	Ex. 2: Gesture (25 drawings)	Ex. 2: Gesture (25 drawings)	Ex. 2: Gesture (25 drawings)
Half Hour	Ex. 7: Modelled Drawing in Lithograph (one drawing)	Ex. 18: Quick Contour (3 or 5 drawings)	Ex. 23: Ten-Minute Form Studies (3 drawings)	Ex. 23: Ten-Minute Form Studies (3 drawings)	Ex. 16: Right-Angle Study (one drawing)
Quarter Hour	Ex. 8: Memory (15 drawings)	Ex. 11: Reverse Poses (6 drawings)	Ex. 8: Memory (15 drawings)	Ex. 12: Group Poses (7 drawings)	Ex. 20: Gesture of the Features (15 drawings)
Quarter Hour	Rest	Rest	Rest	Rest	Rest
Half Hour	Ex. 2: Gesture (25 drawings)	Ex. 2: Gesture (25 drawings)	Ex. 2: Gesture (25 drawings)	Ex. 2: Gesture (25 drawings)	Ex. 2: Gesture (25 drawings)
One Hour	Ex. 7: Modelled Drawing in Lithograph (one drawing)	Ex. 22: Part of the Form in Lithograph (one drawing)	Ex. 22: Part of the Form in Lithograph (one drawing)	Ex. 22: Part of the Form in Lithograph (one drawing)	Ex. 19: The Head in Lithograph (one drawing)

Remember the Daily Composition (Ex. 14) EVERY DAY.

the toes, or the nose. This should be, not a change, but a perfectly natural development.

Draw for three hours as directed in Schedule 8 A.

EXERCISE 22: PART OF THE FORM

In Schedule 8 A you made a one-hour modelled drawing of the whole figure in lithograph crayon. At the end of the hour you probably felt that you could carry the drawing much further but for the fact that it was getting too black. Continue your study of the same pose from the same position in this way. Select some large chunk of the figure, such as the shoulders and the breast or a section of the torso, and make a one-hour modelled drawing of this section on a fresh sheet of paper. In the succeeding lessons choose other parts of the same pose. Make the drawing as large as the paper permits. A drawing of the knee with parts of the leg, for example, will be as wide as the whole figure was in your first drawing.

This is an exercise that may be used to supplement the long study in any medium whenever you have time left over during the pose or when you feel that you are having difficulty with a particular part of the figure. Later, it may be applied to smaller parts of the figure, as a foot, wrist, ear, or chin. Read Exercises 6 and 7 again.

Draw for three hours as directed in Schedule 8 B.

EXERCISE 23: TEN-MINUTE FORM STUDIES

This exercise is a cross between the gesture study and the weight drawing (Exercise 6). Work with the side of your crayon on a large piece of paper, drawing either a ten-minute pose or three different views of a half-hour pose.

Think of the various parts of the body and their relative position in space. Without noticing any of the details on torso, head, legs, and arms, try to indicate only the place of the torso, head, legs, and arms in space, utilizing the pressure of the crayon, heavy or light, to show whether a part of the body comes toward you or goes away from you. Start with the consideration of weight and TRY TO GET THE DISPLACEMENT OF THAT WEIGHT IN SPACE.

In ten minutes little more than this can be done. If you have time left

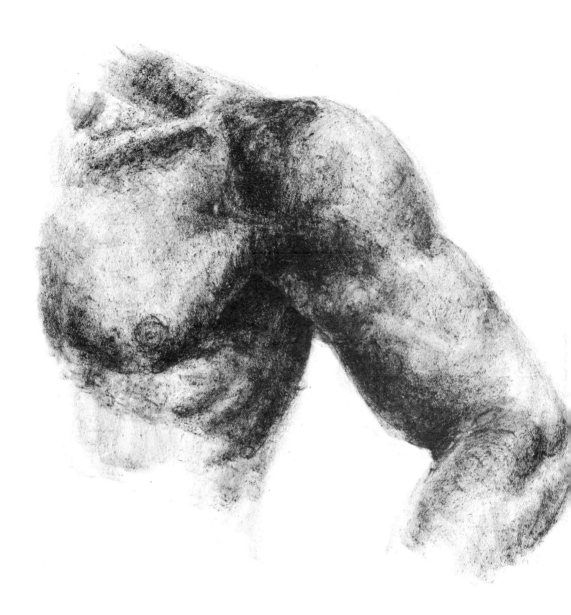

STUDENT MODELLED DRAWING:
PART OF THE FORM

JAPANESE SCREEN PAINTING (TOKUGAWA PERIOD)

Start with the consideration of the weight

over, do not search for the details but define more accurately the position of the parts of the body. This will lead you to develop with more clarity and finesse the shape of these forms.

THE DISPOSITION OF THE FORMS IN SPACE. As we go on, you are to strive more and more to realize the manner in which the form fills the space. There wouldn't be any real movement without space for the body to move in and there wouldn't be any form without space for the form to occupy.

To understand this, imagine, as you draw a standing figure, that you are placing it more or less centrally in a glass box. One arm moves back away

and try to get the displacement of that weight in space.

from you until it touches the back of the box. The knee is bent forward until it touches the front of the box. As you draw, remember that the figure extends into space, forward and back, up and down. You can apply the same idea to a group of figures. The figure at the extreme right touches one side of the box and that at the left touches another. The entire group reaches from side to side and from back to front.

In this exercise you need not be especially concerned with little separate forms. They will come easily enough. This is to be your conception of the existence of those forms in space. At some place, here, there, the figure

projects into space — and into your consciousness. The forms are acting in space and there must be on your part a thrilling consciousness of that.

Draw for six hours as directed in Schedule 8 C and 8 D.

COMPREHENDING THE FORM. Developing the consciousness of the form is a slow, sensitive process. It is not something that can be comprehended instantly, no matter how intelligent you are. The parts of the figure are welded together in a perfectly logical and functional manner. No one can teach you their truth, but by a certain manner of approach you can bit by bit come to know these forms and their relationship to one another. No diagrams, no pat explanations, will suffice, because the form speaks to you only as it does things.

Draw for three hours as directed in Schedule 8 E.

STUDENT DRAWING OF EXERCISE 23

Section 9

An Approach to the Subject of Technique

EXERCISE 24: THE MODELLED DRAWING IN INK — *Continued*

IN SCHEDULE 9 you will devote the long poses to modelled drawing with pen and ink. If you like, you may choose a finer point than before and work rather minutely, spending several hours on one drawing. Or you may combine this exercise with Exercise 22 and make several drawings of parts of the figure. You are asked to put down only your sensation of the weight of the figure and of the forms going back or coming forward. This may be done, of course, with any sort of strokes — rotating or angular, heavy or fine. The way you use the pen is unimportant.

In half-hour studies you probably won't find it necessary to do quite as much filling-in as formerly. The lines may become fewer and should move in the most expedient manner in relation to your feeling of the form and its

SCHEDULE 9

	A	B	C	D	E
Half Hour	Ex. 2: Gesture (25 drawings)	Ex. 2: Gesture (25 drawings)	Ex. 2: Gesture (25 drawings)	Ex. 2: Gesture (25 drawings)	Ex. 2: Gesture (25 drawings)
Half Hour	Ex. 13 and 24: Modelled Drawing in Ink (one)	Ex. 13 and 24: Modelled Drawing in Ink (one)	Ex. 18: Quick Contour (3 or 5 drawings)	Ex. 23: Ten-Minute Form Studies in Ink (3 drawings)	Ex. 25: Back to the Model (one drawing)
Quarter Hour	Ex. 8: Memory (15 drawings)	Ex. 9: Moving Action (5 drawings)	Ex. 8: Memory (15 drawings)	Ex 10: Descriptive Poses (6 drawings)	Ex. 20: Gesture of the Features (15 drawings)
Quarter Hour	Rest	Rest	Rest	Rest	Rest
Half Hour	Ex. 2: Gesture (25 drawings)	Ex. 2: Gesture (25 drawings)	Ex. 2: Gesture (25 drawings)	Ex. 2: Gesture (25 drawings)	Ex. 2: Gesture (25 drawings)
One Hour	Ex. 13 and 24: Modelled Drawing in Ink (one to four drawings)				Ex. 19: The Head in Ink (one drawing)
Remember the Daily Composition (Ex. 14) EVERY DAY.					

L'ASSOMMOIR BY RENOIR
Press back where the form goes back and lightly where it is near you. (Compare Exercises 13 and 24.)

movement, its depressions and elevations. In other words, some of the feeling of the gesture studies may begin to creep into your half-hour studies. Keep working over the whole figure at once.

If you are drawing objects, you have probably limited yourself to single things up to now. Put several things together and make a study of them that will occupy several hours. Collect any of the objects you happen to see around you. These are examples: (1) A large piece of paper folded as if it were corrugated, a wagon wheel, a chain, a dish mop, a bit. (2) A pin cushion, a victrola record, a shutter, the divider from an ice tray, radio tubes. Go to the workshop, the kitchen, or the junk pile and pick up anything you happen to see. The act of putting these things together may be

made into an exercise in gesture. Combine them in such a way that one movement may be felt in the whole group.

Draw for three hours as directed in Schedule 9 A.

TECHNIQUE. Any student can command a good technique in a few years and acquire facility with his medium, but this is not what real study consists of. Anyone can learn to paint. Sometimes it seems that the less one is an artist the more easily and quickly one can acquire the superficial qualities of a painter. But craftsmanship in painting is mere virtuosity, a skill that may hide lack of real perception.

Technique should be taught, not as an end in itself, but as something related to individual expression, as a means toward an end. One cannot separate technique from expression. There is only expression.

The physical command of painting, the sureness, comes of practice with the painter's materials. The act of creating art comes of practice with the materials of the artist. They are two different things. Their proper relationship is established by emphasis on the practice of art.

All that you need in the way of technique for drawing is bound up in the technique of seeing — that is, of understanding, which after all is mainly dependent on feeling. If you attempt to see in the way prescribed by any mechanical system of drawing, old or new, you will lose the understanding of the fundamental impulse. Your drawing becomes a meaningless diagram and the time so spent is wasted.

The actor who overacts makes his mistake, not because of lack of technique, but because he has not had sufficient practice in truly feeling his part. In fact, his desire for technique has thwarted his natural power to feel correctly, or — and most likely — he has had poor direction in the beginning. By poor direction I mean that his training emphasized technique of presentation instead of sending him to life with an eagerness to see nature through his ability to feel.

Draw for three hours as directed in Schedule 9 B.

Often when you seem to have controlled a medium, the medium is really controlling you, so in the formative years it is not wise to give yourself up entirely to any one medium. Later, having had a real experience with various mediums, the artist finds those which are best suited to his method of working, his temperament, and what he has to say. As he grows older, he naturally settles down to the technique from which he can get the best

results. That is normal. He finds it necessary to conserve his physical energy and becomes more concerned with leaving some imprint of himself. Therefore, the time to be experimental is when you are young. For you to settle now into a way of doing something is bad. You cannot say, 'This is my way — I can do it best this way.' You don't know until you have tried other ways, and by trying I mean not for a week but for several years.

The great artists, even if they developed a way of painting which was recognizably theirs, never really stopped experimenting. Titian, for example, continued to use different techniques until the end of his long life. Renoir grew even more experimental as he grew older. It is not that the artist is consciously trying to change his technique. He is changing his attitude to form and color — in fact, to life — and his technique naturally changes, whereas if he were bound by considerations of technique his development would become cramped. Committing oneself to a technique causes stagnation.

Naturally you will become more interested in your method as you work, but you should never forget the main objective — an experience, real, that you wish to re-experience in your medium. The bad feature of commercializing your attitude to your work is that your end becomes a picture rather than an experience. It is equally bad, however, to become a conscious amateur, a dilettante. The serious student is one who wants to go ahead for the simple reason that he feels a pride in growth.

Draw for three hours as directed in Schedule 9 C.

Some students think, when they have paid for their art tuition, that they are buying outright some categorical system of instruction. They want to be told in black and white exactly how to make a certain kind of picture. In this book I am trying to give you ideas to work with rather than ways to work. I have been definite about the materials you use, the subjects you work from, the time you spend. Beyond that there is no valid way for me to be definite. You must be willing to use your own mind and draw your own conclusions.

As long as you draw, each subject will present a unique problem and will demand alert observation. I am not trying to show you how to master a few specific problems but to give you a basis from which to work in future. Sometimes when I see a student struggling with a particular difficulty, it is hard to refrain from giving him a practical clue to its solution. But I know

from experience that, if I can force myself to leave him alone long enough, the solution he eventually reaches will have more personal truth for him than any that I could suggest.

Do not try to learn a formula, but to become sensitive, to feel more deeply. Do not try to master a particular technique. Progress has been made by the people who refused to submit themselves to mediums. The rules of technique have been made by people who copied those who made the progress. You will paint well when you are able to forget that you are painting at all. When you are conscious of your medium, things become difficult, but when your interest is completely absorbed by the model — the idea — your materials become easier and easier to handle. Therefore, practice is the watchword.

If your drawing is the best you can do, it suffices. No human being can do better. The best you can do today will not compare with the best you can do a year from now. What I hope is that after two years you will still be doing the best you can.

Draw for three hours as directed in Schedule 9 D.

EXERCISE 25: BACK TO THE MODEL

Sit with your back to the model during a half-hour pose. Look around at the model as much as you want to and draw just as usual, but don't move your chair. You will find it such a strain to turn around that you will look at the model as seldom as possible, and when you look you will really look.

Draw for three hours as directed in Schedule 9 E.

Section 10

The Simple Proportions—Effort

Exercise 26: The Modelled Drawing in Water Color — *Continued*

Perhaps you feel that the modelled drawing in water color is the most difficult of the exercises you have taken up thus far and that your grasp of it is the least satisfactory. If you have never used water color before, you may feel that the color runs away from you, that the brush is hard to manage, and that your paper shows only a series of meaningless blobs. In that case, provided your effort is sincere, all you need is more practice. On the other hand, if you have used water color, you may have acquired some technique that hampers you in trying to record the simple sensation of weight and of touching the form. Most water-color techniques — in fact, considerations of technique — have a tendency to attract your attention to the surface, to superficial qualities, and away from the core which you

Schedule 10

	A	B	C	D	E
Half Hour	Ex. 2: Gesture (25 drawings)	Ex. 2: Gesture (25 drawings)	Ex. 2: Gesture (25 drawings)	Ex. 2: Gesture (25 drawings)	Ex. 2: Gesture (25 drawings)
Half Hour	Ex. 15 and 26: Modelled Drawing in Water Color (one)	Ex. 15 and 26: Modelled Drawing in Water Color (one)	Ex. 23: Ten-Minute Form Studies (3 drawings)	Ex. 15 and 26: Modelled Drawing in Water Color (one)	Ex. 15 and 26: Modelled Drawing in Water Color (one)
Quarter Hour	Ex. 8: Memory (15 drawings)	Ex. 11: Reverse Poses (6 drawings)	Ex. 8: Memory (15 drawings)	Ex. 12: Group Poses (7 drawings)	Ex. 20: Gesture of the Features (15 drawings)
Quarter Hour	Rest	Rest	Rest	Rest	Rest
Half Hour	Ex. 2: Gesture (25 drawings)	Ex. 2: Gesture (25 drawings)	Ex. 2: Gesture (25 drawings)	Ex. 2: Gesture (25 drawings)	Ex. 2: Gesture (25 drawings)
One Hour	Ex. 15 and 26: Modelled Drawing in Water Color (one drawing)		Ex. 15 and 26: Modelled Drawing in Water Color (one drawing)		Ex. 19: The Head in Water Color (one drawing)

Remember the Daily Composition (Ex. 14) EVERY DAY.

are meant to comprehend. You must make a tremendous effort to overcome that tendency. If you failed to do so, it would be better to skip this exercise altogether and continue with crayon or ink.

Remember that you are not trying to paint with water color. You are only trying to draw. In order to get the same feeling with the brush that you had with the pen or crayon, it is necessary to keep the brush dry. In the very beginning the brush may be quite wet, though the color should be thick and not watery, but from that point onward keep it dry.

To understand how to do this, make an experiment. Take a perfectly dry brush, one that has not been in the water at all, and dip it into the paint just as the paint comes from the tube. Make several marks on your paper.

Courtesy of the Metropolitan Museum of Art
CHINESE WATER-COLOR PAINTING: THREE RABBITS, ATTRIBUTED TO KUNG CHI
In order to get the same feeling with the brush that you had with the pen or crayon, keep the brush dry.

STUDY OF A GOAT AND A DOG BY A LOMBARD ARTIST OF THE 15TH CENTURY

You will see that the paint does not spread but stays where you put it. This is, of course, a little too dry because the paint probably stands up on the paper and the hairs of the brush spread, but it will give you an idea of how dryness enables you to control the paint. Now try this. Make a mixture of burnt sienna and black with a very little water in your water-color pan. Wash your brush and wipe it quite dry on the paint rag. Then dip the brush into the mixture and you will find again that you can control the brush better because there is no excess water in it. By working in this way you should be able to handle the brush just as easily as a crayon.

When you continue the same water-color drawing on a second day, first take a clean damp brush (not too wet) and lighten the parts of the figure that are nearest to you by working the brush into the paint. (Keep cleaning the brush as you do this; otherwise, the paint you take off goes on again.) This will have two good effects. It will dampen the drawing, which had gotten completely dry, so that it will take the paint more easily, and it will keep the drawing from getting so dark that you cannot continue to model. In other words, just as you use the dark color to push back the forms that go back, you can use this washing out or lightening of the color to pull toward you the forms which are nearer you. Since the manila paper will stand a great deal of washing and many layers of paint, you can continue working in this way almost indefinitely — or until you feel that you have actually reconstructed the entire figure with all its details.

This control of the brush will not come all at once, but it will come. In Schedule 10 I have asked you to devote two hours each to two modelled drawings. If you find that you cannot yet continue satisfactorily with one drawing for two hours, do not let that worry you. Simply make one-hour studies using different views of the pose or different parts of the figure. If you feel that you are beginning to make progress with this exercise, keep it up for a longer time than I have specified. It will be very helpful if you repeat Schedule 10 once or even twice, devoting as much time as you can (up to four hours) to one modelled drawing.

If you are drawing landscapes, I suggest that you add two or three colors at this point, permanent blue, lemon yellow, and viridian green or Hooker's green. This will give you a closer approximation of the color, but you are still not to think of trying to reproduce exactly any color that you see. Begin by building up the whole thing with one color (yellow ochre) and then modelling with a darker color. Modify the blue by mixing black with it.

Think of the earth as something that has endured for thousands of years while the grass has sprung up from it and lasts only for a season. The hills have been pushed up by strong geological forces while the gullies have been washed out by rain. Think how long it would take to walk from where you stand to the horizon and what an eventful journey that would be. Think of all the things that man can do or has done to the expanse of earth you see. Permit yourself to become receptive to the temper imposed on it by sun, wind, cloud, distance, heat, storm.

Draw for three hours as directed in Schedule 10 A.

THE SIMPLE PROPORTIONS. This is really a first lesson in anatomy, but it is a very simple one. I will start by giving in the simplest terms possible the normal proportions of the human figure. No one of these measures is exact, or could be exact, for no two figures have the same proportions. Nor is this planned to be an ideal figure but only a starting point for further study. The diagrams which illustrate these measurements are not *drawings* just as a map is not the trip. Your drawings are to be continuously meaningful to the actuality of the figure.

The torso is divided into two equal parts, shoulders to waist and waist to thigh, and we use a half-section of the torso as the unit of measure. From the shoulders to the waist then we count as *one*. From the waist to the thigh is also *one*. From the collarbone to the top of the head is approximately one or somewhat less. From the highest point of the leg to the middle of the knee is *one and one-half*. From the middle of the knee through the foot, if it is placed flat on the floor, is also *one and one-half*. The highest point of the leg on the outside is less than half of the way up into the lower part of the torso.

The width of the shoulders equals *one* and the neck occupies a third of the distance across the top of the shoulders. The arms fit into the torso at the shoulders just as sleeves are set into a coat. From the shoulder to the elbow

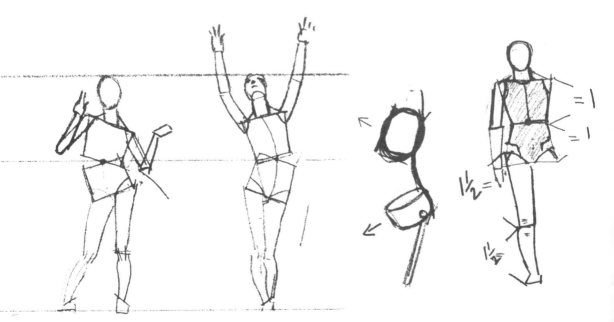

is *one* and from the elbow to the wrist is *one*. The head is longer in the front than it is at the back so it sits on the neck at an angle, and the neck seems to be set down farther in the front than it is in the back.

The upper part of the torso is supported by the basket of the ribs and the lower section by the pelvic bone, and the spine holds these two sections together in the back. In the front they are held together by the large perpendicular muscle of the abdomen. From the side the two sections of the torso have the same proportions as from the front, but because the spine has a slight curve they appear to be joined together in the back and somewhat separated in the front. When the body bends, either forward or back, the torso seems to fall in or expand, rather like an accordion.

From the back the proportions are naturally the same because the silhouette is exactly the same. (The front view and the back view of any object must be the same in silhouette.) The back of the figure, however, looks different from the front. It is a good deal flatter and a difference in muscular construction makes the torso seem longer and the legs shorter. In the front the muscles of the chest do not overlap the arms as the muscles of the back do. But the bone construction, front, side, and back, is necessarily one thing, and it is the bone construction which causes the proportions.

Draw for six hours as directed in Schedule 10 B and 10 C.

TALENT AND EFFORT. I never concern myself with how much talent my students have. I couldn't say to anyone in the beginning, 'You have no talent.' I believe that nature is lavish with talent just as it is with acorns — but not all acorns become oaks. Talent is something that develops, or appears, as you work. The fact that you gravitate toward an art school — the very fact that you have opened this book — indicates that you have at least a hankering for art. What is required is the necessary effort.

Most of us are so constructed that we try to take care of ourselves and save ourselves effort. But when you are too careful and save yourself too much, you cease to be creative because there cannot be creation without a terrific amount of energy. Energy is like the heat which is required to weld things together, for creation is a welding of things that have not previously been united — making them fit together as a unit, making of them a new thing, a fresh thing.

Draw for three hours as directed in Schedule 10 D.

If you really want to learn to draw, you must be willing to build the underpinning. I have had students whose imagination far exceeded what might be called their student qualities, their capacity for sustained and detailed study. They want to run before they can walk. Unless they can discover the other qualities they need to balance this errant imagination, they often give up drawing and try some other art. If you are a student of this type, you may find some of these exercises burdensome. That will not matter, *so long as you do them.* No art is all made up of one thing. There are many ingredients, of which imagination is an important one but not the only one, and the ingredients must be balanced.

I have had other students who seemed to be more interested in 'being artists' than in drawing. They were enthralled by a train of mental ideas rather than by the feeling of responding on paper to a vivid experience of the senses. Such students are likely to be found, not sitting in front of the model, but sitting over a cup of coffee in a neighboring café, talking about art. The student who really learns to draw will be the one who *draws.* As Leonardo said, the supreme misfortune is when theory outstrips performance.

Draw for three hours as directed in Schedule 10 E.
Repeat Schedule 10.

Section 11

The Study of Drapery

THE HUB. The advisability of studying drapery is obvious. The student will spend much more time drawing the costumed figure when he is out of school than he will drawing the nude, yet I have found that most students leave school with little or no conception of how to draw clothes. Aside from this obvious practical reason, the precise study of a piece of drapery makes all other forms more clear.

There is only one important principle to remember. Wherever the drapery is held, either against the wall with a thumbtack or on the figure as it is at the knee and the elbow, that point becomes a hub from which the folds radiate. As a simple demonstration of this, pick up a piece of cloth from the floor with your right hand and hold it at arm's length. The folds all radiate from the particular place where the cloth is held. Now pick up another point with your left hand and hold it somewhat away from the right hand. You will immediately see that you have two hubs and that some of the folds move from one hand to the other. The other folds also radiate from those hubs, attempting to drop to the floor.

The same thing happens in the folds of the trousers when a man bends his knee. The top part of the knee, the under side of the knee, and the place where the cuff makes contact with the ankle all act as hubs. Wherever the figure holds the drapery by pressing against it, those points become hubs.

SCHEDULE 11

	A	B	C	D	E
One Hour	Ex. 27: Quick Studies of Drapery (five to ten)	Ex. 27: Quick Studies of Drapery (five to ten)	Ex. 27: Quick Studies of Drapery (five to ten)	Ex. 27: Quick Studies of Drapery (five to ten)	Ex. 27: Quick Studies of Drapery (five to ten)
Two Hours	Ex. 28: Long Study of Drapery (one four-hour drawing)		Ex. 28: Long Study of Drapery (one six-hour drawing)		
Remember the Daily Composition (Ex. 14) EVERY DAY.					

No model is to be used in this Schedule.

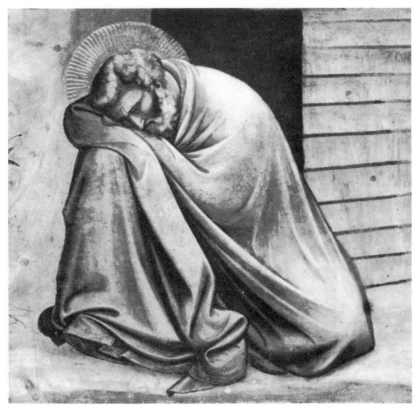

Chapel of the Arena, Padua

VISION OF SAN GIOVACCHINO (DETAIL) BY GIOTTO
*Wherever the drapery is held, as at the knee and the elbow, that point becomes a hub
from which the folds radiate.*

The folds flow from one to the other, always of course, due to the force of
gravity, attempting to drop to the earth and dropping in proportion to the
weight of the cloth.

EXERCISE 27: QUICK STUDIES OF DRAPERY

Materials: Use a piece of cloth something like bed sheeting, about
three by five feet in size. It should be white or of a solid light
color, of medium weight, and without sheen.

Tack the drapery flat against the wall with a tack in each of the upper corners. In the following paragraphs I will describe five different arrangements, which include the main principles affecting drapery (except when it is pleated). In each case, first read the description and attempt to make a gesture drawing of it from imagination. Then arrange the drapery according to the directions and make another drawing which will enable you to check up on your erroneous ideas. In other words, you are to make use of what we have already described as 'structural imagination.' The attempt to draw should always precede the act of draping the material.

Arrangement 1: Remove the tack in the upper left-hand corner, which we will call Tack *A*, and pin the top of the cloth to the wall one foot from the corner. Remove Tack *B* in the upper right-hand corner and do likewise, keeping the cloth taut between the two tacks. You will notice that the drapery cascades at either end. The section which was released dropped lower than the original bottom line of the drapery and its length is the diagonal from the place where the tack is to the lower corner.

Arrangement 2: Pin the drapery back to its original flat position on the wall. Remove Tack *A* from the cloth and move it six inches to the right, where it is placed in the drapery but not pinned to the wall. Then move Tack *A* with the drapery one foot more to the right and fasten it in the wall. Move Tack *B* similarly to the left, thus leaving the cloth between the two tacks slack. You will notice that the two sides cascade as before though naturally they do not drop quite as much. There are also folds running from one tack to the other. These folds are affected also by the pull of gravity for, as they move across, they are also dropping down.

Arrangement 3: Leaving the drapery as it was pinned in Arrangement 2, take the point at the middle of the top of the drapery and pull it up to a point halfway between *A* and *B*, fastening it with a third tack which we will call *C*. You will notice that there are now three hubs.

Arrangement 4: Release Tack *C*. Pick up the drapery at a point one foot below the center of the slack section, carry it up to the point halfway between *A* and *B*, and tack it to the wall with Tack *C*.

Arrangement 5: Remove Tack *C*. Reach behind the drapery to a point one foot below the center of the slack section. That point is then pulled up and tacked between *A* and *B*. The fourth and fifth arrangements are the same except that the drapery is picked up from the front in the fourth and from behind in the fifth.

In subsequent quick studies, arrange the drapery as you choose, always planning the arrangement and making a drawing from imagination before actually draping the material. The following suggestions will help you to vary the arrangement. Start at first with the drapery tacked flat against the wall. Place a pin at any point on the cloth, such as one foot below the top on the left side or two feet below the top on the right side or in the center. Then say to yourself, 'I am going to pick up the cloth at the point where the pin is and tack it to the wall at a point one foot higher.' Or you may choose to tack it two feet higher or a certain distance to the right or left and somewhat higher. First draw what you think will happen and then tack the drapery according to your plan and draw what actually happens. Later place two pins in the cloth instead of one and tack the cloth in two new places at the same time. Instead of starting with the drapery flat, you may start with the drapery held by only one tack or by two tacks placed at any two points along the top edge with the section between them either taut or slack.

Exercise 28: Long Study of Drapery

Materials: You will need a second piece of cloth for this exercise, similar to the first, since the folds must remain undisturbed for several days. Use a 2B drawing pencil for the lighter parts of the drawing (sides), a 4B pencil for the darker parts (base), and a kneaded eraser.

Starting with the drapery flat against the wall, tack it in two places, causing folds to radiate from two hubs. First make a gesture drawing of this on a large piece of manila paper. Then settle down to study the folds in detail.

Use a temporary rule that every fold has three surfaces — a top, a right side, and a left side. The top is naturally that part of the surface which is closest to your eye. The sides move back from the top of the fold to the base of the drapery, the base being that part which touches the wall and from which the folds rise. Where a side is turned under so that it is not visible, there is an undercut under the edge of the fold. This is a term borrowed from sculpture.

These surfaces are to be treated arbitrarily in the following manner. The top is to be left white. The sides are to be made a medium gray, both the

Every fold has (at least)
3 surfaces
are
1 top — white
2 right side - grey
3 left side grey

Base — dark grey

undercut

same shade. The base is to be made a much darker gray but not black. The undercut is to be indicated by a black line which graduates as it moves away from the edge of the fold, giving the impression that the pencil has reached under where the fold turned under and has then come out again with lessening pressure. Similarly, the sculptor would lessen the pressure of his tool as he came out from under an undercut. Under no condition are you to feel that you are putting a black line under the edge of the fold as it turns under. You are following the fold as it goes under and comes out again.

The question of which is the top and which is the side will often be a matter of arbitrary decision on your part. Ten students studying the same drapery might make ten different selections and each would be right as long as each had arrived at an understanding of the structural significance of the folds. Some tops may be closer to you than others because some folds may be very deep and others very shallow. If the folds are so shallow that they do not seem to count as folds, they may be considered part of the base.

Having decided what part of the fold is the top, you will think of the sides, no matter what direction they face in, as sides of that top. There are times when a side is seen for a while but then turns under as the fold twists up or around. The part of the side which is seen is treated as a side, being made gray. As it turns under the undercut treatment is used. You will notice that the undercut treatment overlaps somewhat the side treatment because the undercut begins while part of the side can still be seen.

You must always account in your drawing for the three surfaces that a fold must have. When one of the sides turns under and disappears from view, that side is nevertheless accounted for by the use of the undercut. Quite often two folds will start bravely as separate identities but will merge into one, thus forming a Y-shaped fold.

There should be no gradations in shading except where you come out from the undercut, so that with that exception only four tones will appear — white, light gray, dark gray, and black. The drawing should be so clear that there can be no possible doubt as to what you have considered to be top, side, or base, and exactly where each begins and ends. It should be so clear that a woodcarver could carve a piece of wood from it without any other explanation. In fact, he could carve a piece of wood more easily from the right sort of drawing than from the original drapery.

Draw for six hours as directed in Schedule 11 A and 11 B.

THE INSECT TRAIL. To test the clearness of your finished drapery study, imagine that a small insect (preferably a pleasant one) starts at one side and crawls horizontally across the drapery. Imagine that his feet have been dipped in ink so that he leaves a trail behind him. This trail would move up the side of a fold, flat across the top, down the other side, flat across the base. Coming to an undercut, the insect would disappear and then come out again higher or lower according to your eye-level. Take your pencil and mark such a trail across your drawing.

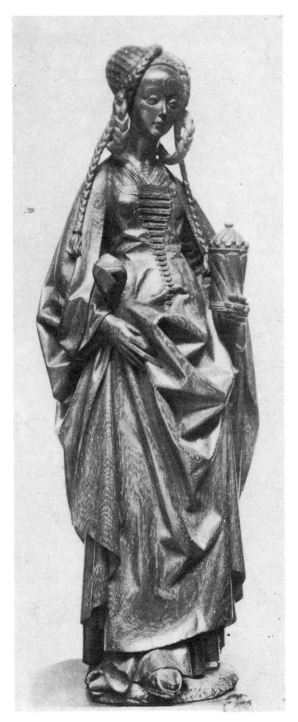

SAINT MADELEINE, 16TH CENTURY WOOD CARVING

*A drapery study should be so clear that a woodcarver could carve
a piece of wood from it without any other explanation.*

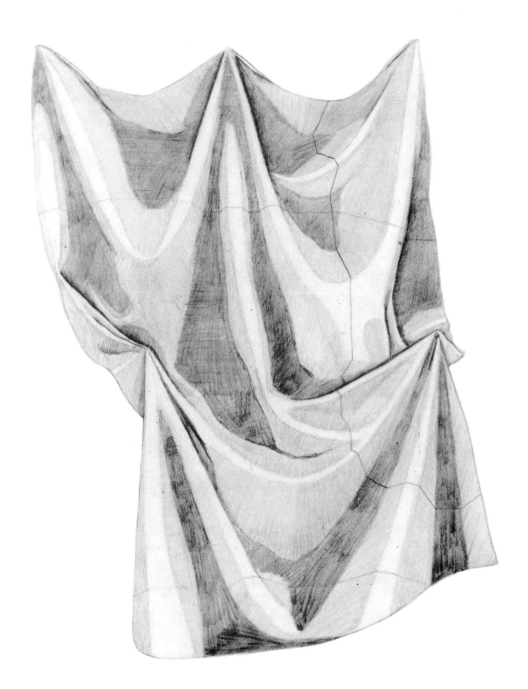

STUDENT DRAWING OF DRAPERY

Always account for the three surfaces that a fold must have.

This trail is comparable to a cross-contour line on the figure. It is like walking over a landscape, up over hills, down into valleys. The piece of cloth, like the contour of the figure or the surface of the earth, is one continuous thing even though part of it may be hidden from view. There must be no unexplained gaps or holes in it.

Draw for six hours as directed in Schedule 11 C and 11 D.

FUTURE DRAPERY STUDY. These particular drapery exercises will not be scheduled again in this text, but this is a type of study to which you will wish to return. Therefore, I will make several suggestions that may help you in future when you have varied needs for draperies in painting. The student who has no nude model at his disposal, or who wishes to supplement study from the model with other subjects, will find it extremely useful to carry forward some type of drapery study continuously.

In future long studies you may leave either the left or the right side of the folds white, making the other side dark gray and the top and the base light gray. Your drawing will thus show the effect of a drapery with the light falling from either the left or the right side.

For both quick and long studies the drapery material may be varied as follows: (1) Pleat the drapery along the top with three-inch pleats, using thumb tacks, before draping it. Draping a material that has first been either pleated or gathered affords an excellent study of the folds you encounter when drawing clothes. (2) Use a piece of material with strong horizontal stripes and, subsequently, with checks or striking designs. (3) Use materials that present a variety of texture, as cheese cloth, canvas, and taffeta.

A large piece of wrapping paper, thinner than the kind you draw on, may be draped very successfully with a few thumb tacks. It will be rather angular, somewhat like taffeta, but is excellent for practice.

Dip a piece of light muslin or cheese cloth about four feet square in a weak, fairly watery solution of plaster of paris or in a strong starch solution. While it is still wet, give it a twist. When it sets, the folds will hold their shape, and it can be moved about for study from different angles in various lights.

Draw for three hours as directed in Schedule 11 E.
You will find it helpful to repeat Schedule 11.

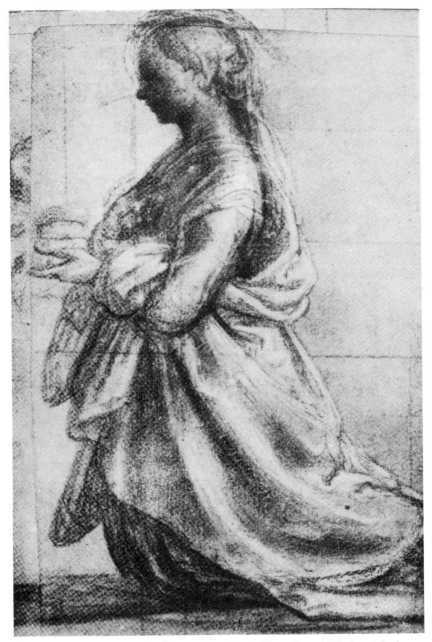

THE MAGDALEN KNEELING BY FRA BARTOLOMMEO
The drapery follows the form and the gesture.

Section 12

The Figure with Drapery — The Subjective Impulse

EXERCISE 29: THE FIGURE WITH DRAPERY

FOR all the exercises in Schedule 12 the model is asked to pose with the piece of drapery which you have been studying. Naturally, when the model rests and then continues a pose, the folds will change somewhat. This will not disturb you if you understand clearly the principle of the hub. As long as the pose is the same, the hubs are the same. When you recognize the folds as radiating from those hubs, the difference in details may be easily adjusted on your paper.

I make one suggestion at this time. Just as in the nude poses you consider

SCHEDULE 12

	A	B	C	D	E
Half Hour	Ex. 2 and 29: Gesture (25 drawings)	Ex. 2 and 29: Gesture (25 drawings)	Ex. 2 and 29: Gesture (25 drawings)	Ex. 2 and 29: Gesture (25 drawings)	Ex. 2 and 29: Gesture (25 drawings)
Half Hour	Ex. 7 and 29: Modelled Drawing in Lithograph (one)	Ex. 13 and 29: Modelled Drawing in Ink (one)	Ex. 15 and 29: Modelled Drawing in Water Color (one)	Ex. 16 and 29: Right-Angle Study (one)	Ex. 23 and 29: Ten-Minute Form Studies (three)
Quarter Hour	Ex. 8 and 29: Memory (15 drawings)	Ex. 9 and 29: Moving Action (5 drawings)	Ex. 8 and 29: Memory (15 drawings)	Ex. 10 and 29: Descriptive Poses (6 drawings)	Ex. 20: Gesture of the Features (15 drawings)
Quarter Hour	Rest	Rest	Rest	Rest	Rest
Half Hour	Ex. 2 and 29: Gesture (25 drawings)	Ex. 2 and 29: Gesture (25 drawings)	Ex. 2 and 29: Gesture (25 drawings)	Ex. 2 and 29: Gesture (25 drawings)	Ex. 2 and 29: Gesture (25 drawings)
One Hour	Ex. 7 and 29: Modelled Drawing in Lithograph (one)	Ex. 13 and 29: Modelled Drawing in Ink (one)	Ex. 15 and 29: Modelled Drawing in Water Color (one drawing)		Ex. 19: The Head in any Medium (one drawing)

Remember the Daily Composition (Ex. 14 or 30) EVERY DAY.

National Museum, Naples: Photograph by courtesy of Department of Archaeology, Bryn Mawr College
STREET MUSICIANS, A MOSAIC BY DIOSKOURIDES
Compare Exercises 28 and 29.

muscles, fat, and flesh as one thing, so you are now to consider the figure and the drapery as one thing. The drapery follows the form and the gesture. When the model changes to a new pose, the folds are determined not only by that pose, but by the previous one as well and by the movement the model made when she changed from the one to the other. The drapery represents the residue of the action the model takes. It is a path back to the cause.

The following will indicate the type of poses desired. (1) The model holds the long side of the drapery and pulls it over her shoulders like a cape, letting it fall from the shoulders wherever it will. (2) The model holds the short side of the drapery around her waist while standing, sitting, or stepping forward, a pose that throws the drapery into some relief against the figure. (3) The model places the drapery across her chest and catches it in the back with her hand over her shoulder. (4) The model turns her back, holds the drapery behind her, and with one hand brings a corner of it over her shoulder to the pit of her neck.

Draw for six hours as directed in Schedule 12 A and 12 B.

EXERCISE 30: THE DAILY COMPOSITION — *Continued*

The time comes when you find that your daily compositions have pretty well exhausted the interest in places that exist around you in your immediate daily life. Then you may sometimes vary the exercise by selecting as a subject some event which happened to you in the past or in which you played the part of a spectator. At first you will find it easier to draw things in which you took an active part, because the memory of what you did will add to the memory of what you saw. If you are beginning to draw with some ease, enlarge the composition. Do not limit yourself to pencil, but use the medium which causes the least friction for you in putting down the idea.

As you draw, starting with some actual place or event that you happen to think of, you may add anything that occurs to you, regardless of whether it actually happened or existed or even seems related to the thing you started with. For example, you may remember a time last summer when you were riding on a lake in a canoe and you start drawing the canoe. The canoe makes you think of Indians, so you end up by drawing Indians paddling down a river. It does not matter how far your drawing wanders from the thing you started with.

The use of this exercise depends much on the temperament of the student. It gives him a chance to use the things that interest him and to dramatize more freely what he has seen. Some students show great progress when allowed to make use of imagination. Others may be totally at a loss for subjects and will continue to work more satisfactorily with daily events. In any case, at least half of the daily compositions should draw on some simple happening within the day's experience. These are only first steps toward the study of composition and the first step is always observation.

Draw for three hours as directed in Schedule 12 C.

THE SUBJECTIVE IMPULSE. In a very simple way, the imaginary daily composition introduces into your drawing a subjective element about which we will have more to say later.

Two kinds of impulses go into the production of a work of art, the subjective and the objective. The subjective impulses spring from within your own consciousness, while the objective impulses come from the things outside yourself which you observe and draw. If twenty students make twenty

drawings from the same model, no two drawings will be identical and some will be vastly different from others. That is because the personality and experience of each student, which are subjective elements, enter into his drawing.

For example, the canoe which you started to draw was an objective thing, and you might have made a more or less objective drawing of the scene as it actually existed. But the memory of the canoe aroused certain feelings within yourself, reminded you of other experiences or other knowledge, and to the extent that those other things within your mind were brought into play, your drawing became subjective.

Just as two lines converging at a point are necessary to make an angle, both you and something outside yourself are equally necessary to create a work of art. As one atom of oxygen and two atoms of hydrogen combine to make something that is neither hydrogen nor oxygen but a new thing — water — so a drawing is a new thing resulting from the activity within your mind and the outside stimulus of a model or an event.

To create is to build something fresh, something that is the result of these two types of experience, the objective and the subjective. The subjective qualities are the qualities that make art, but they must begin somewhere. Though art cannot come from slavish copying based purely on external observation, neither can it come out of the artist's mind alone. Something starts outside of him, though he may not even be conscious of it, and makes him want to create. The artist, when he begins to paint, has had an experience which he combines with other previous experiences. He wants to transpose it or tell someone about it or re-experience it in painting or in some other form of art. He tries to give to a piece of canvas a sense of existence so that it lives in itself, becoming as much alive and as real as the experience that he has had.

But the first step in drawing is an objective step — the observation of facts as they exist. And that step is the surest way toward the development of subjective power, which is after all the power of an accumulated real knowledge.

It is hard for the creative mind to grasp what the creative force is. It is a force that takes hold of you without your even being able to understand it. There are some who have the creative force without the sustaining intelligence which is also necessary. Creation is really a meeting of those two things.

Temperament is merely an incident, just as one banker may be temperamental and another not, while both have the genius for banking. The idea that an artist must be a tragic sort of figure is all wrong. Some artists are, like Van Gogh and Gauguin. Some, like Titian and Renoir, are not. Tragedy is caused by a man's nature and environment and is as irrelevant to painting as it is to other professions. Many young art students react against the prosaic world and feel that they must be 'different.' They are afraid if they act like other people they will be like other people. The real difference between the artist and one who is not an artist is not so simple as that.

Draw for six hours as directed in Schedule 12 D and 12 E.

ARAB ATTACKING A PANTHER BY DELACROIX
The line can show both gesture and weight.

Section 13

The Sustained Study

THE WELDING OF YOUR KNOWLEDGE. In each of the exercises you have taken up we attempted to isolate some important principle in order that you might be able to concentrate on it with all your energy. All of these ideas are a part of drawing — it seems to me an essential part — and they are eventually to become welded into the one act of drawing. This is the point in your study at which the welding begins.

Actually this process of welding has already begun, as you will readily see if you compare your first drawings with the ones you made yesterday. Your gesture studies now have much more of the form and perhaps something of the quality of contour while your line is capable of showing both gesture and weight. But at this point you begin a sustained study in which you consciously try to utilize all that you have learned.

It naturally follows that, unless you have practiced the preceding exer-

SCHEDULE 13

	A	B	C	D	E
Half Hour	Ex. 2: Gesture (25 drawings)	Ex. 2: Gesture (25 drawings)	Ex. 2: Gesture (25 drawings)	Ex. 2: Gesture (25 drawings)	Ex. 2: Gesture (25 drawings)
Half Hour	Ex. 31: Extended Gesture Study (one)	Ex. 31: Extended Gesture Study (one)	Ex. 31: Extended Gesture Study (one)	Ex. 31: Extended Gesture Study (one)	Ex. 31: Extended Gesture Study (one)
Quarter Hour	Ex. 8: Memory (15 drawings)	Ex. 11: Reverse Poses (6 drawings)	Ex. 8: Memory (15 drawings)	Ex. 12: Group Poses (7 drawings)	Ex. 20: Gesture of the Features (15 drawings)
Quarter Hour	Rest	Rest	Rest	Rest	Rest
Half Hour	Ex. 2: Gesture (25 drawings)	Ex. 2: Gesture (25 drawings)	Ex. 2: Gesture (25 drawings)	Ex. 2: Gesture (25 drawings)	Ex. 2: Gesture (25 drawings)
One Hour	Ex. 32: The Sustained Study (one study composed of three drawings)				Ex. 19 and 31: The Head in Pencil (one drawing)
Remember the Daily Composition (Ex. 14 or 30) EVERY DAY.					

cises as you were directed and for as long as you were directed, you must fail in doing this one. All of these exercises are tied up together in the effort to understand the fundamental truth *out there* — in the model or the event. Each effort, as fleeting as it may seem, is a link in the chain of your progress. If you have missed any one, go back to it now. The person who tries to get ahead of himself is like a juggler trying to juggle eight balls before he has learned to juggle two. It takes him twice as long if he finally succeeds in learning it at all.

EXERCISE 31: THE EXTENDED GESTURE STUDY

This is the first step in the sustained study, but it is one which you will use also for separate half-hour drawings. Start with a gesture study on a large piece of manila paper, using a 4B pencil, and go on from that to delineate more carefully the forms and contours, including the outside contours. Having made a real contact with the gesture in the first few minutes, you can then afford to develop the drawing as to its other details such as the forms of the various parts. You may include some feeling of the contour study, but continue to use the same principle of thinking what the thing is doing, still feeling the quality of the gesture even when you are drawing a contour.

Use an eraser if the number of lines used in the beginning confuses this more clear delineation of the forms. You may use any and all methods at your command to arrive at the correct proportions and the posture, even to the extent of measuring how much higher one point is than another or the angles and distances that are created from point to point. In such measuring there is danger of making your drawing static so, after you have checked up the proportions, return again to the conviction of the gesture. Do not shade the drawing.

Courtesy of the Metropolitan Museum of Art
DANCING FIGURE BY PONTORMO

EXERCISE 32: THE SUSTAINED STUDY

Materials: In addition to a 2B and a 4B pencil and a kneaded eraser, you will need a piece of manila paper and two pieces of tracing paper all of the same size (fifteen by twenty). Tracing paper is a transparent drawing paper which may be bought in single sheets or in pads. The kneaded eraser may be shaped into a point so as to erase a very small part of the drawing if desired.

First make an extended gesture study (one-half to one hour) as described in Exercise 31. When you have carried the drawing as far as possible on this particular piece of paper, place a piece of tracing paper over it and make a contour study (one-half to one hour). As in previous contour studies, draw only when looking at the model, glancing down at times to locate your place on the paper. But now, because you see your gesture drawing underneath, a certain correlation is set up between the impulse that you are getting from the model and the drawing which shows through the tracing paper. You may look at the paper a little more often in order to coordinate the two, but draw only when looking at the model.

Draw for three hours as directed in Schedule 13 A.

Remove the extended gesture drawing altogether and place a clean piece of tracing paper over your contour study. You are now to model the drawing, using alternately the 2B and the 4B pencil. Even if you find yourself working successfully with one pencil, change at intervals to the other.

At this point you make a definite change in the way you model the figure, though the change is not so great as it may seem at first. In the modelled drawing in lithograph, ink, and water color, the part of the form which was closest to your eye was made lightest. Actually, the lightest part of any form could never be at a point directly opposite the eye because, if it were, the source of light would have to be in the eye. Even if the only light on the figure were from a flashlight held close to your eyes, the lightest part of the figure would not be exactly opposite you, though almost.

Now you are to make lightest that part of the figure which actually is the lightest, and darkest that part which actually is the darkest. In other words, the part of the figure that is now made dark is the part that has shadow on it, but you are not to feel that you are drawing the shadow. You are modelling the figure exactly as you did before except that you let the drawing become

CARPENTER BY VAN GOGH

*You cannot start where some other painter left off. You have to start where he started —
at the beginning — and you have to start with the same integrity and the same interest.*

dark where the shadow happens to be. Use exactly the same emotional and physical reaction to the form, thinking that one part is near you while another goes away from you. Once you have shifted the lightest part of your drawing away from the point opposite your eye to the point where the light falls, you will forget that there is any difference between this and your first modelled drawing. The change is so simple that many students make it instinctively before it is described to them.

In your first modelled drawing, if the lightest part of your drawing had corresponded to the lightest part of the figure, you could never have been sure that you were drawing the form and not the light and shadow. In the effort to make the adjustment of the eye from a dark part of the figure which appeared light in your drawing, or vice versa, you became aware of the form as completely distinct from the light on it. You are still to be aware of the form in that way. Draw the actual form, which is something solid and real that you could touch, and not the lights and shadows which are passing and intangible, changing when the light is moved a few feet.

As a rule, the lights in a classroom are arranged in a semicircle overhead around the model, throwing many cross-shadows which tend to confuse the form. Make a decision as to what you will consider the main source of light, whether it be from the left or right or front, and attempt to use only the one set of shadows which indicates the one source of light. Don't try to match in your drawing the degree of light or shade that you see. Your drawing may look very dark or quite light when you finish. That doesn't matter as long as the forms are clear.

Eliminate cast shadows. A cast shadow is one which is cast on a form from another form. For example, if the light is from the front and the model stands holding his arm in front of him, the shadow which the arm throws on the body is a cast shadow, whereas the shadows on the arm itself are natural shadows caused by the fact that the arm is round and parts of it move away from the light. (Later you will utilize some cast shadows, for there are times when a cast shadow helps to show the projection of the form which causes it and to delineate the contours of the form on which it falls. But nearly always, if you use them at all, it is necessary to modify their value, to make them less dark than they appear to the eye.)

Keep the contour drawing underneath as long as it helps you with the position of the forms. Remove it when it is no longer needed because the edges of a modelled drawing will naturally not be as dark as the lines of a

contour drawing. As you model the lightest part you may find that it becomes somewhat shaded so that it is hard for you to make other parts dark enough by comparison. Then use the eraser to pull the form toward you, making it white again. But do not leave those parts of the figure white from the beginning. If you do, it is like leaving a hole in the figure at that place. You want to feel that you have *touched* the entire figure.

The softer pencil is useful in the absolute undercut, as in the corner of the eye, the nostrils, the ear, and between the toes and fingers. When you are trying to suggest a hole going into a form, that place becomes darker by its very nature than the parts around it, not necessarily because it is dark but to suggest its hole-like quality.

Draw for six hours as directed in Schedule 13 B and 13 C.

CHANGING THE POINT OF VIEW. It is well known that the printed or spoken word has a tendency to take on authority once it is printed or spoken. To get away from it almost takes a revolution. The same thing is true with your own drawing. The very mistakes you make, as they linger on the paper, have this tendency to become authoritative. To combat it, move about the room during the long pose, making occasional scribbled drawings. A thing is factually the same from whatever point of view you see it, but seeing it from different points of view will illuminate the meaning of the forms and lines you have been looking at.

Draw for six hours as directed in Schedule 13 D and 13 E.

THE POSE NUDE AND CLOTHED. In each of the succeeding schedules you are to make two sustained studies of the same pose. For one the model will pose nude and for the other in whatever clothes he or she happens to be wearing. The pose is to be exactly the same for both drawings and you draw it from exactly the same position. Begin by making an extended gesture drawing of the nude and another of the clothed pose. You should always make a contour study of the nude, but you may sometimes omit the contour study of the clothed pose, modelling the clothed figure on a piece of tracing paper placed over the nude contour. For the quick studies also the model should alternate posing in the nude and posing in his clothes.

Apply what you have learned about drapery to everyday clothes. In drawing the folds you may leave white that part which is lightest and you need not limit yourself to three simple tones, but make up your mind from

the beginning which is the top of the fold, which is side, and which is base, and draw those elements just as clearly as before. The base will be that part of the clothing which touches the figure and it must now be modelled as the figure would be. The knee, the shoulder, and the elbow will play an important part as hubs.

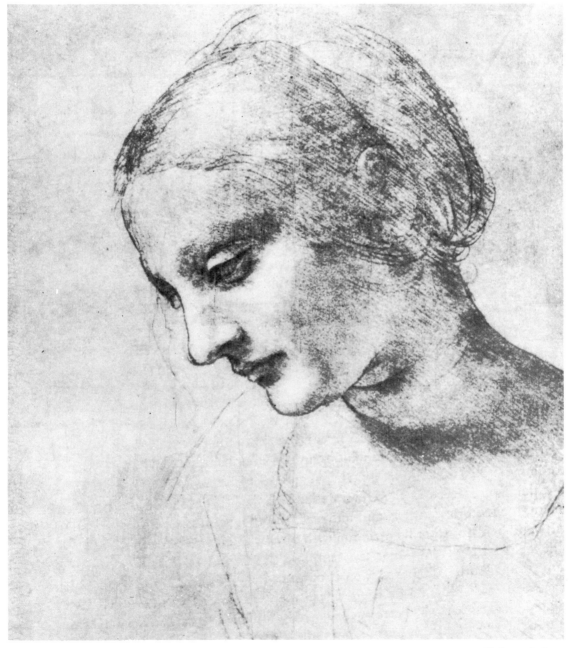

The Louvre, Paris

HEAD OF A WOMAN BY LEONARDO DA VINCI

SPRING BY PIETER BRUEGEL

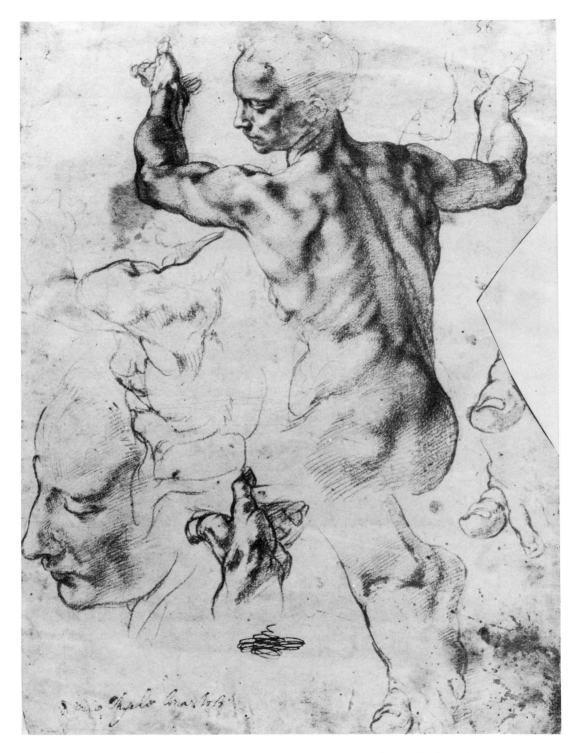

STUDIES FOR THE LIBYAN SIBYL BY MICHELANGELO

STUDY OF TREES BY TITIAN

STUDY FOR LANDSCAPE WITH COWS BY RUBENS

SEATED NUDE BY COROT

STUDY OF FEMALE TORSO BY WATTEAU

THE SHEPHERDESS BY MILLET

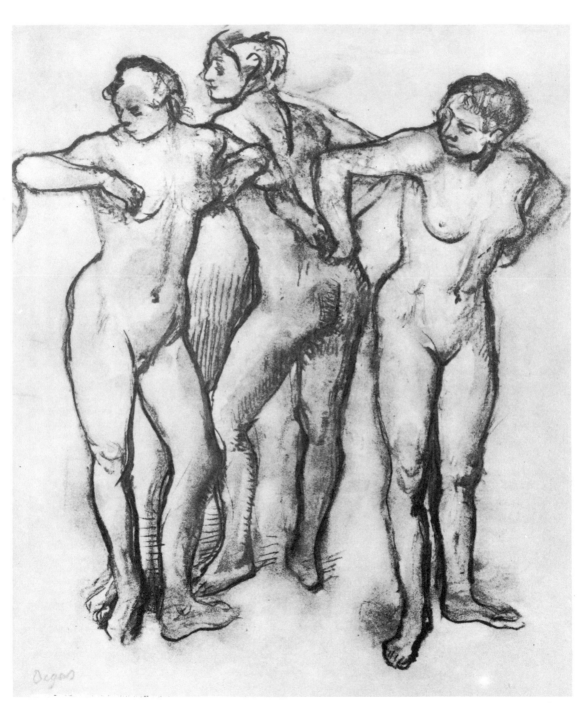

THREE NUDE DANCERS BY DEGAS

Section 14

Light and Shade

AN APPROACH TO LIGHT AND SHADE. *There is no such thing as shadow.* This, of course, is not literally true, but, while it is sometimes advisable to think of a shadow as a positive thing with a positive power, for you at this time it is much better to think of shadow as it actually is — merely the absence of light. Even the expression, a 'cast shadow,' means that one thing is blocking the light from another and the place where the light does not get through is *called* a shadow.

In drawing the part on which less light falls, you should have no consciousness of the shadow, but should be aware only of the form and its surfaces. With this clearly understood we may go on to observe some of the facts of light and shade. It is my object to borrow from these facts only those points which can be utilized in giving the drawing a more convincing expression of your comprehension of the form. There are any number of books that

SCHEDULE 14

	A	B	C	D	E
Half Hour	Ex. 2: Gesture (25 drawings)	Ex. 2: Gesture (25 drawings)	Ex. 2: Gesture (25 drawings)	Ex. 2: Gesture (25 drawings)	Ex. 2: Gesture (25 drawings)
One Hour *	Ex. 32: The Sustained Study, Nude (one study composed of three drawings)				Ex. 16 and 31: Right-Angle Study (one)
Quarter Hour	Rest	Rest	Rest	Rest	Rest
Quarter Hour	Ex. 2: Gesture (15 drawings)	Ex. 2: Gesture (15 drawings)	Ex. 2: Gesture (15 drawings)	Ex. 2: Gesture (15 drawings)	Ex. 2: Gesture (15 drawings)
One Hour *	Ex. 32: The Sustained Study, Clothed (one study composed of either two † or three drawings)				Ex. 19 and 31: The Head in Pencil (one drawing)
Remember the Daily Composition (Ex. 14 or 30) EVERY DAY.					

* Hereafter, you may sometimes substitute Exercises 8–12, 18, 20, or 23 for Exercise 2 at your convenience, if you so desire. The same pose is to be used for the sustained study, nude and clothed.
† The contour drawing may be sometimes omitted.

deal most completely — more completely than this book is planned to — with the physics of light, but if you go into the subject too closely and too scientifically you are apt to become somewhat confused for our purpose. Primarily you are concerned with the shape of things, not with the shape of lights or shadows.

RECTIFICATION FOR THE SAKE OF FORM. Light and shadow can be a very real help to you in seeing and understanding the form. Across the room you might not distinguish a ball from a disk were it not for the different way in which the light falls on the two objects. The folds in a distant range of mountains may be distinguished most clearly when the shadows appear. If you are drawing a fat man, the lights and shadows that fall on him will form shapes that are very descriptive of the model.

It is also true, however, that shadows can misrepresent the form on which they fall and, when they do, they must be rectified or modified in relation to the facts as you know them. If you ever must choose between representing a shadow truthfully and representing the form truthfully, unquestionably ignore the shadow and draw the form. One of my students remarked that I make light and shade out to be the villain of the piece, viciously hiding the real truth from us. Shadows can be a helpful element only when you make the integrity of the form your first consideration.

Suppose a playing card interrupts a light falling on an egg so as to make a cast shadow on the egg. It would be possible for one line of the shadow to be absolutely straight. If you make the line straight in your drawing, it will give the impression that the egg is a flat instead of a rounded object. In that case it is up to you to change the line of the shadow so that it follows the contour of the egg. This is true of many cast shadows that fall on the body and tend to destroy the form on which they exist.

There are times when the light destroys the sense of the position of some part of the body. For example, look at the back view of a model who has stepped forward on his left foot, having the left knee bent and the right leg straight. The calf of the left leg, which is bent, receives more light than that of the right leg, which is really closer to you. Here you should remember the modelled drawing, in which you pushed back as the leg moved away from you. In pushing, because you had a crayon in your hand, you made the part which went back darker. Utilize some of that knowledge and make the bent leg darker than it looks. Similarly, in a front view of the head an ear may catch more light than the forehead because

of its shape or angle. You should make that ear darker than it seems.

If you think of the whole form as a sort of cylinder, the whole of the light side is nearer to the light than any part of the dark side. For that reason, the shadows on the light side are sometimes made lighter and the lights on the dark side darker. It is always necessary to remember the whole in the way you became aware of it when building the form outward from its core (Exercise 6).

A reflected light generally appears stronger than it actually is because you see it in immediate contrast to a dark shadow. If you make it as bright as it looks, it has a tendency to pull toward you a section of the form that is actually moving away. Therefore, you often darken it.

Metal or anything hard and polished is likely to have a strong and isolated highlight. To the eye the highlight may not appear to exist on the surface at all, any more than the beam from a searchlight exists within the searchlight. If you draw that highlight as bright as it seems, you will lift that part of the surface out beyond the rest of the surface, thus destroying the continuity of the form. It is surprising how much less intense the highlight can be made and still seem quite bright enough.

When a landscape is lit up by very strong sunlight, it is unwise to make the shadows as dark as they seem. This seeming darkness is due partly to the fact that the eyes are blinded by the strong light. Under no condition should a shadow be made so dark that it seems to put a hole into the surface of a thing where no hole exists.

In a piece of drapery the difference in the amount of light that the top and the base receive is practically nil. In fact, especially in a white drapery, the base may seem lighter than the top if it is surrounded by shadow or turns a little so as to catch the light. You know, however, that the base is farther away and that you must make your drawing so clear that no one will be in doubt as to what part is base. Therefore, you borrow from your knowledge of form and push the base back by graying it a little.

The first truth is the form. You must put into your drawing most forcefully the facts which you know to be true rather than what you see. What you see, the impression that a thing makes on the eye, will take care of itself — in fact, most of the time it is far too insistent. You cannot truthfully portray vision without a knowledge of the facts which underlie it.

Draw for six hours as directed in Schedule 14 A and 14 B.

LIGHT ON A CUBE. A box is sitting on the table. The only source of light is directly opposite and somewhat higher than the middle of the left side of the box. As the rays of light move down to the box, they strike the left side and the top somewhat evenly, making them light to about an equal degree, while the front of the box is dark or in shadow.

Along those edges of the box where the light and shade come together, the shade will seem more dark because it is on those edges that the contrast is greatest. There is a contrast, not only of light and dark, but also of movement because along that edge one plane or side of the box turns directly away from the other. Even if you do not see this, or if it were not to be seen, you will accentuate the line which already indicates this change of direction in order to create the sensation of form which you know to be there. If the light actually falls equally on the left side and the top of the box (tilt the box until you see that it does) you will notice that the edge between those two sides is lighter than the sides. That is because this edge catches more light than either of the sides and its lightness emphasizes the change of movement between them.

Draw for three hours as directed in Schedule 14 C.

LIGHT ON A SPHERE. Now instead of the box there is a ball resting on the table and the light is in the same relative position to the ball as it was to the box, falling from the left side halfway between the back and the front. Remembering the manner in which the light struck the box, you will expect the ball to receive the greatest amount of light at a point on the middle of the left side. However, the point which appears lightest will be somewhat between that point on the side and the point nearest you. Similarly, you might expect the darkest part to be on the right side halfway between the front and the back, whereas actually the darkest part falls somewhat nearer you.

It would be simple merely to describe this, but one should try to understand the *why*. The cube and the sphere are very different. In the cube there are acute and abrupt changes of direction, while the change of direction in the sphere is constantly even and unbroken. On the cube there seem to be lines. Although there are no lines actually (the apparent line being simply the place where two planes meet) we make use of lines to indicate this abrupt change. And we use a dark to emphasize it or, one could almost say, to exaggerate it, because light falls on a cube in such a way as to exaggerate this

change. (Only the expert will realize that your exaggerations are really true.)

As you look at the sphere there is no line on it although you might draw a contour on it at any place, just as you might draw a contour at any place on the figure. Because the movement is not acute, the change of direction is not cut through by apparent lines. Therefore, the darkest note will not be immediately next to the lightest note. Just as there is a gradual movement around the surface of the sphere there is a gradual change from light to dark. While there is still a contrast where the light and shade come together, the contrast is also gradual. The darkest area and the lightest area do not actually meet as in the cube.

Draw for three hours as directed in Schedule 14 D.

THE CAST SHADOWS. Because the box comes between the light and the table, there will be on the table a cast shadow having the general shape of the box. The closer the light is to the box the larger the shadow will be because the box then blocks off more light from the table. The size of the light in relation to the size of the box also has its effect. If the light were much larger and were placed close to the box, the light rays around the box would succeed in lightening the cast shadow and obliterating much of it. If the light were small enough and close enough, none of its rays would succeed in getting around the box at all. When the source of light is lowered, the shadow becomes longer, just as the late afternoon shadows are longer than those at midday.

The cast shadow of the ball follows exactly the same principle as that of the box except that there is more light passing into it. The ball in theory makes contact with the table at a single point and, therefore, the light passes under some of its bottom surfaces. This light, as it strikes the table, is reflected back on the curved surface of the ball, causing that part of the ball to appear lighter than some other parts which are nearer the light. The strength of this reflected light depends on the color of the ball and the color of the table. If the ball rests on a white table, the reflected light will be very strong.

Draw for three hours as directed in Schedule 14 E.

Section 15

An Approach to the Study of Anatomy

THE BASIS OF ACTION. The human figure is built for action, and the best approach to the study of anatomy is that which constantly relates the anatomy of the figure to the possibility of movement. The shapes of the body in action are entirely different from those of the dormant body. It is the gesture that gives everything its shape. The bones and muscles have been modelled into their form by action, through centuries of existence, and those forms are not static. If anatomy were illogical it would be terribly difficult, but this basis of action makes it logical. What you need mainly to know is the movement of the figure and its limitations — where it can and cannot move.

Books on anatomy do not make it sufficiently clear that the muscles and bones are all covered with fat and flesh and that the nude figure is the bones, the muscles, the fat, and the flesh as a unit. There are times when these muscles merge with one another in their action or lack of action under the

SCHEDULE 15

	A	B	C	D	E
Half Hour	Ex. 2: Gesture (25 drawings)	Ex. 2: Gesture (25 drawings)	Ex. 2: Gesture (25 drawings)	Ex. 2: Gesture (25 drawings)	Ex. 2: Gesture (25 drawings)
One Hour	Ex. 32: The Sustained Study, Nude (one study composed of three drawings)				Ex. 33: Study of the Bones * (one drawing)
Quarter Hour	Rest	Rest	Rest	Rest	Rest
Quarter Hour	Ex. 2: Gesture (15 drawings)	Ex. 2: Gesture (15 drawings)	Ex. 2: Gesture (15 drawings)	Ex. 2: Gesture (15 drawings)	Ex. 2: Gesture (15 drawings)
One Hour	Ex. 32: The Sustained Study, Clothed (one study composed of three drawings)				Ex. 19 and 31: The Head in Pencil (one drawing)
Remember the Daily Composition (Ex. 14 or 30) EVERY DAY.					

* The model poses nude, as for the sustained study.

cover of this fat and flesh so as to create a unit of almost abstract form. That is, you do not think of bones or muscles or flesh separately, but as a unit. It becomes itself, a new thing, and it must eventually be thought of as that new thing.

A MEANS TO AN END. Anatomy in the hands of the artist is merely another instrument for making the figure articulate and clear. It is never to be thought of as an end in itself but only as a means to an end. It is quite possible for a student to acquire sufficient knowledge of anatomy through his knowledge of the figure without having made any special study of the subject or ever even having heard the word. The archaic Greeks knew little of anatomy and their figures are anatomically inaccurate, but they constitute great works of art.

The knowledge of anatomy can become an interesting thing for itself without regard to art, but purely anatomical drawings of the figure are like the drawings a botanist without art training might make of flowers. They are good diagrams but are unimportant as far as art is concerned. The student who self-consciously displays his knowledge of anatomy on every occasion is apt to be as boring and as impotent as the kind of person who feels it necessary to parade his information on any other subject.

Anatomy is the one study on which I do not advise students to concentrate in the beginning. Rather, approach it lightly and casually in the same way that you would make drawings during a telephone conversation. Think less of the anatomy than of the figure as you know it, fitting the anatomy into your knowledge of the figure even though your knowledge is not yet exactly correct. I have seen so often a lot of waste energy, disillusionment, and disappointment among students because nothing 'works' in the beginning. It takes many drawings, many efforts, to relate the information in anatomy charts to what you know of the figure through your other experience with it. Therefore, it is better not to take the study too seriously at first or to devote too much time to it. But it should be continued and, if it is, the anatomy will become comprehensible and you will find yourself more interested, more serious about it, and more able to concentrate.

EXERCISE 33: STUDY OF THE BONES

Materials: For the exercises described in this book you will need a set of practical, cheap anatomy charts. Suitable charts may be

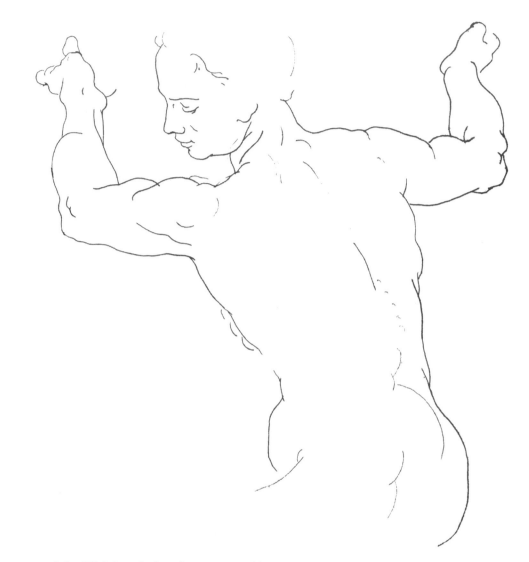

*A contour of the Michelangelo drawing on page 133,
used as the basis for study of the bones (opposite).*

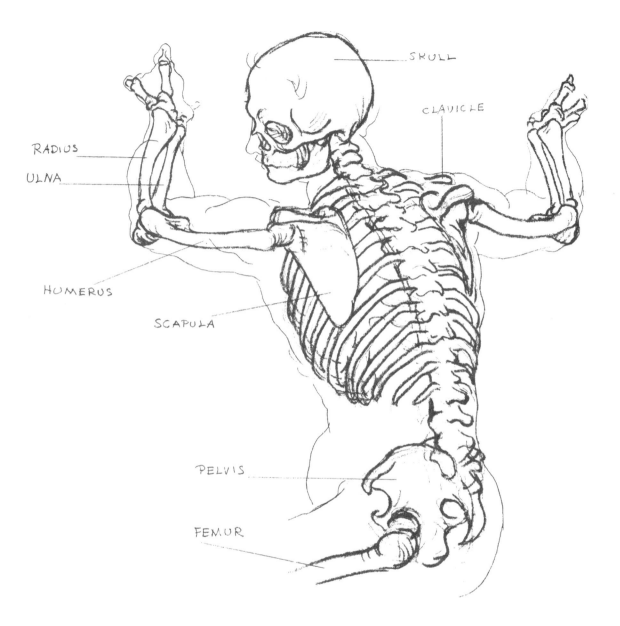

SKULL

CLAVICLE

RADIUS

ULNA

HUMERUS

SCAPULA

PELVIS

FEMUR

ordered from the Art Students' League, 215 West 57th Street, New York City, if they are not available at your local book or art store. For the student who wishes later to go deeply and thoroughly into the study of anatomy, there are no better books on the subject than those of George B. Bridgman.

Place a new piece of tracing paper over the contour drawing (nude) which you made for the current sustained study and place a chart of the full-length skeleton before you. With your softest pencil or a piece of charcoal sketch in the bones as well as you are able, attempting to make them fit into their proper place in your drawing of the figure. They should be sketched in loosely in the spirit of a gesture drawing, following the action of the figure with little regard for the shape of the individual bones. To guide you, you have the chart, the model, who is still posing, and your contour study. There are certain places on the figure where the bones come close to the surface, showing clearly under the flesh. These places help you to place the bones correctly and you should correlate them on the drawing, the model, and the chart.

This part of the study should not take more than fifteen minutes. During the rest of the hour develop the bones in more detail, using the charts of the separate bones. But even here you are not to worry about the exact shapes of the bones except as they affect the shape of the figure. Study their capacity for movement.

THE USE OF ANTIQUE CASTS. Small antique casts of the full-length nude figure may be used for the exercises in anatomy if you are unable to secure a nude model. Purchase first one and then others as you can afford and need them. If you use a cast, you will, of course, make a sustained study of it, the contour drawing of the cast being used as the basis for anatomy study.

These casts may be used in a number of ways. Place them in various positions — at an angle or tilted — for quick or long studies. Draw them draped either with cloth or with thin wrapping paper. Use them as models for living subjects in compositions of your own. Later, when you begin to paint, you can paint them in flesh colors, looking at the statue as a guide to values.

Draw for fifteen hours as directed in Schedule 15.

Section 16

The Long Composition

AN APPROACH TO THE STUDY OF COMPOSITION. If you wish to compose, no matter what you know of composition, you quickly find that you need material to compose with. Therefore, it seems logical that the first exercise in composition must be one in which you attempt to acquire the necessary data in relation to human activity and its environment. The simplest and most efficient practice is to do one composition every day, drawing from that day's experience. That is an exercise you have already begun and one which you should continue faithfully even though you are to supplement it with a longer study having the same objective.

You cannot express yourself with a language that is chaotic. A sufficiently large vocabulary of facts must be at your command to give you the opportunity of selection. If I asked you to draw, from the results of your observation up to date, a man *sitting* in ten different ways, I wonder how similar you would make all the ten postures. Yet, actually, how completely differ-

SCHEDULE 16

	A	B	C	D	E
Half Hour	Ex. 2: Gesture (25 drawings)	Ex. 2: Gesture (25 drawings)	Ex. 2: Gesture (25 drawings)	Ex. 2: Gesture (25 drawings)	Ex. 2: Gesture (25 drawings)
One Hour	Ex. 32: The Sustained Study, Nude (one study composed of three drawings)				Ex. 33: Study of the Bones (one drawing)
Quarter Hour	Rest	Rest	Rest	Rest	Rest
Quarter Hour	Ex. 2: Gesture (15 drawings)	Ex. 2: Gesture (15 drawings)	Ex. 2: Gesture (15 drawings)	Ex. 2: Gesture (15 drawings)	Ex. 2: Gesture (15 drawings)
One Hour	Ex. 32: The Sustained Study, Clothed (one study composed of three drawings)				Ex. 19 and 31: The Head in Pencil (one drawing)

Homework: Ex. 14 or 30: The Daily Composition; Ex. 34: The Long Composition (fifteen minutes a day for one week)

ent are the ways in which one man can squirm around on a chair and change his position ten times in half as many minutes.

You will need also to know the inanimate background of human activities, which helps to give character to the activity. Often I have asked students to draw from memory (with no artistic pretensions) the front doors of their own homes. In spite of the fact that they recognize their houses and are able to open their doors, they often do not know whether the door is panelled, what the trim around it is like, or even which side the knob is on. The artist should make an objective contact with all sorts of objects — and this contact is always to be made by paying attention to what the thing is doing.

During one of my former composition talks at the Art Students' League one of my students, who had had the typical college training in art, asked me to draw a perfect composition. My answer was, 'Of what?' He said, 'Oh, nothing in particular — just a plan for a perfect composition.' And I asked him, 'Doing what?' Then I explained to him and to the class that possibly the most important point I could make was that there is no such thing as a perfect plan for a composition isolated from factual conditions — idea, event, actors, background. I reminded the class that in all our exercises we begin with the objective impulse and, until we are completely familiar with people and things, we study no theories.

One terribly mistaken conception that I have found to exist in the minds of most art students is the idea that through some preconceived plan of design they can successfully reason out the action of a figure or a composition. Nothing could be further from the truth. Only to the extent that you are capable of allowing yourself to feel the action through your own sense of balance can you understand. The real way to get ideas or conceptions is through a practical experience in which the senses play a major part. If this part of your study — simple, first-hand observation — is done thoroughly and well, the so-called rules of composition will never trouble you seriously.

It can be said that the design of a painting (that is, its composition) is the element which insures its unity, and gesture is the unifying element. Without an awareness of the gesture there can be no understanding of the design or its reason.

You do not start with the rules of composition. You start with the gesture which gives the design. It is wrong to make a plan first and then fill the plan

with activity. The activity should come first. One sees murals in which workers are about to hit each other over the head with their pickaxes instead of hitting the earth. In such paintings the plan came first. The plan should grow out of the activity, out of what is happening. The pattern grows out of a concrete and actual condition.

No matter how interesting the mechanics of composition are, they lead you to nothing. You can cold-bloodedly create a composition with which there is no apparent fault, but what of it? Diagrams without a real objective search are meaningless, and that search must be touched by the thing called the creative impulse, which is willing at all times seemingly to destroy the rules. When you become self-conscious about rules, they impose limitations upon you. Just as certain expressive slang terms actually become part of a language, so new forms created by the painter take their place in art. You cannot govern the creative impulse. About all you can do is to eliminate obstacles and smooth the way for it.

EXERCISE 34: THE LONG COMPOSITION

This is a study on which you will spend not less than fifteen minutes or more than a half-hour a day. I suggest that you view it as homework, working every day and completing a composition each week regardless of how often your class meets. If that is impossible, take fifteen minutes out of each lesson, completing a composition with each schedule. Work entirely from memory, using a large piece of paper and pencil or, later, any medium you choose.

Begin by selecting a definite place which you can visit easily in the usual course of the day without making a special trip — for example, a drug store. On the first day do not attempt to memorize any particular things about the store or to analyze or understand it. Merely observe your reaction to it, your feeling about the place. Upon entering the drug store you are immediately aware that it has a different atmosphere from a grocery or any other kind of store. There must be something, or a combination of things, which creates this impression. These things might well be different for different people and it is not too easy to know what they are for you. Therefore, do not jump at a conclusion.

On the first day put down a record of these impressions just as you do in the daily composition. You will find that, while you have gathered a general

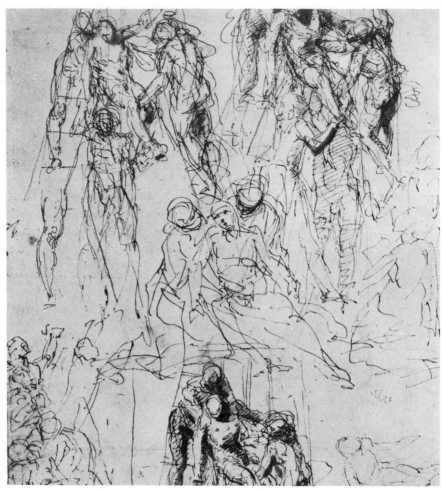

THE DEAD CHRIST BY VERONESE

*The long composition should
begin with the gesture.*

THE VISITATION BY RUBENS

And no 'life' is lost in the final thing.

impression, your drawing is apt to be weak when it comes to details and the precise connection of things. So you go back to the place the next day, understanding this weakness, knowing what to look for. Do not attempt to study too many details on one day — I should say not more than three. For example, on one visit to the drug store you might observe the exact contours of the syrup spigot and of a container on the fountain and one of the signs. Notice the gesture of each thing and from that sort of contact you will best be able to reconstruct its appearance.

After you have done this for some time, you will find by experience that the first things to note are the largest elements you have to deal with — the shape and proportion of the entire interior, the arrangement and pro- portion of the various counters, the relation of the entrance to the counters, the system of paying. The place has been planned in a certain way *for use*. The person who comes in buys what he wants and finds the cash register on his way out. The displays that he passes on the way out are probably so arranged as to make him buy bargains. An appreciation of what takes place in the store will make you more observant.

It is not necessary, nor is it possible in this exercise, to memorize the appearance of particular persons to be included in the composition. Having decided upon the posture or gesture of a person, study the details from other people that you see anywhere. If you are using the back view of a man standing at the cigar counter, you can study the back views of men stand- ing in railroad stations, on street corners, or elsewhere to note some specific detail, as how the coat collar fits, whether it allows the shirt collar to show, how high up on the neck or how close to the ears it comes, or whether the line of it turns up or down.

After working for two or three days you may find that your paper is getting so crowded with lines that it is difficult to go on drawing. If so, put a piece of tracing paper over it and continue on that. Try to keep the draw- ing flexible and plastic to the very end. It should maintain always some aspect of the gesture studies.

The time will come, several months from now, when you wish to introduce into the long composition the variation suggested in Exercise 30 for the daily composition. Then, you may start with a subject that is remembered or imagined, but keep in mind the purpose of this exercise, which is to give you an adequate knowledge of places and things. Start, as before, by build- ing up the entire composition within a short time, regardless of correctness

of details, thinking only of the gesture. You will discover as before that there are many facts to be used about which your memory is blurred and vague. This will point out to you what to look for. Then it is up to you to go every day, very conscientiously, to places where such facts and details may be studied, making observations and making the necessary corrections on your drawing.

Draw for fifteen hours as directed in Schedule 16.

STUDY FOR HANDS BY DÜRER
Compare Exercise 35.

Section 17

Exercises in Black and White Crayon

EXERCISE 35: THE SUSTAINED STUDY IN CRAYON

Materials: In addition to cream manila and tracing paper, you will need an HB drawing pencil for tracing the contour and a sheet of rough-toothed, medium gray paper, such as construction paper, or a cheap pastel or charcoal paper. The sheet may be fifteen by twenty inches in size or larger, as eighteen by twenty-four. For the modelling, use any two of the following (one black and one white) or all of them: a black Conté crayon, medium; a white Conté crayon, medium; a Wolfe carbon pencil, medium or soft; a white Conté pencil, medium; a piece of white blackboard chalk. Later you may substitute paper of various colors or brown manila wrapping paper for the gray paper.

SCHEDULE 17

	A	B	C	D	E
Half Hour	Ex. 36: Gesture in Black and White (25 drawings)	Ex. 36: Gesture in Black and White (25 drawings)	Ex. 36: Gesture in Black and White (25 drawings)	Ex. 36: Gesture in Black and White (25 drawings)	Ex. 36: Gesture in Black and White (25 drawings)
One Hour	Ex. 35: The Sustained Study in Crayon, Nude (one study composed of three drawings)				Ex. 33: Study of the Bones (one drawing)
Quarter Hour	Rest	Rest	Rest	Rest	Rest
Quarter Hour	Ex. 36: Gesture in Black and White (15 drawings)	Ex. 36: Gesture in Black and White (15 drawings)	Ex. 36: Gesture in Black and White (15 drawings)	Ex. 36: Gesture in Black and White (15 drawings)	Ex. 36: Gesture in Black and White (15 drawings)
One Hour	Ex. 35: The Sustained Study in Crayon, Clothed (one study composed of three drawings)				Ex. 19 and 35: The Head in Crayon (one drawing)

Homework: Ex. 14 or 30: The Daily Composition; Ex. 34: The Long Composition (fifteen minutes a day for one week); Ex. 37: Drapery in Black and White (optional).

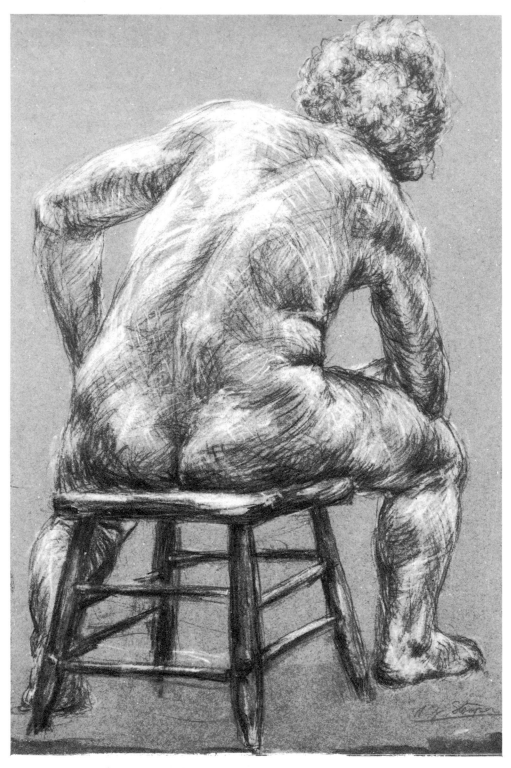

STUDENT DRAWING: THE SUSTAINED STUDY IN CRAYON

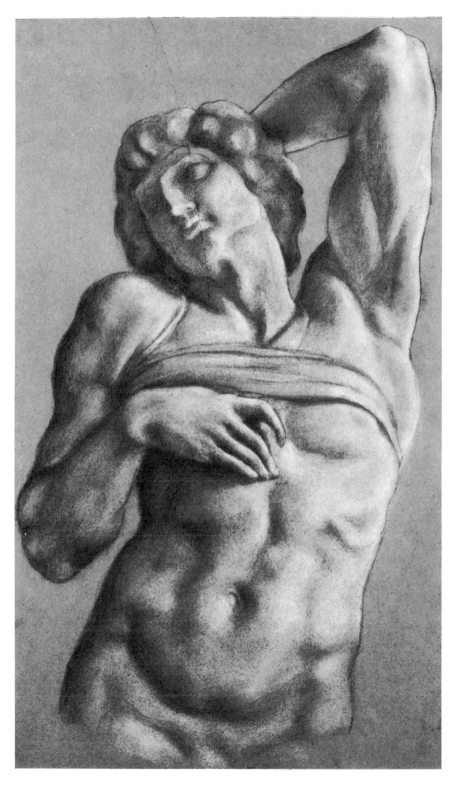

STUDENT DRAWING: THE SUSTAINED STUDY IN CRAYON

THE first two steps in this study are identical with those of the sustained study in pencil (Exercise 32) — an extended gesture study in pencil on manila paper and a contour study made over it on tracing paper. It then becomes necessary to transfer the contour to the gray paper. Do this by blacking the space around the lines on the back of your contour study with a Wolfe carbon pencil. (Do not use lead pencil for this purpose because the graphite would repel the carbon which you are to use later for modelling.) Then place the contour drawing right side up over the gray paper and go over the contours with the HB pencil, pressing hard enough for the lines

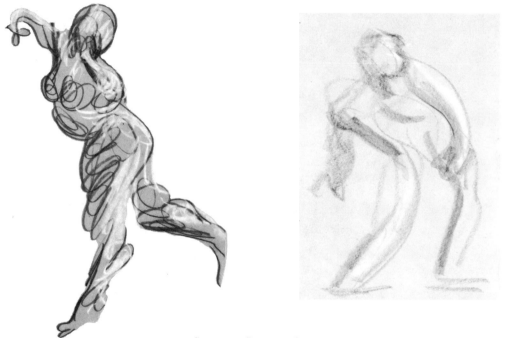

STUDENT GESTURE DRAWINGS

to show on the gray paper but not hard enough to make grooves in it.

The tracing is apt to become mechanical because, as you move your pencil over the lines, you lose consciousness of what those lines mean and are. This mechanical and diagrammatic look can be avoided if while tracing you hold to the feeling you had while making the original contour study, moving your pencil in the same sensitive, seeking, and slow manner. Even when

tracing, you can't make a swift line slowly or a slow line swiftly. The experience must be simultaneous with the drawing. When the tracing is finished, you will find that you have a clean-cut contour on the gray paper, the lines of which are in carbon pencil. Soften these lines with a kneaded eraser, or with art gum, so that it will be necessary to re-study them as you build up this drawing.

I have found that some students are more successful when they start modelling with the black crayon or pencil and others with the white. It is immaterial which you use in the beginning. Assume that you start with

 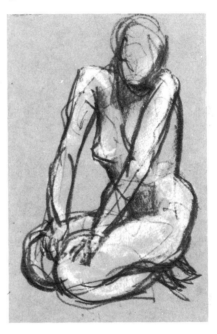

STUDENT GESTURE DRAWINGS

the black. Model just as you did in the modelled drawings except that now you model only the dark parts, remembering that you think of those parts, not as shadow, but as form moving in space. Then change to the white pencil or crayon and model those parts on which the light falls, with more feeling of what they are doing than of what the light is doing. Eliminate cast shadows.

You cannot remove the contour when you are through with it as you did in the pencil study. Therefore, it is continually necessary to relate the con-

tour, which is already on the paper, to the modelling, and the contour as it first existed will change. Sometimes you will find yourself pressing it back, sometimes erasing it or parts of it. In other words, to a certain extent you model the contour. All of this is done with the sense of making an actual physical contact with the model.

I have often found students to be self-conscious in the attempt to utilize

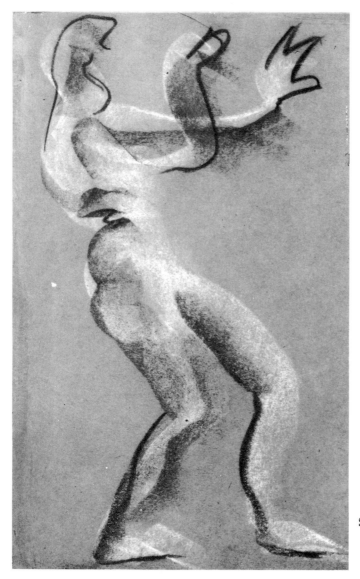

STUDENT GESTURE DRAWING

the gray of the paper, carefully leaving it as a middle tone between the light and the dark. When this happens, it means that the student has not understood the full meaning of the directions. He has not tied up this exercise with the experience of the modelled drawing. As the form comes toward you, you push less hard with the black crayon until finally you lift it. As the form goes away, you push less hard with the white crayon until you lift it. Where those parts meet the gray paper may show through in places, but there is no feeling that you have failed to touch the form there. You are not thinking of the drawing but of the model.

As you continue to go over the forms, trying to make them clearer, you may find yourself changing the crayon frequently. The black and the white may mingle or one may intrude into the area of the other. Do not be afraid of overworking the drawing.

EXERCISE 36: GESTURE IN BLACK AND WHITE

Materials: Use a black and a white Conté crayon (or charcoal and blackboard chalk) and a small piece of rough gray paper about ten by fifteen inches in size (or of dark brown manila wrapping paper which has sufficient tooth). As you proceed, use paper of as many different colors as you can acquire. (A cheap 'construction paper' may be bought in ten-cent stores or school supply stores.)

This exercise is the twin brother of our very first gesture exercise although we dress it a little differently. Go back to the first things we said about gesture, in Sections 1 and 2, and relate them to this exercise in the light of your present knowledge.

The model poses for a minute or less and you draw in a simple manner with the black crayon, seeking the impulse of the gesture, keeping the crayon on the paper and moving loosely from top to bottom and around. Change quickly to the white crayon and do exactly the same thing. After some practice make this one change: start with the white crayon and then proceed with the black.

Because you are using a white crayon and because parts of the body are lighter than others, you will be apt (and rightly so) to find yourself emphasizing those parts with the white crayon even while working in a simple manner. But there should be no conscious attempt to isolate the patches of white from the patches of black even if, as sometimes happens, large dark shadows

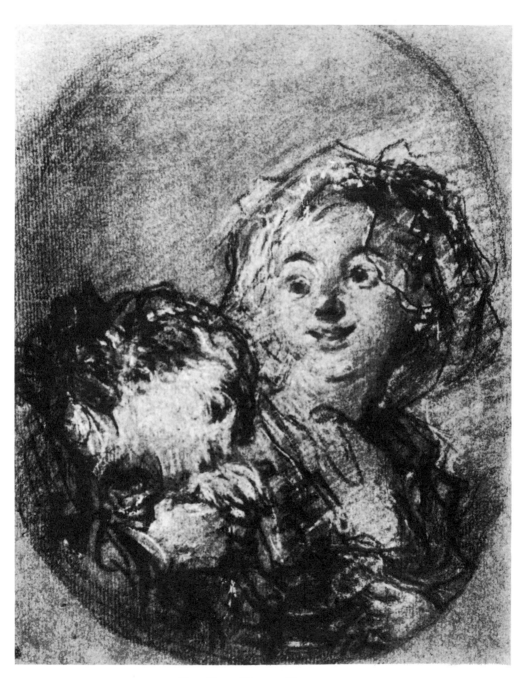

THE HAND KISS BY FRAGONARD

completely separate the lighted areas. This is not an exercise in light and shade. Continue to feel the unity of the body through the attempt to follow the gesture. This may sound contradictory but it is not. You are thinking of the whole gesture, the whole movement, but naturally, because you are using two colors, you will find yourself subconsciously influenced by the light and shade.

EXERCISE 37: DRAPERY IN BLACK AND WHITE

Using the materials listed in Exercise 35, make a long study of drapery on a piece of gray paper, using light and shade but always feeling the form. Devote to it as much time as you can and will outside of your regular work in the next three schedules.

Draw for fifteen hours as directed in Schedule 17.

Section 18
Studies of Structure

EXERCISE 38: GESTURE STUDIES OF ANATOMY

THESE are one-minute gesture studies which follow the directions for Exercise 2 with one new element. As you draw, still attempting to draw the *whole* figure, include some feeling of the movement of the bones within the figure. Record loosely the gesture of the spine, the general basket shape of the ribs, the basin of the pelvis, the ball of the skull, the wedge of the foot. Let the bones and the figure move as one thing.

EXERCISE 39: HAND AND ARM

Make a large fifteen-minute contour drawing of a hand and arm, including the elbow but not the shoulder. Put a piece of tracing paper over the drawing and spend the remainder of an hour in studying the bones of the

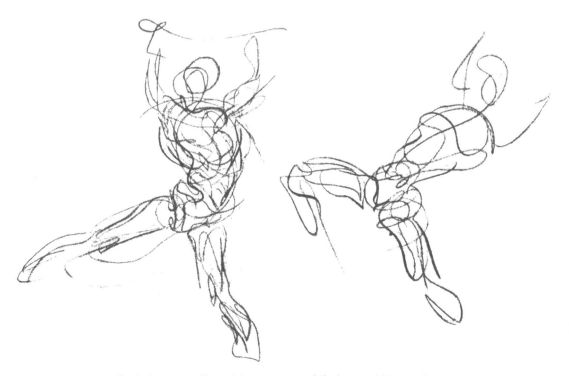

Include some feeling of the movement of the bones within the figure.

hand and arm with the help of your anatomy charts. Having drawn the bones from the front, you can put a new piece of tracing paper over the contour and draw a back view of the same bones.

When the hand turns, the elbow and the bone on the little finger side of the lower arm stand still, acting somewhat as an axis for the turn, while the thumb moves in a semicircular way. At the end of the turn the position of the hand is changed by the width of the hand. Prove this to yourself by placing your hand and arm flat on a table, palm up. Moving your arm as little as possible, turn the palm of your hand down. You will see that the little finger remains in practically the same place on the table while the thumb has changed from its first position by twice the width of the hand.

When the hand is held straight out, palm down, the top of the arm appears to overlap the hand whereas the bottom of the hand overlaps the arm. The bones from the wrist to the four knuckles vary in length, the bone to the middle finger being the longest. Therefore, the knuckle of the middle finger is highest when the fist is closed.

Draw for three hours as directed in Schedule 18 A.

SCHEDULE 18

	A	B	C	D	E
Half Hour	Ex. 36: Gesture in Black and White † (25 drawings)	Ex. 36: Gesture in Black and White (25 drawings)	Ex. 36: Gesture in Black and White (25 drawings)	Ex. 36: Gesture in Black and White (25 drawings)	Ex. 36: Gesture in Black and White (25 drawings)
One Hour *	Ex. 35: The Sustained Study in Crayon, Nude (one study composed of three drawings)				Ex. 19 and 35: The Head in Crayon (one drawing)
Quarter Hour	Rest	Rest	Rest	Rest	Rest
Quarter Hour	Ex. 38: Gesture Studies of Anatomy (15)	Ex. 38: Gesture Studies of Anatomy (15)	Ex. 38: Gesture Studies of Anatomy (15)	Ex. 38: Gesture Studies of Anatomy (15)	Ex. 38: Gesture Studies of Anatomy (15)
One Hour *	Ex. 39: Hand and Arm (2 drawings)	Ex. 40: The Shoulder Girdle (2 drawings)	Ex. 41: Leg and Knee (2 drawings)	Ex. 42: The Foot (2 drawings)	Ex. 43: The Eye Ex. 44: The Ear (4 drawings)

Homework: Ex. 14 or 30: The Daily Composition; Ex. 34: The Long Composition (fifteen minutes a day for one week); Ex. 37: Drapery in Black and White, continued (optional).

* Use the same pose, nude throughout. † Make gesture drawings of hands.

EXERCISE 40: THE SHOULDER GIRDLE

Make a large contour study of the back view of the figure, including only the portion from the neck to the waist line. Then study the bones of the shoulder.

The shoulder girdle is formed by the collarbone (clavicle) in front, and the shoulder blade (scapula) in the back with its attachment, the spine of the scapula, which is almost a separate bone. These bones should always be thought of together because they move together. The collarbone is very simple. It joins the breastbone (sternum) at the pit of the neck and extends across to the arm. The shoulder blade is shaped roughly like a triangle, slightly cupped over the ribs, with the inner side parallel to the spine. The outer side has a socket into which the armbone fits. The spine of the scapula is rib-shaped and slightly curved. It runs along the top of the shoulder blade and extends beyond it to a point near the end of the collarbone.

This you can see from your charts. The important thing to remember is that the movement of the arm controls the movement of the shoulder blade in this way: When the arm is lifted, the armbone pushes up the collarbone and the spine of the scapula, and this forces the bottom of the shoulder blade to swing out so that the inner side is no longer parallel to the spinal column. Ask your model to move his arms in various ways and watch this process.

The term 'shoulder girdle' arises from the fact that the collarbone in the front and the two spines of the scapula in the back form a 'girdle,' somewhat elliptical in shape, which encircles the shoulders. You will see this clearly if you can get up above your model and look down on the top of his head. The neck rises up from the center of this ellipse.

Draw for three hours as directed in Schedule 18 B.

EXERCISE 41: LEG AND KNEE

Make a large contour drawing of a leg, including the ankle and part of the hip. Then study the bones of the upper and lower leg and the knee.

The mark made by the top ridge or crest of the pelvic bone (ilium) is clearly seen and, because of this, beginners usually imagine it to be the starting place of the leg. The truth is that the bone of the leg starts lower down although certain muscles of the leg go up beyond the leg and are

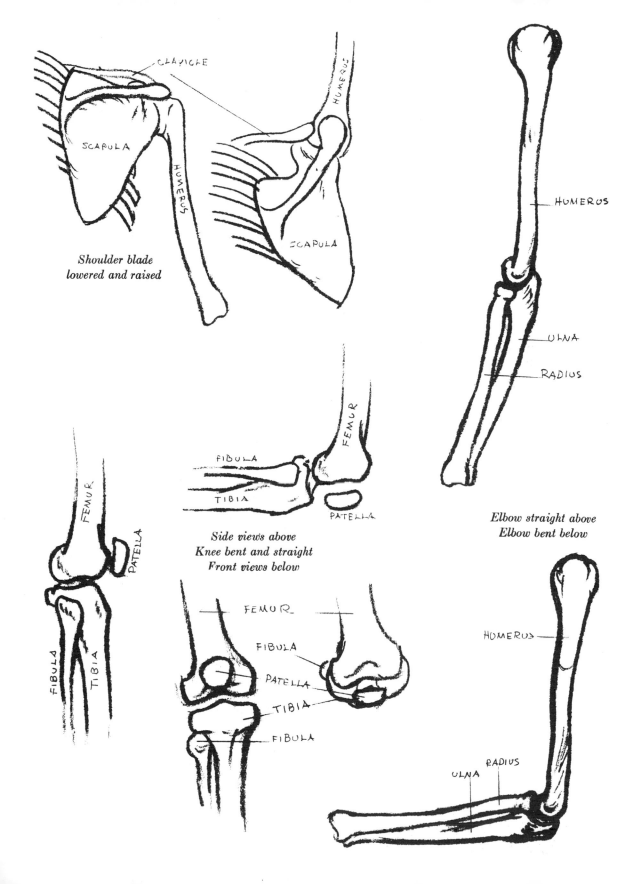

CLAVICLE

SCAPULA

HUMERUS

HUMERUS

SCAPULA

*Shoulder blade
lowered and raised*

HUMERUS

ULNA

RADIUS

FEMUR

FIBULA

TIBIA

PATELLA

*Side views above
Knee bent and straight
Front views below*

*Elbow straight above
Elbow bent below*

FEMUR

PATELLA

FIBULA

TIBIA

FEMUR

FIBULA

PATELLA

TIBIA

FIBULA

HUMERUS

ULNA

RADIUS

fastened under the crest of the pelvic bone. The bone of the upper leg slants inward from the pelvis to the knee whereas the bones of the lower leg are more nearly perpendicular. This seems obvious when you observe that the body is wider at the hips than it is at the knees. The bone of the upper leg (femur) is shaped at the top like a hammer that is striking into a socket in the pelvic bone.

The upper leg and the lower leg are interlocked at the knee, which is formed by the protuberances of the bone of the upper leg and of the large bone of the lower leg (tibia) with the addition of a separate bone, the knee-cap (patella). In a normal standing position the knee-cap is directly in front of the lower protuberance of the bone of the upper leg. It is held from above by the tendon of the big front muscle of the leg and from below by a ligament. The tendon may be thought of as a piece of rubber which can stretch, whereas the ligament may be thought of as a piece of leather which stretches very little. Obviously, when the leg is bent the tendon will give and the ligament will not, so the knee-cap must follow the lower leg.

The lower leg has two bones. The larger (tibia) is on the inner side of the leg and starts higher at the knee and stops higher at the foot. The smaller (fibula) starts lower at the knee and runs down lower at the foot. Therefore, the ankle seems higher on the inside than on the outside.

The lower leg is not set directly under the upper leg. From the front you see that it is set toward the outside. From the side you see that it is set toward the back. This offsetting of the bones creates a spring-like arrangement which acts as a shock absorber. If the lower leg were set directly under the upper leg, the shocks received by stepping and jumping would be transmitted from the foot in a straight line to the thigh. The thigh would not last very long, just as a wagon would not last very long if the wheel were fastened under it by a straight vertical rod instead of a spring. This principle of offsetting works throughout the body, even including the fingers.

Draw for three hours as directed in Schedule 18 C.

EXERCISE 42: THE FOOT

Make a large contour drawing of a foot and ankle and then study the bones of the foot.

The two bones of the lower leg grip the foot like a pair of ice tongs so that the foot appears to be set up into the leg. From the side you see that the foot is like an arch. The anklebone (astragalus), which is directly under the leg, is the keystone of the arch and supports the weight of the body. Behind that is the heel and in front are the long bones of the foot. These three make the arch.

Draw for three hours as directed in Schedule 18 D.

EXERCISE 43: THE EYE

Make two large fifteen-minute contour drawings of the eye, a front view and a side view.

The socket of the eye is simply a big hole in the skull. In that is placed the eyeball, of which only a small part is seen. The eyelids, upper and lower, rest on this ball and their form therefore follows it — that is, the lids move back from the center of the ball into the face and have a ball-like form, which is instantly obvious when the eyelids are closed. The upper lid has an awning-like movement. It is longer than the lower lid and extends farther out at the corners. The highest point of the curve of the upper lid is not directly opposite the lowest point of the lower lid because the upper lid follows the shape of the forehead while the lower lid follows the cheekbone.

EXERCISE 44: THE EAR

Make two large fifteen-minute contour drawings of the ear, a front view and a side view.

The ear fundamentally is a little funnel. Do not think of it, as many people do, as a kind of design stuck on the side of the head. Keep in mind the fact that all the little lines and forms are made to catch the sound and carry it around so that it enters the hole of the ear. All the channels lead into the funnel.

FUTURE STUDIES OF STRUCTURE. Our discussion of anatomy is not intended to take the place of any of the numerous books on anatomy which are in use. I am merely striking a few high points. These are points which dramatize the form and the movement. Using them as a guide, or an ex-

ample, you will proceed to concentrate on whatever part of the structure is puzzling you most in future study of the bones (Exercise 33). Never lose sight of the dramatic phases of the construction. Think of the bones in terms of what they enable the body to do.

Draw for three hours as directed in Schedule 18 E.

Section 19

Analysis Through Design

MOVEMENT AND CONTRAST. When I use the word *design* with reference to a drawing or painting, I mean simply that it has been organized in relation to movement. As there is movement in every act of nature, there must be the sense of movement in every work of art. It is the artist's task to attempt to understand, first in nature, then in his own field, this principle of movement.

Without contrast, and the understanding of contrasts, no sense of movement could be observed. In fact, without contrast there is no sense of existence. The world of existence revealed by the senses to the artist is a relative one. A thing is not soft unless you know hardness, not hot unless you know cold. This series of exercises (Sections 19 and 23) is planned to intensify the contrasts that are to be found in movement, form, and finally

SCHEDULE 19

	A	B	C	D	E
Half Hour	Ex. 45: Contrasting Lines (5 drawings)	Ex. 45: Contrasting Lines (5 drawings)	Ex. 46: Straight and Curved Lines (5 or 25 drawings)†	Ex. 46: Straight and Curved Lines (5 or 25 drawings)†	Ex. 46: Straight and Curved Lines (5 or 25 drawings) † ‡
One Hour	Ex. 35: The Sustained Study in Crayon, Nude (one study composed of three drawings) *				Ex. 33: Study of the Bones (one drawing)
Quarter Hour	Rest	Rest	Rest	Rest	Rest
Quarter Hour	Ex. 36: Gesture in Black and White (15 drawings)	Ex. 36: Gesture in Black and White (15 drawings)	Ex. 36: Gesture in Black and White (15 drawings)	Ex. 36: Gesture in Black and White (15 drawings)	Ex. 36: Gesture in Black and White (15 drawings)
One Hour	Ex. 35: The Sustained Study in Crayon, Clothed (one study composed of three drawings)*				Ex. 19 and 35: The Head in Crayon (one drawing)

Homework: Ex. 14 or 30: The Daily Composition; Ex. 34: The Long Composition (fifteen minutes a day for one week); Ex. 37: Drapery in Black and White, concluded (optional).

* Use paper of different colors. † Use both one-minute and five-minute poses for this exercise. ‡ Use group poses.

color. We do them only as exercises, the practice of which should lead to some of the fundamental laws of painting.

Go back to the most simple use of drawing — the line. There are contrasts between the long and the short, the broad and the narrow, but the greatest contrast in line is the difference between the straight and the curve. A line has no character by itself. Draw one line on a piece of paper. Is it short or long? You cannot say until you put another line of different length beside it. Then it becomes either long or short in comparison with the second line. Similarly, a line can seem curved in comparison with one line and straight in comparison with another, but for the present we will stick to the absolutely straight line, which we will contrast with a definite curve.

EXERCISE 45: CONTRASTING LINES

In the beginning, as a matter of pure exercise, draw a straight line to represent some contour on one side of the model. Then, attached to that, make a curved line. Continue up or down that side of the figure or object, alternating straight and curved lines and attaching each line to the one before it and the one after it. Proceed in the same way all around the figure, but, wherever there is a straight line on one side, try to put a curve opposite it on the other side. Use five-minute poses and always draw around the entire figure. These drawings will probably look like charts.

Draw for three hours as directed in Schedule 19 A.

As a natural result of practicing this exercise, you will begin to search the model in order to discover which contours may be best expressed by straight lines and which by curved lines. From now on, you do not have to make the straight follow the curve and the curve the straight. You will use each when it seems most suitable. However, the principle of alternation works pretty accurately and you should end up with approximately an equal number of straight and curved lines.

Draw for three hours as directed in Schedule 19 B.

EXERCISE 46: STRAIGHT AND CURVED LINES

This is a quick study, for which you may use sometimes a one-minute pose and sometimes a five-minute pose. As I have said before, there is only

HEAD OF A WOMAN FROM THE ESPOLIO BY EL GRECO
Select those lines which seem to intensify the meaning of the pose.

STUDENT DRAWING OF EXERCISE 46
Look for one movement either straight or curved that runs through the figure.

one reason for making quick studies — to make a contact with the gesture. You are to use straight and curved lines, but use them as a means of analyzing, even quickly, the gesture. This study is done concurrently with ordinary gesture drawing and each feeds the other. It will be only a short time before the impulse you receive from the natural gesture of the model will fuse with your arbitrary use of the straight or curved line.

First reach about in your drawing for the movements that are biggest, simplest, and most connected, thinking of them as either straight or curved. As you do this, strive to find one movement, either straight or curved, that goes through the entire figure. This line need not be continuously on the

contour but might start on the contour and then run inside of the body. It may sometimes include only the main part of the body or seem to divide into two lines, but on the whole try to see it as one line that will carry through the figure.

Assuming that you have found a dominating curve, you should immediately attempt to see some complementary straight lines. After these first simple straight and curved lines are found, they themselves may be gone over and broken up or subdivided but always with the impulse of the gesture. Bear in mind that there is no one absolute analysis to be made. Out of twenty studies of one pose you might make twenty different selections in its presentation. They could all be right provided your first im-

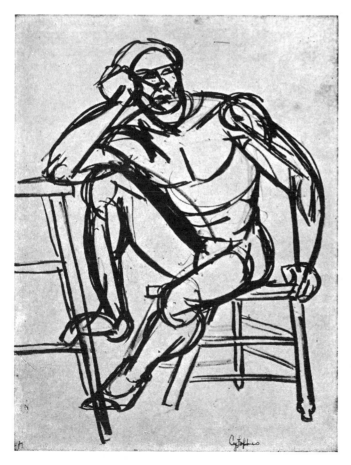

STUDENT DRAWING OF EXERCISE 46

pulse came from the gesture and provided you succeeded in establishing the necessary balance between the straight and the curve.

You are attempting something that might be called *simplification*, but I choose to call it *emphasis*. Try to select those lines, those forms, those rhythms, that speak specifically of the meaning of the whole gesture. A figure has one gesture. The parts are all there, but each plays a particular role — some the leading role, others a very secondary one. Others are silenced completely or become temporarily merged with other forms.

Draw for three hours as directed in Schedule 19 C.

MOTIF AND VARIATION. On one side of the form there is usually a simplification of movement which suggests the holding power of the form. The movement is less broken and much stronger, serving as a motif or theme. On the opposite side there is variation or relief, which prevents the motif from being monotonous and at the same time identifies it through contrast. The need for variation is expressed in the old sayings that variety is the spice of life, and all work and no play makes Jack a dull boy. You would lose the sense of a thing without variation, just as you lose the sense of a word when it is repeated over and over. Variation gives rest to the spectator, allows him to relax at times, just as he does in any other phase of life. It is like the comic relief in a serious play.

ACTION AND REACTION. If you exert force on an object, there is a reaction in exact proportion to the amount of energy acting, even though that reaction is not always observable. Press down with your arm on the table. Although the table cannot be said to move, actually it is pressing back (resisting) with an equal amount of force. Since it does not give, you think of it as being a force that reacts.

As you press against the table, the downward movement of the arm is indicated in various muscles and bones. The reacting force is also indicated as you will see if you compare the arm pressing against the table with an arm hanging limp. For example, the bone at the shoulder appears to be pushed up although the arm is pushing down. The flesh of the arm is pressed in by the table. It is impossible for the arm to take on the appearance of pressing unless the table is there to resist. In the forms that you see, the primary downward movement provides the motif while the reacting force provides the variation.

If there were not a reaction for every action, there would be destruction.

If the table were not able to resist the pressure of your arm, it would collapse. Likewise, in a drawing there must be such an equalization of forces.

Draw for three hours as directed in Schedule 19 D.

INTERLOCKING FORMS. In the moving figure, identical curves do not appear exactly opposite each other. If they did — or if you represented them in that way (Figure 1) — that part of the form would have a tendency to complete itself like a circle, thus destroying the continuity of the *whole* figure and preventing the eye from following the movement throughout it. These contours or forms are to be thought of as having an interlocking movement (Figure 2). Before the impulse of one has a chance to die out — in fact, at some place where it is reaching its crescendo of power — it is picked up by another and carried forward. Each impulse carries the momentum of the preceding one. (When you look at a diagram of a completely static or theoretical figure, you can see that the body is bilaterally symmetrical, having identical lines on the two sides. However, as soon as an actual figure moves — and we always think of the moving figure — this ceases to be apparent because movement is at work in the form.)

DESIGN VERSUS ORNAMENT. These exercises may seem awfully close to a certain kind of static pattern or decoration, but the difference is that we see the model *through the gesture.* When you think of design, think that the thing has been planned for a certain kind of *movement.* I never think of design as ornament. When you ornament a thing, you apply a substance or a treatment foreign to it after it is formed, whereas when you design a thing you organize it or plan it in the making. You change it by doing things to it — by cutting it down, moving it over, pushing it back.

As you do this, you are transposing facts to fit your needs of expression. These can be two separate things — they are. After a while the artist does this so instinctively that he thinks he is being perfectly natural. It becomes, after a while, the artist's way of seeing things, which is necessarily different from the layman's way of seeing things — a mechanic's or a scientist's. He sees them through the artist's medium.

Draw for three hours as directed in Schedule 19 E.

Section 20

Study from Reproductions

AN APPROACH TO THE STUDY OF PICTURES. An intelligent and active study of the great paintings of all times is absolutely necessary. Every great painter has taken advantage of it just as doctors and chemists take advantage of previous work in medicine and chemistry.

When you look at the finished work of a painter, you don't see all that has gone on behind the scenes. For the student, it is necessary to go behind the finished work and see the impulse from which it sprang. There is no such thing as starting where Cezanne, for example, left off. You have to start where Cezanne started — at the beginning — and you have to start with the same integrity and the same interest.

From a study of the established masters of painting try to squeeze the sap of life. Study not their manners but their motivation.

SCHEDULE 20

	A	B	C	D	E
Half Hour	Ex. 36: Gesture in Black and White (25 drawings)	Ex. 36: Gesture in Black and White (25 drawings)	Ex. 36: Gesture in Black and White (25 drawings)	Ex. 36: Gesture in Black and White (25 drawings)	Ex. 36: Gesture in Black and White (25 drawings)
One Hour	Ex. 35: The Sustained Study in Crayon, Nude (one study composed of three drawings)				Ex. 33: Study of the Bones * (one drawing)
Quarter Hour	Rest	Rest	Rest	Rest	Rest
Quarter Hour	Ex. 46: Straight and Curved Lines (15 drawings)	Ex. 46: Straight and Curved Lines (3 drawings)	Ex. 46: Straight and Curved Lines (15 drawings)	Ex. 46: Straight and Curved Lines (3 drawings)	Ex. 46: Straight and Curved Lines (15 drawings) †
One Hour	Ex. 35: The Sustained Study in Crayon, Clothed (one study composed of three drawings)				Ex. 19 and 35: The Head in Crayon (one drawing)

Homework: Ex. 14 or 30: The Daily Composition; Ex. 34: The Long Composition (fifteen minutes a day for one week); Ex. 47: Composition from Reproductions (one hour a week); Ex. 49: Analysis of Reproductions (optional).

* You may substitute Exercise 48 for the scheduled anatomy study at your own convenience.
† Use group poses.

An analysis of Raphael's Alba Madonna in 'Light and Dark' (Exercise 49A)
and of Titian's Diana and Callisto in 'Straight and Curved Lines' (Exercise 49C)

EXERCISE 47: COMPOSITION FROM REPRODUCTIONS

Materials: Inexpensive prints or any clear reproductions in books or magazines will serve for this exercise whether they are in black and white or color. In fact, they will serve better than large expensive reproductions.

Draw on your paper a small frame which approximates the shape of the reproduction. It should be small enough for a wrist movement to take in the whole — something less than four inches. The tendency is to make the drawing too detailed if it is too large.

Allow the eye and the pencil, more or less at the same time, to roam in a rather easy and casual manner wherever the movements, lines, forms, darks, and lights seem to beckon, with no attempt to delineate their meaning either with your pencil or in your mind. You are not to think of one form as a chair, another as a man, or another as a drapery. To you they are movements. Nor are you to think of the story of the picture. Be guided by and fastened upon the movement or — as we call it — the gesture of the entire picture.

You should be able to do six of these studies in something less than fifteen minutes and you should do six a day for four years. Whenever your own composition gets too fixed, which easily happens, do a few of them. If more convenient, work for an hour once a week instead of ten or fifteen minutes a day. Take one painter at a time, studying each for a week. Begin with the works of Rubens, Matisse, Tintoretto, Degas, Giotto, Daumier, El Greco, Forain, Rembrandt (especially drawings) and Van Gogh. Thereafter choose as you like, alternating more recent with earlier painters.

Draw for six hours as directed in Schedule 20 A and 20 B.

EXERCISE 48: ANATOMY FROM REPRODUCTIONS

Materials: Use reproductions showing the nude figure and approximating if possible the size used for your sustained studies. (Prints may be enlarged cheaply by photostat process.)

Place a piece of tracing paper over the print and work exactly as you do in other anatomy exercises where you use your own contour drawing. As

a starting point I suggest Michelangelo, Rubens, Leonardo, Titian, Raphael, Tintoretto, Signorelli, Dürer.

Draw for six hours as directed in Schedule 20 C and 20 D.

EXERCISE 49: ANALYSIS OF REPRODUCTIONS

Exercise 47 can be enlarged upon as time goes on in the following ways. (A) Taking three or four of these gesture compositions and the reproductions from which they were made, spot in very freely and in a somewhat connected manner the dark parts. Don't draw static or separated shadows, but feel their movement in a general way. (B) Take one of these gesture compositions and turn it upside down. Without looking again at the reproduction, use the gesture that is on the paper as a starting point and make over it a new drawing of something you have recently seen or done. Continue with ink if the pencil becomes too black. (C) In the same manner in which you attempted to experience the figure in Exercise 46, analyze the composition in straight and curved lines. Allow the gesture of the reproduction to act as the impulse.

Draw for three hours as directed in Schedule 20 E.

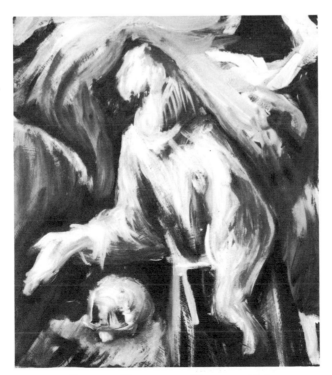

STUDENT DRAWING OF EXERCISE 49 A
*An analysis of the 'Lights and Darks' in El Greco's
Saint Francis (in black and white oil color)*

Section 21

The Muscles

How the Muscles Work. Muscles are like rubber bands — they can pull but they cannot push. Therefore there must be two sets of muscles for every motion — one set to pull out and another to pull back. The two sets are placed more or less opposite to each other and while one pulls the other is relaxed. Likewise, in twisting, there is one set of muscles to twist to the right and another set to twist to the left.

The muscles are attached to the bones and operate on the bones, pulling them back and forth. Although we speak of muscles as if they belonged to one bone, as 'muscles of the upper arm,' actually they belong to two. A muscle could not do anything if it existed only on one bone. The muscle that pulls the forearm up could not pull if it were not attached to the upper arm too.

S C H E D U L E 2 1

	A	B	C	D	E
Half Hour	Ex. 36: Gesture in Black and White (25 drawings)	Ex. 36: Gesture in Black and White (25 drawings)	Ex. 36: Gesture in Black and White (25 drawings)	Ex. 36: Gesture in Black and White (25 drawings)	Ex. 36: Gesture in Black and White (25 drawings)
One Hour	Ex. 35: The Sustained Study in Crayon, Nude (one study composed of three drawings)				Ex. 33 and 50: Study of the Bones and Muscles * (2 drawings)
Quarter Hour	Rest	Rest	Rest	Rest	Rest
Quarter Hour	Ex. 46: Straight and Curved Lines (3 drawings)	Ex. 46: Straight and Curved Lines (15 drawings)	Ex. 46: Straight and Curved Lines (3 drawings)	Ex. 46: Straight and Curved Lines (15 drawings)	Ex. 46: Straight and Curved Lines (3 drawings) †
One Hour	Ex. 35: The Sustained Study in Crayon, Clothed (one study composed of three drawings)				Ex. 19 and 35: The Head in Crayon (one drawing)

Homework: Ex. 14 or 30: The Daily Composition; Ex. 34: The Long Composition (fifteen minutes a day for one week); Ex. 47: Composition from Reproductions (one hour a week).

* Devote approximately a half hour to each exercise with the model posing nude. As you progress, concentrate on first one part of the figure and then another. † Use group poses.

At every point of the body where twisting is possible, such as the neck, the forearm, and to a less extent the lower leg and the waist, the muscles are arranged so that instead of going straight down or straight across they have a diagonal movement. For example, the muscles which turn the hand over are attached to both the elbow and the hand and move around the forearm with a movement similar to the lines on a barber's pole.

In studying muscles, the important thing is to study *how they work*.

As an example of the kind of study I mean, let's take a look at the deltoid or shoulder muscle. (Keep the charts of that muscle before you as you read this.) To understand the manner in which the arm is held to the torso at the shoulder, imagine that you are making a doll out of wood. Take one block of wood for the upper section of the torso and a smaller rectangular piece for the upper arm. Cut off the top corners of the block representing the torso and place the arm against the angle thus cut out as in the diagram. It now becomes necessary to fasten the two pieces together, so you nail a strip of leather on top of the torso, pull it down across the top of the arm, and nail it to the outside of the arm. You see, however, that this will not keep the arm from slipping forward or backward out of place. You need a piece of leather that is somewhat caplike in form, having a flap at the front and the back to cover these openings. And that is essentially the way the deltoid muscle is constructed. To pull the doll's arm forward you would need a piece of rubber from the front of the torso to the arm. This represents the chest (pectoral) muscle, one for the right arm and one for the left. On the back the same thing is accomplished by the latissimus dorsi, which grips the torso and grips the arms, pulling the arms back.

EXERCISE 50: STUDY OF THE MUSCLES

Place a piece of tracing paper on top of your drawing of the skeleton (Exercise 33) and, from the charts and the model, study the muscles. The most important thing is to show the attachment of each muscle to the bone. In drawing the leg muscles, for example, you should show that the biceps of the upper leg separates into two tendons which reach around and grip the big bone of the lower leg, leaving an opening through which the calf

muscle extends to grip the bone of the upper leg. The lower tendon of the calf muscle grips the heel. The arrangement of these muscles on the back of the leg is a perfect example of the overlapping which occurs throughout the body.

Because of this overlapping you should draw only a limited number of muscles in one study. For example, since the deltoid covers the place where the biceps is attached to the bone, you might draw the biceps on one arm and the deltoid on the other, showing the whole of each muscle. Any number of studies may be made over the same drawing of the skeleton, each having a different choice of muscles.

On a front view of the figure you see, not only the muscles of the front, but parts of the muscles of the side and back as well. An important example of this is the trapezius muscle, a part of which is visible in the front view of the shoulder although it is a muscle of the back. Likewise, from the side you see muscles of the front and back and from the back you see muscles of the side and front. It is necessary to remember this when trying to correlate the figure and your drawing with anatomical charts because you see forms on the figure that are muscles from another side. You should not think of the front of the body as if it were distinctly separated from the sides like the front of a box.

Neither should you think of the muscles as separated from the rest of the body except for the purpose of study. In drawing the figure the muscles should never be so overplayed that the actual main form is lost. For example, when you study the muscles of the neck, you observe that they are very different in the front and the back. In the front the bonnet-string muscles of the neck (sternomastoid) are seen to extend from behind the ear down to the pit of the neck, whereas the trapezius muscle of the back reaches all the way up to the base of the skull. The study of these muscles may have a tendency to break up the form

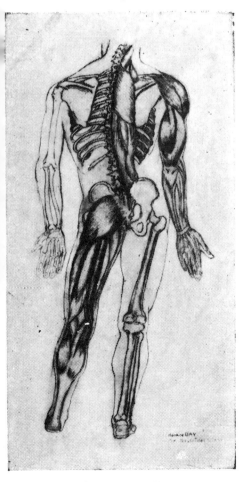

STUDENT DRAWING OF EXERCISE 50

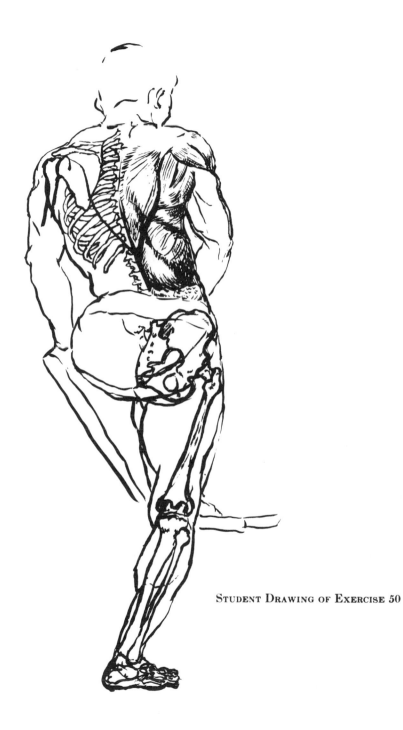

STUDENT DRAWING OF EXERCISE 50

of the neck in your mind, but the important way to think of the neck is
as a cylinder that rises from the shoulders to support the head like a ped-
estal. It is the unit that locks into the head and into the shoulders, and it
moves as a unit without ever losing this simple cylindrical form.

Draw for fifteen hours as directed in Schedule 21.
If possible, repeat Schedule 21.

STUDENT DRAWING OF EXERCISE 50

Section 22

Exercises in Black and White Oil Color

EXERCISE 51: SUSTAINED STUDY IN OIL COLOR

Materials: In addition to cream manila and tracing paper, you will need a sheet of dark brown manila wrapping paper (about fifteen by twenty); two tubes of oil color — zinc white or titanium white and any good black; two long-haired flat bristle brushes, about a quarter of an inch and three-quarters of an inch wide; a cheap palette; a palette knife; rectified turpentine, which you will put into an oil cup or small jar; a supply of clean rags about five inches square. (The brown paper is far cheaper than canvas or board and serves better for this exercise. Oil studies on brown paper will prove durable if mounted on prestwood or heavy cardboard.) Always wash the brushes thoroughly after use, first with turpentine or kerosene and then with soap and water.

SCHEDULE 22

	A	B	C	D	E
Half Hour	Ex. 52: Gesture Drawing in Oil (5 drawings)	Ex. 53: Half-Hour Study in Oil (one)	Ex. 52: Gesture Drawing in Oil (5 drawings)	Ex. 53: Half-Hour Study in Oil (one)	Ex. 52: Gesture Drawing in Oil (5 drawings)
One Hour	Ex. 51: Sustained Study in Oil Color, Nude (one study composed of three drawings)				Ex. 33 and 50: Study of the Bones and Muscles (2 drawings)
Quarter Hour	Rest	Rest	Rest	Rest	Rest
Quarter Hour	Ex. 46: Straight and Curved Lines (15 drawings)	Ex. 52: Gesture Drawing in Oil (3 drawings)	Ex. 46: Straight and Curved Lines (3 drawings) *	Ex. 52: Gesture Drawing in Oil (3 drawings)	Ex. 46: Straight and Curved Lines (15 drawings)
One Hour	Ex. 51: Sustained Study in Oil Color, Clothed (one drawing)				Ex. 19 and 51: The Head in Oil (one drawing)

Homework: Ex. 14 or 30: The Daily Composition; Ex. 34: The Long Composition (fifteen minutes a day for one week); Ex. 47: Composition from Reproductions (one hour a week).

* Use group poses.

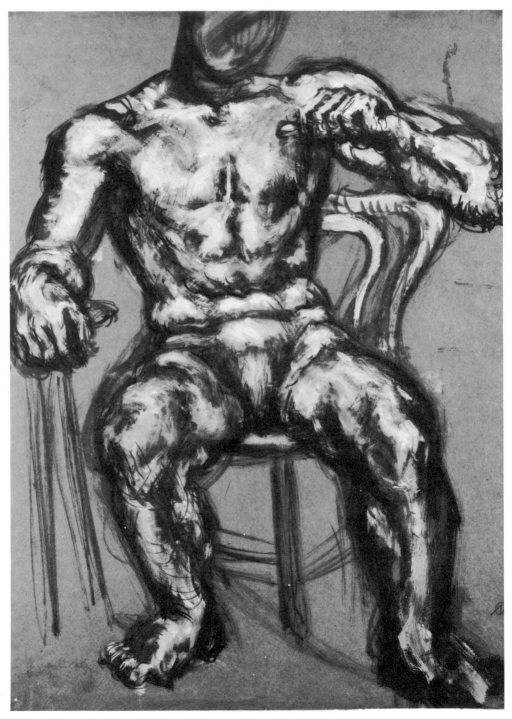

STUDENT DRAWING: THE SUSTAINED STUDY IN OIL

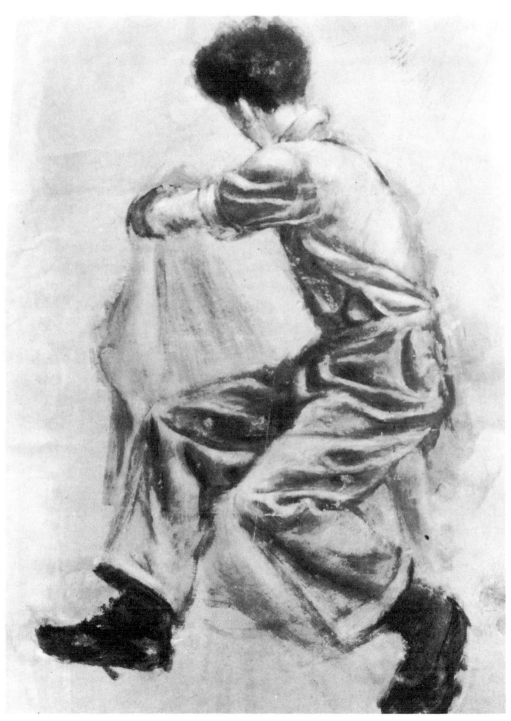

STUDENT DRAWING: THE SUSTAINED STUDY IN OIL

MAKE an extended gesture study of the nude pose in pencil on cream manila paper and over it a contour study on tracing paper. Then transfer the contour to the brown paper just as you did previously to the gray paper. (The extended gesture study of the clothed pose may be made in pencil directly on the brown paper and then worked over with paint.)

This study is like the sustained study in black and white crayon, the only new problem being the technical one involved in the use of the paint. The most important technical consideration has to do with getting rid of the excess oil in the paint. First squeeze a portion out of the tube on to a small piece of paper and spread it with a palette knife. As the paint rests there, the oil is absorbed by the paper. To what extent the paint should be dried in this manner is a matter of individual choice, but my advice is to err on the side of dryness. (You can always add linseed oil if it gets too dry.) When the paint is in the right condition, you can work almost as if you were drawing with chalk.

There are many artists who prefer working with a very oily medium and the experienced artist is, of course, quite capable of making a choice. But in every case that I have ever seen the wetness of oil paint has been the main technical handicap among students. The tendency of one color to spread into another, the tendency of the paint to run beyond the areas it was intended for, the difficulty of putting one color over another without having the two mix and become muddy are all due to the excessive amount of oil that is in the color as it comes from the tube. Before the advent of commercial tube colors painters mixed their own powdered color and they mixed it according to taste. By drying out the color you can alter the consistency to that which gives you the best results.

When the paint is dry enough to be moved on the drawing without sloshing around and getting out of control, proceed to draw with it in much the same manner that you drew with the black crayon and the white crayon (Exercise 35). Don't try to mix the black and white on your palette or on one brush, but use one brush for white and the other for black, working first with one and then with the other as you did with the crayons. Don't dig the brush down into the paint, but get a 'gob' of sticky paint on the end of it and paint almost with the paint rather than with the brush. Drag the paint along, feeling that it is actual substance (not tone or color) and applying it thickly. Use the turpentine to keep your brushes from getting gummed up, but don't let it mix with the paint because it would then counteract the drying-out process.

ST. CHRISTOPHER BY TITIAN

The paint becomes the best medium for the study of drawing when used correctly.

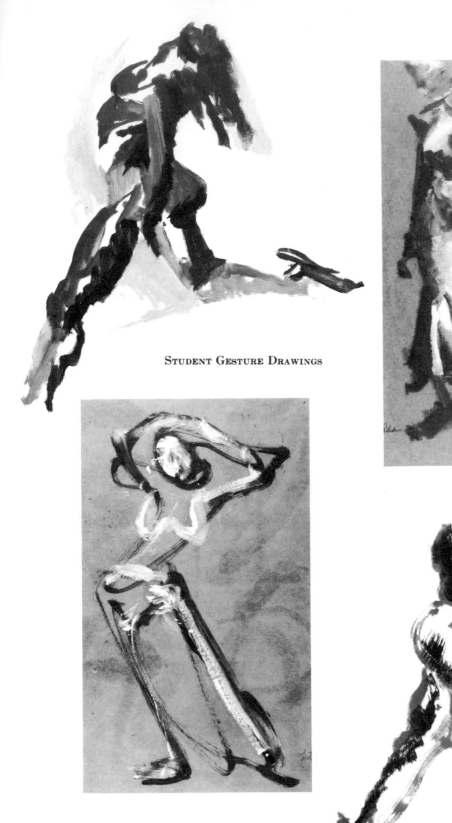

STUDENT GESTURE DRAWINGS

Feel that you touch every part of the form. Because the brush is broader than the crayon, you may feel that you are touching more of the surface at once. This is like the difference between the modelled drawing in lithograph, when you used the side of the crayon, and the modelled drawing in ink.

The paint becomes the best medium for the study of drawing when used correctly. These directions are given only as a starting point to help you feel that you are really drawing, not with any idea of teaching you a way of 'handling paint.' If you painted steadily for eight months, I couldn't keep you from learning to handle paint even if I tried. The secret, if it is one, is to be so completely interested in studying the model that the paint just follows. Forget that you are drawing or painting and feel that you are using this medium to reach out and touch the model.

EXERCISE 52: GESTURE DRAWING IN OIL

This is a five-minute study that is like the gesture study in black and

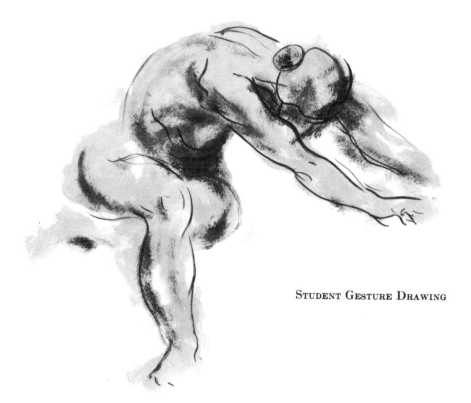

STUDENT GESTURE DRAWING

STUDENT GESTURE DRAWINGS

white crayon (Exercise 36) except that you use black and white oil color on a large sheet of brown paper. Since you must work quickly, do not dry out the color before using it.

EXERCISE 53: HALF-HOUR STUDY IN OIL

Start with a gesture study (Exercise 52) and proceed to work for a half hour with something of the feeling of the modelled drawing (Exercise 7) and the extended gesture study (Exercise 31).

Draw for fifteen hours as directed in Schedule 22.

Section 23

Analysis Through Design — continued

EXERCISE 54: THE PREDOMINATING SHAPE

THIS is another one-minute or five-minute gesture study making use of straight and curved lines. Instead of starting with one line that runs through the entire figure, as in Exercise 46, start with what seems to you to be the predominating two-dimensional shape. This shape may be suggested by the whole figure (for example, a squatting figure may have the general shape of a triangle) or by a part of the figure that is important in the pose (when the model ties his shoe, the bent shoulders and the arms may suggest an oval). Having decided on this first shape, add to it or break it up with other straight or curved lines suggested by the pose, continuing just as you do in Exercise 46. It is not necessary to make your shapes exactly geometri-

SCHEDULE 23

	A	B	C	D	E
Half Hour	Ex. 52: Gesture Drawing in Oil (5 drawings)	Ex. 53: Half-Hour Study in Oil (one)	Ex. 52: Gesture Drawing in Oil (5 drawings)	Ex. 53: Half-Hour Study in Oil (one)	Ex. 52: Gesture Drawing in Oil (5 drawings)
One Hour	Ex. 51: Sustained Study in Oil Color, Nude (one study composed of three drawings)				Ex. 33 and 50: Study of the Bones and Muscles (two drawings)
Quarter Hour	Rest	Rest	Rest	Rest	Rest
Quarter Hour	Ex. 54: The Predominating Shape (3 or 15 drawings) *	Ex. 52: Gesture Drawing in Oil (3 drawings)	Ex. 55: Modelling the Straight and Curve (3 drawings)	Ex. 52: Gesture Drawing in Oil (3 drawings)	Ex. 56: Straight and Curve in Frames (one drawing)
One Hour	Ex. 51: Sustained Study in Oil Color, Clothed (one drawing)				Ex. 19 and 51: The Head in Oil (one drawing)

Homework: Ex. 14 or 30: The Daily Composition; Ex. 34: The Long Composition (fifteen minutes a day for one week); Ex. 47: Composition from Reproductions (one hour a week).

* Use both one-minute and five-minute poses for this exercise.

cal. They may be somewhat irregular. Beware of using a circle, for it **tends** to isolate or conclude itself, and things should never be isolated.

Draw for six hours as directed in Schedule 23 A and 23 B.

EXERCISE 55: MODELLING THE STRAIGHT AND CURVE

This is a continuation of Exercise 46, so begin by making a gesture drawing in straight and curved lines, using lithograph crayon. Then model **the** drawing. Use five-minute poses at first, lengthening them gradually **to a** half-hour or more.

The way of modelling is necessarily indefinite. The most exact direction I can give is this — just as your straight and curved lines do not follow the

Be selective — do not try to model all of the form. (*Exercise 55*)

contour as it exists but heighten the meaning of the contour in relation to gesture and design, so your modelling does not follow the form exactly as it exists but seeks to heighten the meaning of the form. Do not try to model all of the form, just as with straight and curved lines you do not try to draw all the contours, but be very selective. Choose those surfaces to model that intensify the meaning of the pose. Model them with two aims. One is to describe or to emphasize the form and the other is to create on your paper

STUDENT DRAWING OF EXERCISE 55

a well-balanced design based on the gesture of the model. Those were also your aims in putting down the straight line or the curved line.

It would be a mistake for me to try to pin this down to a particular method. You must be given a certain amount of leeway because your drawing will develop out of your own feeling and understanding if you are not too much limited. Some of my students have more completely filled the space between the outside edges of the figure and have done it successfully, while others have left considerably more blank space. Either could be correct. You may go through one way of working and come to the other.

Remember the existence of what is underneath the planes which appear. The sense of substance should always be in your consciousness and, naturally, in your drawing.

If you are at a loss as to how to begin modelling, I suggest that you simply draw a few cross-contours or vertical contours on the figure and start filling in the space near or between those lines. But do not fill in all the space. Jump from one place to another, seeking to intensify the gesture. One way to progress in this exercise is not to look too often at the model. When you do look, look to see the gesture — hardly know that you are looking at the parts. You will find yourself selecting, saving, those forms which are most affected by the gesture. Add whatever lines seem necessary for the simple emphasis of your first impulse. This should be no cheap imitation arrived at by conscious distortion, but an effort to comprehend the gesture in a fresh way.

Draw for six hours as directed in Schedule 23 C and 23 D.

EXERCISE 56: STRAIGHT AND CURVE IN FRAMES

Draw on your paper several frames of various shapes and proportions — square, rectangular, round, triangular, et cetera. Start in a somewhat haphazard way with one of the smaller details of the figure. For example, you may begin by selecting the inner line of the model's shirt collar as a curve which you decide to place in the upper left-hand corner of the square. Having this arc moving down from the left-hand corner in a square, you are now

STUDENT DRAWING OF EXERCISE 55

STUDENT DRAWING OF EXERCISE 55

presented with a dual problem: (1) looking at the model and deciding what can be turned into a curve and what into a straight line; (2) relating the next line you choose to the square and to the curved line which is now in the square.

You immediately see in relation to the second problem (that is, of continuing to fill the square) that you must move at some time or other diagonally across to the lower right-hand corner. It is instinctive to find yourself selecting from the model the line that will most quickly carry the movement in that direction. Therefore, you may skip the shoulder and select next the line of the arm from the shoulder down. The reason you do this is that the

diagonal unifies. Any engineer would recognize this principle — you see it in steel girders and in the simple architecture of country barns. When you start with a four-sided piece of paper, your first effort is to hold these four sides together, and this can be done with the least waste of effort by a diagonal movement. A perpendicular line down the middle of the paper would divide it instead of pulling it together.

Having solved this problem, you must choose a third line which is related to the square and to the two lines that are now in it. No matter how you see the space, the things in it are to fill it and fill it in a pictorial manner. Continue selecting lines in this way during a fifteen-minute or half-hour study. The drawing may be made from anything you happen to look at — your own hand, a clump of bushes, any part of the figure, a group pose. The subject will probably not be recognizable in the drawing. When you become accustomed to the exercise, begin to make use of modelling.

Obviously, your selection of lines cannot be exactly the same when you begin to work in a triangle or circle instead of the square. This exercise is planned to help you see the figure or the event in what might be called its more abstract relationship to the paper. It enables you to see the model in a new way, from a fresh point of view, as if you looked at it through a

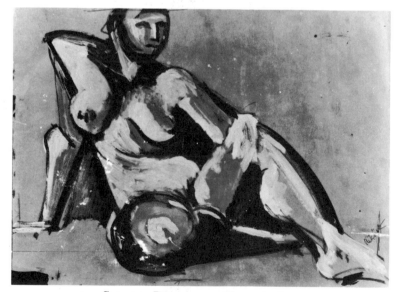

STUDENT DRAWING OF EXERCISE 55

AFRICAN NEGRO SCULPTURE: WOODEN MASK
*You will find yourself selecting, saving, those forms which are most
affected by the gesture.*

[204]

new pair of glasses after wearing a pair that did not suit. (Take one of these drawings, turn it upside down, and make a scribbled gesture drawing of another subject over it. This will give you further understanding of the way the lines relate to each other and the paper.)

THE PATH FOR THE EYE. As you fill the paper, you build a path for the eye. The line moves in a certain direction and the eye follows it. As the eye comes toward the end of a line, it is caught by another line which moves farther or turns and travels in another direction. You make the eye follow exactly where you want it to follow. You let it stop and linger in places, move it swiftly at other places, and bring it sometimes back again. In building this path, you naturally choose the lines (or the forms or colors) which best indicate the movement you intend, that movement being dictated by the gesture of the model.

The straight line in general suggests more strength than the curve because it moves more quickly from point to point, so the strongest movement is apt to be a straight line.

Sometimes when you have made a straight line for the sake of the gesture or in contrast to other lines, you find that its movement is too strong, that it carries the eye too quickly. You wish to invite the eye to linger a little. Then you can slow the movement down by cutting across it with lines which do not necessarily exist in the model (Figure 1). In other words, the way of slowing up the eye is to force it to turn at times in different directions from

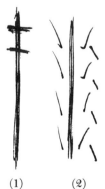

the main movement. This principle is often made use of in stores by the placing of counters and signs, and on the stage by the physical movement of the actors. Similarly, you can step up a line by making arrows alongside it and you can slow that up by making other lines in opposition to the arrows (Figure 2). These principles are to be found in all good composition although we isolate them for the moment.

Draw for three hours as directed in Schedule 23 E.

(1) (2)

Analyze some of your own quick compositions (Exercise 14) in straight and curved lines.

Section 24

The Subjective Element

THE RELATIONSHIP OF EXPERIENCES. Every fresh experience is related, whether consciously or not, to some past experience. To say that in a practical way for the art student: When you first see a new model, something about that model — whether the pose or the figure or the shape of the nose or the color of the hair — immediately reminds you of something else that you have seen. This happens whether you will it or not. Naturally this memory of the other person or thing has a tendency to influence, to color, what you see now. This is as it should be and only the student with a rigid academic training would completely overcome this tendency. An over-emphasis of the immediate experience (that is, of the objective) would tend to isolate it from everything else we know. There must always be something of the subjective. It is these relationships of our experiences — our ability to relate them — that make each of us a complete entity. This

SCHEDULE 24

	A	B	C	D	E
Half Hour	Ex. 52: Gesture Drawing in Oil (5 drawings)	Ex. 53: Half-Hour Study in Oil (one)	Ex. 52: Gesture Drawing in Oil (5 drawings)	Ex. 53: Half-Hour Study in Oil (one)	Ex. 52: Gesture Drawing in Oil (5 drawings)
One Hour	Ex. 51: Sustained Study in Oil Color, Nude (one study composed of three drawings)				Ex. 33 and 50: Study of the Bones and Muscles (two drawings)
Quarter Hour	Rest	Rest	Rest	Rest	Rest
Quarter Hour	Ex. 46: Straight and Curved Lines * (15 drawings)	Ex. 52: Gesture Drawing in Oil (3 drawings)	Ex. 55: Modelling The Straight and Curve (one drawing)	Ex. 52: Gesture Drawing in Oil (3 drawings)	Ex. 56: Straight and Curve in Frames (one drawing)
One Hour	Ex. 57: The Subjective Study (one)	Ex. 51: Sustained Study in Oil Color, Clothed (one drawing)			Ex. 19 and 51: The Head in Oil (one drawing)

Homework: Ex. 14 or 30: The Daily Composition; Ex. 34: The Long Composition (fifteen minutes a day for one week); Ex. 47: Composition from Reproductions (one hour a week).

* Sometimes substitute or incorporate Exercise 54.

exercise attempts to utilize these relationships in connection with the study of art.

EXERCISE 57: THE SUBJECTIVE STUDY

When you look at the model or at what the model is doing, attempt to visualize the thing or person that the model or the pose reminds you of. You may find this difficult in the beginning. You are apt to have a great many different thoughts that do not seem at all related either to the model or to one another, but no matter how far-fetched your thought is, or the object that you visualize, it is bound to have been at least partially influenced by the present experience, that of looking at the model. It is quite possible, because the effort is necessarily a little self-conscious in the beginning, that you won't be able to formulate any thoughts relating to the model, that your mind will seem a blank. If so, then deliberately think of something. It may be a fish or a horse or a flower. While it is apparently a forced idea, it too is necessarily influenced by the model. So put down whatever you think of, no matter how you manage to think of it, using any medium you choose. It acts as a starting point.

Looking back and forth from this starting point to the model, go on adding other things, some of them suggested by the starting point and some by the model. It may seem that you get no suggestions from the model. Nevertheless, if you continue to look at the model and back again at the drawing, you may rest assured that a certain amount of the impulse will come from each. And a certain amount of it will come from whatever experiences you have had, what has happened to you during the day, what is going on around you, the conditions of your drawing material, the very sounds in the room or coming in from outside, whether you are conscious of hearing them or not. In the beginning we said that correct observation utilizes as many of the senses as can reach through the eye at one time. In the beginning we emphasized most the sense of touch. This exercise can bring into play hearing, taste, and smell to an equal degree.

This study is much like the word-association test used in psychology, in which you call a word and have the hearer give his immediate reaction with another word. A new model walks into the studio and takes a pose. The first form or shape that flashes into your mind (which can be put into a word) is a fish. You put down a drawing of a fish. If this were a word-association

test, it would work somewhat in this manner. The fish makes you think of a fishline and the fishline makes you think of a boat. The boat is one with funnels out of which smoke is coming. The smoke makes you think of fire and the fire makes you think of destruction and falling objects.

But weaving the model into this train of thought tends to change it. For example, it happens that the model makes you think of a fish. You draw a fish and *then glance back at the model*. The model has a petulant mouth which makes you think of a circle, but when you glance back to the paper on which the fish was drawn, the circle evolves into a net. As you glance back at the model, you carry the impulse of the net, which causes you to look, let us say, at the model's hair. The hair, yellow and smooth and silky, makes you think of wheat. But as you carry this impulse back to the drawing of the fish with the net, it becomes merged with the idea on your paper and the wheat becomes seaweed. Of course, it might become something else. This is merely an example. No mind can tell how another mind will work. I cannot look into another mind, nor can a person look into his own mind for something that has not yet happened.

The things that come into your mind need not necessarily be real or familiar shapes. For example, the shrill noise of a fire siren may intrude from outside and cause you to run a thin, piercing line all the way through your drawing. What you draw need not be anything so recognizable as a fish. It need not necessarily be anything that could be expressed by a word. We attach too much significance to the word, which is apt to be misleading. Subconscious thoughts are so fast that we cannot grasp them. You probably missed about six before you got to the fish. If you really put down your subconscious thoughts, you would hardly have been aware of the impulse which you put down. Sometimes when students show me their drawings, they say half-apologetically, 'I don't know why I drew that. I just drew it.' When that happens they are doing the exercise in the best possible way. Be guided by your own feeling in relation to the subject.

Naturally, you don't have to start with a person to practice this exercise. Look around at the place where you happen to be sitting and put down the first thing that comes into your mind. Suppose you find yourself in a grove of thick pine trees and the branches overhead remind you of an umbrella. Draw the umbrella, then look again at the place. The drawing, as it develops, need not contain any self-conscious composition, but if the shapes and movements fit together, or compose, that too is all right.

THE QUALITY OF GESTURE. From these first crude beginnings you begin to become aware that the quality of the model which suggested a fish was fish-like, not because the model looked like a fish especially, but because he or she suggested the capability of a fish. A fish looks like a fish because of its capability for a certain kind of gesture or a certain kind of life. The artist's constant effort is to abstract from the fish that quality which is most fish-like — its gesture. Therefore, you will find yourself putting down,

Courtesy of the Metropolitan Museum of Art
FISH AT PLAY BY CHAO-K'EH-HSIUNG (CHINESE, SUNG DYNASTY)
The artist's constant effort is to abstract from the fish that quality which is most fish-like.

not a fish, but a drawing which is the gesture of a fish and which might coincide with the gesture of other things. Similarly, when you draw the grove of pine trees, you may find yourself drawing neither the trees nor the umbrella but that gesture which made you think of the one when you saw the other.

THE PURPOSE. We are not trying to develop surrealism or any particular type of painting in this exercise. It helps you to see with more discrimination and should add something to any sort of drawing of the model. We are trying to loose certain powers that you have. You do not even need to understand them.

Our particular object is to bring you back to seeing the model and representing the model in a manner more personally truthful than in any other exercise yet described. As you go on, you will develop the ability to relate the meaningful parts of your experience and gain a better command over those forces, those ingredients, which are peculiarly your own. There is some part of each human being, no matter how many millions of human beings there are and have been and will be, that is totally different from every other. That is natural, for no two people have the same heritage combined with the same experiences in the same order. All the tendencies of training to make people conform to their social environment are unable to defeat this little grain of personality that is theirs. There is a tendency in art schools — there usually has been a tendency in anything called a school — to make a great virtue of conformity. Nothing could be more false in art.

The subconscious mind has a logic of its own that often transcends the logic of the conscious mind. This exercise, practiced purely as exercise, will enable the subconscious mind to work for you when you need it. It is my belief that the truly great artists of all times — and this is one reason for their greatness — have allowed the subconscious to work for them much of the time. This does not mean that conscious energy, the activity of the conscious mind, is not also very necessary. But relax the conscious mind and let the subconscious work by the direct stimulation of an event.

From long practice we attain what we all strive for — that equilibrium, the proper balance, between the subjective and the objective impulse, between the conscious use of the model and the subconscious reaction. You are trying to weld those two impulses together. The proportion of each required to produce the most fruitful act for the individual may be different for different people and at different times in the life of one individual. It may take more of the subjective to weigh the same with one as with another, but the balance must be attained. If I force myself completely on the model, that is wrong. Or if the model forces itself completely on me, that is wrong. There is a place in the middle where we meet and continually interact.

DREAM OF THE BUTTERFLIES BY REDON

Drawing or painting may express ideas formed by means of visual experience without being necessarily a literal recording of that experience.

CONCEPT AND APPEARANCE. Drawing or painting may be thought of as a way of expressing certain of our ideas about objects, which have been formed by means of visual experience, without being necessarily a literal recording of that experience. Our concept of an object is far from being identical with the projection of that object upon the retina of the eye. Indeed we may express our concept in the terms of drawing and painting without in any way imitating the visual image.

Forms do not have to be taken from the visible world — it is equally logical to borrow from the invisible world. On the other hand, it is not necessary self-consciously to ignore or exclude the forms of the visible world. Even a subjective study may bear a physical resemblance to the model. Just as there is variety in all of nature, there is variety in people. One may paint abstractly and another not, but they make use of the same impulses and when they use them correctly a work of art can result.

Subject matter is not as important as you may think. The subject is only a means of exchange. It has no absolute value — its value is relative. Time and circumstances affect it as they do all other things. It must not matter to the artist what subject matter temporarily proves convenient.

The subject which is proper for you is that which gives you sufficient impulse to go on to a real creative effort. At the time when you are most interested in the act of painting, the subject will become entirely fused with the painting. Art is supposed to transcend the episode and give a pleasure for itself. The episode is a starting place for the artist, and a very necessary one, but it is also a leaving-off place for the artist when he is producing art and it is a leaving-off place for the person who looks at the picture with real art appreciation. The sketchiest and most trivial subjects are as susceptible as any others of the most profound artistic reconstruction. All that is required is an artist capable of penetrating them.

Draw for fifteen hours as directed in Schedule 24.

Section 25

An Approach to the Use of Color

DRAWING AND PAINTING. This is the point at which, if you came to my class, you would go on to the study of painting. It is not the purpose of this book to go into that subject, but naturally these exercises have not been planned with the idea that you would stop when you finished them. You will go ahead. And I believe you will find that experimentation and observation, based on the approach you have already learned, will carry you forward into painting in a natural way even if you are working without other instruction.

The use of black and white crayon on colored paper has already introduced you to the use of color although you thought of that medium only as a means of drawing. And perhaps the most important point I can make is that you are not to think of painting as something separate from drawing. Just as you used three different mediums to accomplish the same purpose

SCHEDULE 25

	A	B	C	D	E
Half Hour	Ex. 58: Gesture on Colored Paper (5 drawings)	Ex. 53: Half-Hour Study in Oil (one)	Ex. 58: Gesture on Colored Paper (5 drawings)	Ex. 53: Half-Hour Study in Oil (one)	Ex. 58: Gesture on Colored Paper (5 drawings)
One Hour	Ex. 51 and 61: The Sustained Study in Oil Color, Nude (one study composed of three drawings)				Ex. 33 and 50: Study of the Bones and Muscles (two drawings)
Quarter Hour	Rest	Rest	Rest	Rest	Rest
Quarter Hour	Ex. 59: Straight and Curve in Color (3 drawings)	Ex. 58: Gesture on Colored Paper (3 drawings)	Ex. 59: Straight and Curve in Color (3 drawings)	Ex. 58: Gesture on Colored Paper (3 drawings)	Ex. 56: Straight and Curve in Frames (one drawing)
One Hour	Ex. 57 and 60: The Subjective Study (one)	Ex. 51 and 61: The Sustained Study in Oil Color, Clothed (one drawing)			Ex. 19 and 51: The Head in Oil (one drawing)

Homework: Ex. 14 or 30: The Daily Composition; Ex. 34: The Long Composition (fifteen minutes a day for one week); Ex. 47: Composition from Reproductions (one hour a week).

in the modelled drawing — crayon, ink, and water color — so you can achieve that same purpose, or assist in achieving it, by the use of color. My advice is that you continue these exercises for a while, gradually adding more color as you work. Review in your mind the one objective of each study and seek for a means by which color can contribute to a more complete realization of that objective. This section contains some exercises which may help you to do that.

The following is a list of oil colors which I suggest that you experiment with during the next few months: ivory black, raw umber, burnt sienna, alizarin crimson, light red, cadmium red, yellow ochre, cadmium yellow pale, either titanium or zinc white, viridian green, permanent blue. This list is given only as a practical starting point. These are not necessarily the colors I use myself or the ones you will use ultimately. The ones you use will be chosen by you on the basis of experimentation, not by me. You will probably need also a larger bristle brush, a small flat sable brush, and a No. 3 water-color brush. You need not add all these colors at once. Add only one or two at a time and find out all that you can about each — what you can do with it — before you try another. As in previous exercises, study by concentrating on a specific problem.

COLOR AND MOVEMENT. Whenever you are uncertain as to how to begin a study, think of the movement, sense the movement. Learn to identify yourself with the movement of the thing, the model, the event. Just as a line, a shape, a fold of drapery, responds to movement, so color responds to movement. Think of color as spreading out, pushing in, jumping, advancing or retreating. What you see has been designed by movement. The gesture of the thing is the surest and strongest impulse, and if you aren't sensitive to it you can't paint form *with life*.

EXERCISE 58: GESTURE ON COLORED PAPER

In the one minute or five minutes allowed for gesture studies in oil, there is not time to think very much about the color you are using. Therefore, I suggest that you first introduce the element of color in this simple way. Color the brown paper by laying over it a coat of oil paint, using any color mixed with white. Prepare a number of sheets in this way, using as many colors as you have. (Cheap pastel paper of various colors, like that used for crayon studies, may also be used, though you should first shellac it to save

FIELDS AT AUVERS BY VAN GOGH
Whenever you are uncertain as to how to begin a study think of the movement.

time and paint. For this purpose use ordinary white shellac diluted with two parts of alcohol to one of shellac.) On this paper, make gesture studies in black and white oil. If you have time, add something of one other color, using the one which seems most needed to balance the color that is already on the paper. (These suggestions may be applied also to half-hour studies in oil.)

EXERCISE 59: STRAIGHT AND CURVE IN COLOR

Make gesture drawings in straight and curved lines as in Exercise 46, using any two oil colors, as red and blue, on large sheets of brown paper. Do not worry too much about which color you are using, but feel your way through the gesture first with one and then the other almost haphazardly. Use one color for both the straight and curved lines until you are tired of it and then take up the other for a while. Soon, if you are thinking primarily of gesture, you will find that you select a color, just as you choose between the straight line and the curve, because it best describes the movement you see.

EXERCISE 60: THE SUBJECTIVE STUDY — *Continued*

Most students find that the subjective study (Exercise 57) becomes much easier when it is practiced in color. Introduce into it immediately as much color as you like, used in any way you like. Put down any color that comes to mind regardless of whether you see it or not. In fact, in the beginning you should force yourself a little to use colors that you do not actually see. Your choice will be determined by the way you feel about the subject. A pleasant experience would not be recorded in the same colors as an unpleasant one.

There is a universal tendency to associate certain colors with certain emotions or certain things. For example, we often speak of seeing *red*, feeling *blue*, or being *yellow*. We sometimes think of people as being very vivid whereas, if you analyze their actual physical characteristics, they are quite colorless. Start, not with a color you see, but with the color that the model or something else connected with the subject happens to make you think of.

The use of color is necessarily a personal thing. Schools based on the sys-

MOTHER WITH CHILD ON HER ARM BY DAUMIER

tems of certain painters, no matter how good those painters are, lose the personal experience, the individual evaluation of color, which is necessary to make the effort succeed.

EXERCISE 61: THE SUSTAINED STUDY IN OIL (VARIATIONS)

Continue making sustained studies in only two colors, but try substituting for black and white the following combinations in turn (and then others that you think of): (1) raw umber and white; (2) light red and white with the addition of a little black for the darkest parts; (3) a neutral green (formed by mixing black and cadmium yellow on the palette) and white.

Almost from the beginning you have been conscious of the back of the subject even when the front alone is presented — of the need for complete solidity. A master becomes able to achieve this effect with an economy of means — by the quality of a line or by the use of color alone — but beginners must struggle with the task. This solid result may be achieved most completely by violent contrasts of black and white. Naturally, if you are using one color to pull the form toward you and another to push it away, the two colors which are most opposed (black and white) will produce the maximum difference in the form. We have previously utilized this maximum difference in the sustained study. Actually, the figure doesn't appear to range all the way from black to white, especially when it is only a part of a large composition, and a large quantity of black pigment doesn't serve as a very satisfactory basis for additional color. Therefore, we are substituting other colors for the black, but this can be done *without any sacrifice of the form* provided your comprehension of the form is absolutely clear.

Draw for fifteen hours as directed in Schedule 25.
Repeat Schedule 25, gradually adding and developing the following exercises.

EXERCISE 62: THE SUSTAINED STUDY IN OIL — *Continued*

There is no necessity for feeling at any time that the use of color is confusing or complicated. Actually, the *effect* of color may be achieved by the simplest methods and with the use of very little pigment. The following directions will demonstrate that and serve as a simple step forward.

Return to one of your sustained studies in oil color which was drawn from the clothed model. Over the flesh put a mixture of light red and yellow

drawing. (Look at the actual figure as a guide to the parts which appear cool as contrasted with warm. In general, wherever the form turns it tends to take on a cooler color.) Think of color first as an aid to drawing.

Just as we said that a line has no character (long or short, thick or thin) until we compare it with other lines, so a color has no character apart from other colors. Green is not green merely because it is green, but also because other things are orange or red. You must have noticed how some people's eyes change color with the clothes they wear. Suppose you have a black and white oil study of a tree which you wish to take into color. First try painting it red and letting it dry. Then put green over the red. Notice how this differs from a green that was applied directly over black and white.

EXERCISE 63: FULL COLOR

The time will come when you wish to achieve a maximum experience with the use of color — that is, you wish to concentrate on color just as we have concentrated on other phases of drawing. Then I suggest that you make half-hour or longer studies, using all your colors on paper of various shades. Paint directly — that is, start with color instead of with a mono-tone drawing as in the sustained study (Exercise 62). Use the color lavishly and freely from the outset without prearranged plan or system. If the rest of your student work has been done well, color, no matter how you use it, will contribute to and be determined by your understanding of the thing you are painting.

EXERCISE 64: ARBITRARY COLOR

As you paint, you acquire facility, and when you look repeatedly at the colors of the model you develop an efficient way of representing them which slips easily into mere habit. This exercise has been devised to combat that tendency. It is particularly useful in painting the landscape where the predominance of green sometimes makes the student lose his sensitive, searching approach to color.

Suppose that you are painting a landscape. Select some part of it with which to begin — for example, a meadow. Instead of painting the meadow green, as it is, arbitrarily choose for it another color, any other color — let us say, purple. Having painted the purple meadow, go on with the rest of

ochre. Over the dress, if it was blue, put a simple solid blue. Apply the color so thinly that the drawing remains perfectly clear underneath. (The color may be kept thin either by rubbing it into the drawing with your brush or finger or by mixing a medium with it. Try both methods. As a medium I suggest either of the following: (1) one part Venice turpentine and one part turpentine; (2) one part sun-thickened or stand oil and three parts dammar varnish. The dammar should be a twenty-five percent solution.)

Already your drawing approximates the colors that existed. Then look again at the model, or at other models, and note what seems to you to be lacking in the drawing. Perhaps the dress now seems flat or vague, so you return to white and build up the lightest parts again. If it seems too blue, you can counteract that by adding another color over it after it is dry. In this manner, keep going as long as you want to. Don't feel that you have to reproduce exactly any color that you see. In general, keep the largest areas simple, almost a monotone in color, and then here and there — ultimately in the right place — add color or contrast or emphasis in small bits.

As you learned to draw by drawing, and could learn in no other way, you will learn to paint by painting. It doesn't matter very much what you do so long as you keep trying different things until some begin to work.

COOL AND WARM. When you are using color, the contrast between light and dark is not the only contrast you can make use of. There is also the contrast between cold color and warm color. Demonstrate to yourself the importance of this contrast by making a sustained study in which you use only two tones of gray, a cool gray and a warm gray. The warm gray may be made by mixing on your palette white, black, and a little red, and the cool gray by mixing white, black, and green. Even though the two grays are close together in value (that is, neither one is much lighter or darker than the other) the contrast between cool and warm, like the contrast between black and white, will enable you to present the form as a solid thing.

This contrast may be utilized as you continue the sustained study according to Exercise 62. When you first tried that exercise, you used one simple flesh color. The color contributed nothing to the sensation of the form. The form was there only because it showed through from your drawing. Try using on a nude study two tones of flesh color, one warm (somewhat pink) and the other cool (somewhat green). The contrast between the two adds to the sensation of form so that it appears even more solid than in your

the landscape in whatever colors seem suitable, avoiding only the colors that you actually see (except perhaps in a few minor instances). Do not try to work out a system. For example, if the meadow is yellow green and the trees are dark green, don't think you have to make the trees a darker purple. You can make them red or yellow.

If you paint a smooth stretch of green, it obviously looks like the green grass in a meadow. But when that meadow becomes purple, it requires a new effort to convince the beholder that the grass really is grass. You are brought back to a new realization of that which makes a thing what it is and of that which is necessary in order really to represent it.

Let's repeat what I said the very first time you sat down to draw. That is — drawing depends on seeing. Seeing depends on knowing. Knowing comes from a constant effort to encompass reality with all of your senses, all that is you. You are never to be concerned with appearances to an extent which prevents reality of content. It is necessary to rid yourself of the tyranny of the object as it appears. The quality of absoluteness, the note of authority, that the artist seeks depends upon a more complete understanding than the eyes alone can give. To what the eye can see the artist adds feeling and thought. He can, if he wishes, relate for us the adventures of his soul in the midst of life.

If your student efforts are based upon a sincere attempt to experience nature, you will know that you are on the right track and picture making will take care of itself. The job is to get at the truth — the truth as you will be able to understand it first hand, arrived at by the use of all your senses. When you are really enthralled, really stimulated, by a force other than the visual, strange looking things are apt to occur, but you will not judge your work by formula or conventional standards. You may feel that there is no real necessity for remaining visually truthful or even structurally truthful in relation to the moment. There is always a bigger truth undiscovered — unsaid — uncharted until you meet it.